# 100 Essential Things
# You Didn't Know
# You Didn't Know
# about Math and the Arts

## ALSO BY JOHN D. BARROW

# 100 Essential Things You Didn't Know You Didn't Know about Math and the Arts

## JOHN D. BARROW

W. W. Norton & Company
*Independent Publishers Since 1923*
New York • London

Copyright © 2014 by John D. Barrow
First American Edition 2015

First published by Bodley Head, one of the publishers in The Random House Group Ltd, under the title *100 Essential Things You Didn't Know You Didn't Know about Maths and the Arts*.

Some chapters in this book were previously published, in somewhat different form, in the author's *100 Essential Things You Didn't Know You Didn't Know*.

For information about permission to reproduce selections from this book, write to Permissions, W. W. Norton & Company, Inc., 500 Fifth Avenue, New York, NY 10110

For information about special discounts for bulk purchases, please contact W. W. Norton Special Sales at specialsales@wwnorton.com or 800-233-4830

Manufacturing by RR Donnelley, Harrisonburg, VA
Production manager: Anna Oler

Library of Congress Cataloging-in-Publication Data
Barrow, John D., 1952–
100 essential things you didn't know you didn't know about math and the arts / John D. Barrow. — First American edition.
pages cm
First published by Bodley Head under the title: 100 essential things you didn't know you didn't know about maths and the arts.
Includes bibliographical references.
ISBN 978-0-393-24655-1 (hardcover)
1. Arts—Mathematics—Miscellanea. I. Title.
NX180.M33B37 2015
700.1'05—dc23
2014038116

ISBN 978-0-393-35222-1 pbk.

W. W. Norton & Company, Inc.
500 Fifth Avenue, New York, N.Y. 10110
www.wwnorton.com

W. W. Norton & Company Ltd.
Castle House, 75/76 Wells Street, London W1T 3QT

1 2 3 4 5 6 7 8 9 0

TO DARCEY AND GUY

who are still young enough to know everything

"Art is I, science is we"
Claude Bernard

# Contents

# Contents

# Contents

# Preface

Math is all around us, underpinning situations that are not commonly thought of as "mathematical" at all. This is a collection of mathematical bits and pieces – unusual applications of mathematics to our usual surroundings. The situations are taken from the world of "the arts," a broadly defined discipline encompassing the large subcontinents of design and the humanities from which I have chosen a hundred examples across a wide landscape of possibilities. The selection can be read in any order: some chapters interconnect with others, but most stand alone and offer a new way of thinking about an aspect of the arts, including sculpture, the design of coins and stamps, pop music, auction strategies, forgery, doodling, diamond cutting, abstract art, printing, archaeology, the layout of medieval manuscripts, and textual criticism. This is not a traditional "math and art" book, covering the same old ground of symmetries and perspective, but an invitation to rethink how you see the world around you.

The diverse spectrum of links between mathematics and all the arts is not unexpected. Mathematics is the catalogue of all possible patterns – this explains its utility and its ubiquity. I hope that this collection of examples looking at patterns in space and time will broaden your appreciation of how simple mathematics can shed new light on different aspects of human creativity.

I would like to thank many people who encouraged me to write this book, or helped to gather illustrative material and bring it into its final form. In particular, I would like to thank Katherine Ailes,

Will Sulkin, and his successor Stuart Williams at Bodley Head. Thanks for their contributions are also due to Richard Bright, Owen Byrne, Pino Donghi, Ross Duffin, Ludovico Einaudi, Marianne Freiberger, Geoffrey Grimmett, Tony Hooley, Scott Kim, Nick Mee, Yutaka Nishiyama, Richard Taylor, Rachel Thomas, and Roger Walker. I would also like to thank Elizabeth and our growing family generations for noticing occasionally that this book was in progress. I just hope they notice when it comes out.

<div align="right">

John D. Barrow
Cambridge

</div>

# 1

# The Art of Mathematics

Why are math and art so often linked? We don't find books and exhibitions about art and rheology or art and entomology, but art and math are frequent bedfellows. There is a simple reason that we can trace back to the very definition of mathematics.

Whereas historians, engineers, and geographers will have little difficulty telling what their subjects are, mathematicians may not be so sure. There have long been two different views of what mathematics *is*. Some believe it is discovered, while others maintain that it is invented. The first opinion sees mathematics as a set of eternal truths that already "exist" in some real sense and are found by mathematicians. This view is sometimes called mathematical Platonism. The second contrasting view sees mathematics as an infinitely large game with rules, like chess, which we invent and whose consequences we then pursue. Often, we set the rules after seeing patterns in Nature or in order to solve some practical problem. In any case, it is claimed, mathematics is just the outworking of these sets of rules: it has no meaning, only possible applications. It is a human invention.

These alternative philosophies of discovery or invention are not unique to the nature of mathematics. They are a pair of alternatives that go back to the dawn of philosophical thinking in early Greece. We can imagine exactly the same dichotomy applied to music, or art, or the laws of physics.

The odd thing about mathematics is that almost all mathematicians act as though they are Platonists, exploring and discovering

things in a mentally accessible world of mathematical truths. However, very few of them would defend this view of mathematics if pressed for an opinion about its ultimate nature.

The situation is muddied somewhat by those, like me, who question the sharpness of the distinction between the two views. After all, if some mathematics is discovered, why can't you use it to invent some more mathematics? Why does everything we call "mathematics" have to be either invented *or* discovered?

There is another view of mathematics which is weaker in some sense, in that it includes other activities like knitting or music within its definition, but I think it is more helpful for non-mathematicians. It also clarifies why we find mathematics to be so useful in understanding the physical world. On this third view mathematics is the catalogue of all possible patterns. This catalogue is infinite. Some of the patterns exist in space and decorate our floors and walls; others are sequences in time, symmetries, or patterns of logic or of cause and effect. Some are appealing and interesting to us but others are not. The former we study further, the latter we don't.

The utility of mathematics, that surprises many people, is in this view not a mystery. Patterns must exist in the universe or no form of conscious life could exist. Mathematics is just the study of those patterns. This is why it seems to be so ubiquitous in our study of the natural world. Yet there remains a mystery: why have such a small number of simple patterns revealed so much about the structure of the universe and all that it contains? It might also be noted that mathematics is remarkably effective in the simpler physical sciences but surprisingly ineffective when it comes to understanding many of the complex sciences of human behavior.

This view of mathematics as the collection of all possible patterns also shows why art and mathematics so often come together. There can always be an identification of patterns in artworks. In sculpture there will be patterns in space; in drama there will also be patterns in time. All these patterns can be

described by the language of mathematics. However, despite this possibility, there is no guarantee that the mathematical description will be interesting or fruitful, in the sense of leading to new patterns or deeper understanding. We can label human emotions by numbers or letters, and we can list them, but that does not mean that they will obey the patterns followed by numbers or by English grammar. Other, subtle patterns, like those found in music, clearly fall within this structural view of mathematics. This doesn't mean that the purpose or meaning of music is mathematical, just that its symmetries and patterns comprise a little part of the great catalogue of possibilities that mathematics seeks to explore.

# 2

# How Many Guards Does an Art Gallery Need?

Imagine you are head of security at a large art gallery. You have many valuable paintings covering the gallery walls. They are hung quite low so that they can be viewed at eye level and therefore they are also vulnerable to theft or vandalism. The gallery is a collection of rooms of different shapes and sizes. How are you going to make sure that each one of the pictures is being watched by your attendants all of the time? The solution is simple if you have unlimited money: just have one guard standing next to every picture. But art galleries are rarely awash with money and wealthy donors don't tend to earmark their gifts for the provision of guards and their chairs. So, in practice, you have a problem, a mathematical problem: what is the smallest number of guards that you need to hire and how should you position them so that all the walls of the gallery are visible at eye level?

We need to know the minimum number of guards (or surveillance cameras) required to watch all of the walls. We will assume that the walls are straight and that a guard at a corner where two walls meet will be able to see everything on both those walls. We will also assume that a guard's view is never obstructed and can swivel around 360 degrees. A triangular gallery can obviously be watched by just one guard placed anywhere inside it. In fact, if the gallery floor is shaped like any polygon with straight walls

whose corners all point outward (a "convex" polygon, like any triangle, for example) then one guard will always suffice.

Things get more interesting when the corners don't all point outward. Here is a gallery like that with eight walls which can still be watched by just one guard located at the corner O (although not if the guard is moved to the top or bottom left-hand corner):

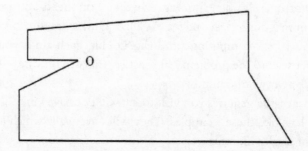

So, this is still a rather economical gallery to run. Here is another "kinkier" twelve-walled gallery that is not so efficient. It needs four guards to keep an eye on all the walls:

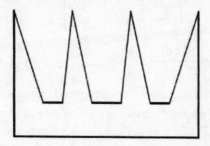

To solve the problem in general we just look at how we can divide the gallery up into triangles that don't overlap.[1] This can always be done. Since a triangle is one of those convex polygons (the three-sided one) that only need a single guard, we know that if the gallery can be completely covered by, say, T non-overlapping triangles then it can always be watched by T guards. It might, of

course, be watched by fewer. For instance, we can always divide a square into two triangles by joining opposite diagonals, but we don't need two guards to watch all the walls – one will do. In general, the maximum number of guards that might be necessary to guard a gallery with W walls is the whole number part[2] of W/3. For our twelve-sided comb-shaped gallery this maximum is $12/3 = 4$, whereas for an eight-sided gallery it is two.

Unfortunately, determining whether you need to use the maximum is not so easy and is a so-called "hard" computer problem for which the computing time can double each time you add another wall to the problem.[3] In practice, this will only be a worry if W is a very large number.

Most of the galleries you visit today will not have kinky, jagged wall plans like these examples. They will have walls which are all at right angles like this:

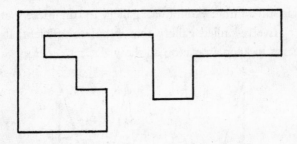

If there are many corners in a right-angled gallery like this, then it can be divided up into rectangles each of which requires no more than one guard to watch its walls.[4] Now, the number of guards located at the corners that might be necessary and is always sufficient to guard the gallery is the whole number part of ¼ × Number of Corners: for the fourteen-cornered gallery shown here this is three. Clearly, it is much more economical on wages (or cameras) to have a gallery design like this, especially when it grows large. If you have a hundred and fifty walls then the non-right-angled design might need fifty guards; the right-angled setup will need at most thirty-seven.

Another traditional type of right-angled gallery will be divided into rooms. Here is a ten-roomed example:

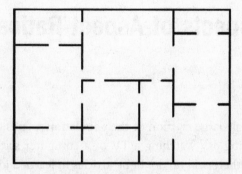

In these cases you can always divide the gallery up into a collection of non-overlapping rectangles. This is expedient because if you place a guard at the opening connecting two different rooms then both are watched at the same time. Yet no guard can watch three or more rooms at once. So now the number of guards that is sufficient, and occasionally necessary, to keep a complete watch on the gallery is the next whole number bigger than or equal to ½ × Number of Rooms, or five for the ten-roomed gallery drawn here. This is a more economical use of resources. All manner of more realistic scenarios have been studied by mathematicians, some in which the guards move, others in which they have limited fields of view or where there are mirrors to help them see around corners. There are also studies of the optimum routes for art thieves to take through a gallery watched by cameras or moving guards so as to avoid all of them! Next time you plan to steal the *Mona Lisa* you will have a head start.

# 3

# Aspects of Aspect Ratios

An alarmingly large fraction of the population spends a good deal of the waking day watching a TV or a computer screen. In fifty years' time there will no doubt be articles in learned journals that reveal effects on our eyesight over the period of the computer revolution that "health and safety" was blind to.

The screens used in the computer industry have evolved toward particular shapes and sizes over the past twenty years. The "size," as we had from the start with TV screens, is labeled by the length of the diagonal between opposite top and bottom corners of the monitor screen. The shape is defined by an "aspect ratio" which gives the ratio of the width to the height of the screen. There have been three or four common aspect ratios used in the computer industry. Before 2003, most computer monitors had an aspect ratio of 4 to 3. So, if they were 4 units wide and 3 units high, then Pythagoras' theorem tells us that the length of the diagonal squared would be 4-squared (16) plus 3-squared (9), which equals 25, or 5-squared, and so the diagonal would be of length 5 units. Screens of this almost-square shape became the old TV-industry standard for desktop computers. Occasionally, you would see a monitor with a 5 to 4 aspect, but 4 to 3 was the most common until 2003.

From 2003 until 2006 the industry moved toward an office standard of 16 to 10, that was less square and more "landscape" in dimension. This ratio is almost equal to the famous "golden

ratio" of 1.618, which is presumably no accident. It has often been claimed by architects and artists to be aesthetically pleasing to the eye and has been widely incorporated into art and design for hundreds of years. Mathematicians have been aware of its special status since the days of Euclid. We shall meet it again in later chapters, but for now we just need to know that two quantities, A and B, are said to be in the golden ratio, R, if:

$$A/B = (A + B)/A = R.$$

Multiplying across, we see that $R = 1 + B/A = 1 + 1/R$, so:

$$R^2 - R - 1 = 0.$$

The solution of this quadratic equation is the irrational number $R = \frac{1}{2} (1 + \sqrt{5}) = 1.618$.

The golden ratio aspect ratio, R, was used for the first-generation laptops, and then for stand-alone monitors that could be attached to any desktop. However, by 2010, things had undergone another evolutionary change, or perhaps it was just an arbitrary change, to a ratio of 16 to 9 aspect. These numbers – the squares of 4 and 3 – have a nice Pythagorean air to them and a screen that is 16 units wide and 9 high would have a diagonal whose length is the square root of $256 + 81 = 337$, which is approximately 18.36 – not quite so round a number. Between 2008 and 2010 computer screens were almost all in the ratio 16 to 10 or 16 to 9, but by 2010 most had moved away from the golden ratio to the 16 to 9 standard, which is the best compromise for watching movies on computer screens. However, the user seems to be a loser again, because if you take two screens with the same diagonal size, then the old 4 to 3 aspect ratio results in a larger screen area than the newer 16 to 9 ratio: a 4 to 3 aspect 28-inch screen has a viewing area of 250 sq.

inches, whereas its 16 to 9 aspect 28-inch counterpart has only 226 sq. inches of display.[1] Of course, the manufacturers and retailers who are seeking constantly to get you to upgrade your screen size will not tell you these things. An upgrade could well be a downgrade.

# 4

# Vickrey Auctions

Auctions of works of art or houses are open in the sense that participants hear the bids being made by their fellow bidders or their agents. The sale is made to the highest bidder, at the price of the top bid. This is a "pay what you bid" auction.

The sellers of small items like stamps, coins, or documents have made extensive use of another type of auction which can be operated by post or Internet as a "mail sale" and is cheaper to operate because it doesn't need to be run by a licensed auctioneer. Participants send in sealed bids for a sale item by a specified date. The highest bidder wins the auction but pays the price bid by the second-highest bidder. This type of sealed-bid auction is called a Vickrey auction after the American economist William Vickrey, who in 1961 studied its dynamics, along with those of other types of auction.[1] Vickrey certainly didn't invent this style of auction. It was first used to sell postage stamps to collectors and dealers in 1893 when auctions began to attract interest from bidders on both sides of the Atlantic and it was not practical for them to travel to the auction in person. Nowadays it is how Internet auctions like eBay work (although eBay requires the next bid to beat the previous highest by a minimum amount).

The usual "pay what you bid" style of sealed-bid auction that is so popular with house sales has problems. If everyone putting in a sealed bid thinks that only he or she knows the real value of the item being sold, then each bid is likely to be less than the item's true value and the seller will be sold short. A buyer bidding

for something like a house, whose value is less well defined, feels driven to overbid and can end up paying far more than should have been necessary to win in an open sale. Some buyers also feel nervous about putting in high bids to a sealed-bid auctioneer because they are giving information to the seller. If you see one item in a mixed auction lot that is very valuable, then by bidding high for it you signal something to the seller, who may suddenly realize what you have seen and withdraw the item from sale.

Overall, the "pay what you bid" sealed-bid style of auction seems to discourage people from buying and selling items for what they are worth. The Vickrey auction does much better. The optimal strategy to adopt in a Vickrey auction is to bid what you think the value of the item is. To see why, imagine that your bid is B and you judge the item's value to be V, while the largest bid from all the other bidders is L. If L is bigger than V then you should make your bid less than or equal to V so that you don't end up buying it for more than it is worth. However, if L is smaller than V then you should bid an amount equal to V. If you bid less you won't get the item more cheaply (it will still cost you L, the price of the second-highest bid) and you may lose it to another bidder. Your optimal strategy is therefore to bid an amount equal to the item's value, V.

# 5

# How to Sing in Tune

The perfect pitch and note-hitting of pop singers often sounds suspicious, particularly when they are amateur competitors in talent shows. Listen to old music shows and there is nowhere near the same degree of perfection. Our suspicions are justified. Some mathematical tricks are being played which clean up and enhance a singer's performance so that out-of-tune voices sound precise and pitch perfect.

In 1996, Andy Hildebrand was using his signal processing skills to prospect for oil. He would study the rebounds of seismic signals sent below the earth to map out the underground distribution of rock and (he hoped) oil. Next, he decided to use his acoustic expertise to study correlations between different musical sounds and devise an automatic intervention system to remove or correct sounds that were off-key or in some other way discordant. Apparently it all started when he decided to retire from his oil prospecting and wondered what to do next. A dinner guest challenged him to find a way to make her sing in tune. He did.

Hildebrand's Auto-Tune program was first used by only a few studios but gradually became an industry standard that can in effect be attached to a singer's microphone for instantaneous recognition and correction of wrong notes and poor pitch. It automatically retunes the output to sound perfect regardless of the quality of the input. Hildebrand was very surprised by these developments. He expected his program to be used to fix occasional discordant notes, not to process entire productions. Singers have

come to expect that their recordings will be processed through the Auto-Tune box. Of course, this has a homogenizing effect on recordings, particularly those of the same song by different artists. At first this software was expensive, but cheap versions soon became available for home use or karaoke performers, and its influence has now become all-pervasive.

The first that most listeners not involved with the music business heard about all this was when a fuss blew up because contestants were having their voices improved by Auto-Tune when singing on the popular *X Factor* TV talent show. Following an outcry, the use of this device was banned on the show and the singers now found it far more challenging to sing live.

The Auto-Tune program doesn't just correct frequencies of the notes sung by the singer to the nearest semitone (keys on a piano keyboard). The frequency of a sound wave equals its speed divided by its wavelength so a frequency change would alter its speed and duration. This would make the music sound as if it was being continually slowed down or speeded up. Hildebrand's trick was to digitize the music into discontinuous sequences of sound signals and change the wave durations so as to keep it sounding right after the frequencies are corrected and the cleaned musical signal is reconstructed.

The process is complicated and relies on the mathematical method know as Fourier analysis. This shows how to split up any signal into the sum of different sinusoidal waves. It is as if these simple waves are the basic building blocks out of which any complicated signal can be constructed. The split of the complex musical signal into a sum of building-block waves with different frequencies and amplitudes enables the pitch correction and timing compensation to be effected very quickly, so that the listener doesn't even know it's being done. That is, of course, unless he or she suspects that the singer's output is a little too perfect.

# 6

# The *Grand Jeté*

Ballerinas can seem to defy gravity and "hang" in the air when they jump. They can't actually defy gravity, of course, so is all this talk of "hanging in the air" mere hyperbole, created by overenthusiastic fans and commentators?

The skeptic points out that when a projectile, in this case the human body, is launched from the ground (and air resistance can be neglected) then its center of mass[1] will follow a parabolic trajectory: nothing the projectile can do will change that. However, there is some fine print to the laws of mechanics: it is only the *center of mass* of the projectile that must follow a parabolic trajectory. If you move your arms around, or tuck your knees into your chest, you can change the location of parts of your body relative to your center of mass. Throw an asymmetrical object, like a tennis racket, through the air and you will see that one end of the racket may follow a rather complicated backward looping path through the air. The center of mass of the racket, nevertheless, still follows a parabolic trajectory.

Now we can begin to see what the expert ballerina can do. Her center of mass follows a parabolic trajectory but her head doesn't need to. She can change her body shape so that the trajectory followed by her head stays at one height for a noticeable period. When we see her jumping we only notice what her head is doing and don't watch the center of mass. The ballerina's head really does follow a horizontal trajectory for a short time. It's not an illusion and it doesn't violate the laws of physics.

This trick is most beautifully executed by ballerinas who perform the spectacular ballet jump called the *grand jeté*. The dancer launches herself into the air where she performs a full leg split, and for artistic reasons tries to create the illusion of gracefully floating in the air. During the jump phase she raises her legs up to the horizontal and puts her arms above her shoulders. This raises the position of her center of mass relative to her head. Soon afterward, her center of mass falls relative to her head as the legs and arms are lowered during her fall back to the floor. The ballerina's head is seen to move horizontally in midflight because her center of gravity is rising up her body during the jump phase. Her center of mass follows the expected parabolic path throughout, but her head maintains the same height above the floor for about 0.4 seconds to create a wonderful illusion of floating.[2]

Physicists have used sensors to monitor the motion of dancers, and the figure below shows the variation of the distance of a dancer's head from the ground during this jump. There is a very distinctive plateau in the middle of the jump that shows the hang in the air and is quite different from the parabolic path followed by the center of mass:

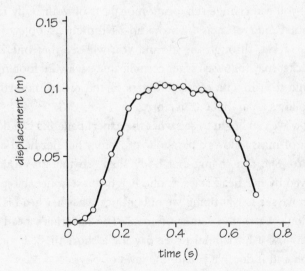

# 7

# Impossible Beliefs

Is it really possible for a belief to be impossible? I don't just mean simply a mistaken belief, but one that is a logical impossibility. The philosopher Bertrand Russell made famous a logical paradox that had far-reaching consequences for mathematicians trying to show that mathematics is nothing more than logic: the collection of all deductions that follow from a collection of starting assumptions, called "axioms." Russell introduced us to the concept of the set of all sets. For example, if our sets are books then the library catalogue could be thought of as a set of all sets. This catalogue itself could also be a book, and therefore at the same time a member of the set of all books, but it need not be – it could be a CD or a collection of index cards.

Russell asked us to contemplate the set of all the sets that are *not* members of themselves. This sounds tongue-twisting but harmless – until you examine it more closely. Suppose you are a member of this set – then by its definition you are not a member of it. And if you are not a member of it then you deduce that you are! More concretely, Russell asked us to imagine a barber who shaves all those people who do not shave themselves: who shaves the barber?[1] This is the famous Russell Paradox.

Logical paradoxes of this sort can be extended to situations in which there are two participants who hold beliefs about each other. Suppose they are called Alice and Bob. Imagine that:

*Alice believes that Bob assumes that*
*Alice believes that Bob's assumption is incorrect.*

This is an impossible belief to hold because if Alice believes that Bob's assumption is incorrect, then she holds that Bob's assumption – that is, "that Alice believes that Bob's assumption is incorrect" – is correct. This means that Alice doesn't believe that Bob's assumption is incorrect, which contradicts the assumption Alice made at the outset. The only other possibility is that Alice doesn't believe that Bob's assumption – "that Alice believes that Bob's assumption is incorrect" – is incorrect. This means that Alice believes that Bob's assumption – "that Alice believes that Bob's assumption is incorrect" – is correct. But this again creates a contradiction because it means that Alice does believe that Bob's assumption is incorrect!

We have displayed a belief that it is not logically possible to hold. This conundrum turns out to be far-reaching. It means that if the language we are using contains simple logic, then there must always be statements that it is impossible to make consistently in that language. In the situations we are looking at, where Alice and Bob hold beliefs about each other, it means that there must always be some belief you can state in your language which it is impossible for you to hold about the other person (or a deity perhaps?).[2] The users of the language can think or speak about these impossible beliefs but they can't hold them.

This dilemma also arises in some court cases where jurors have to assess probabilities for outcomes that may be conditional on other information. They can find themselves drawing a conclusion about guilt that is logically impossible given the evidence of probability that they have accepted. Attempts to remedy this by introducing tutorials about elementary conditional probabilities have been rejected by the British legal system, although they have been successful in the USA.

# 8

# Xerography – Déjà Vu All Over Again

Schoolteachers, university lecturers, and professors once despaired that learning had been replaced by photocopying. Who made the first photocopy and set this juggernaut of paper consumption in motion?

The culprit was an American patent lawyer and amateur inventor named Chester Carlson.[1] Despite graduating in physics from Cal Tech in 1930, Carlson couldn't find a steady job, and his parents were impoverished due to their chronic poor health. The deepening American economic depression hit hard, and Carlson had to settle for any job he could get. The result was a spell in the patent department at the Mallory battery company. Anxious to make the very best of any opportunity, he worked for a law degree at night school and was soon promoted to become manager of the whole department. It was then that he began to feel frustrated that there were never enough copies of the patent documents available for all the organizations that seemed to need them. All he could do was send them off to be photographed – and that was expensive – or copy them out by hand – an unappealing task because of his failing eyesight and painful arthritis. He had to find a cheaper and less painful way of making copies.

There wasn't an easy answer. Carlson spent the best part of a year researching messy photographic techniques, before his library searches uncovered the new property of "photoconductivity" that

had recently been discovered by the Hungarian physicist Paul Selenyi. He had found that when light strikes the surfaces of certain materials, the flow of electrons – their electrical conductivity – increases. Carlson realized that if the image of a photograph, or some text, was shone onto a photoconductive surface, electrical current would flow in the lighter areas but not in the darker printed areas and an electrical copy of the original would be made. He created a makeshift home electronics lab in the kitchen of his apartment in the Queens borough of New York City and experimented through the night with numerous techniques for duplicating images on paper.[2] After being evicted from the kitchen by his wife, he moved his lab to a beauty salon owned by his mother-in-law, in nearby Astoria. His first successful copy was created there on October 22, 1938.

Carlson took a zinc plate, coated it with a thin layer of sulphur powder, and wrote the date and place "10-22-38 Astoria" in black ink on a microscope slide. Turning the lights down, he charged up the sulphur by rubbing it with a handkerchief (just as we might rub a balloon on a woollen sweater), then placed the slide on top of the sulphur and put it under a bright light for a few seconds. He carefully removed the slide and covered the sulphured surface with lycopodium fungus powder before blowing it off to reveal the duplicated message. The image was fixed with heated wax paper so that the cooling wax congealed around the fungus spores.

He dubbed his new technique "electrophotography" and tried hard to sell it to businesses, including IBM and General Electric, because he didn't have any money for further R&D. But none showed the remotest interest. His equipment was awkward and the processing complicated and messy. Anyway, everyone said carbon paper worked just fine!

It was not until 1944 that the Battelle Research Institute in Columbus, Ohio, approached Carlson and entered into a joint agreement to improve his crude process with a view to commercialization.[3] Three years later, the Haloid Company, a Rochester-based

manufacturer of photographic papers, bought all the rights to Carlson's invention and planned to market his copying devices. Their first change, with his agreement, was to abandon Carlson's cumbersome name for the process. "Electrophotography" was superseded by "xerography" thanks to the suggestion of a professor of Classics at Ohio State University. The etymology is Greek, literally "dry writing." In 1948, the Haloid Company shortened this to the trademark "Xerox." The "Xerox machines" which they marketed soon enjoyed commercial success, and in 1958 the company reflected this by changing its name to Haloid Xerox Inc. The Xerox 914 machine, new in 1961 and the first to use ordinary paper, was such a big success that they dropped the Haloid completely to become simply the Xerox Corporation. Revenues that year ran to $60 million and by 1965 they had grown to a staggering $500 million. Carlson became fabulously wealthy but gave away two-thirds of his income to charities. His first photocopy created an unnoticed change in the working practices of the whole world. Information transfer would never be the same. Pictures as well as words could now be routinely copied.

# 9

# Making Pages Look Nice

The advent of simple, inexpensive computers and printers has revolutionized our ability to create attractive documents. At the click of a few keys, in addition to making corrections, we can change typefaces, spacing, margins, font sizes, colors, and layout, and then see our document in preview before printing it onto many possible media. Each time we have a brand-new, clean copy. This is so easy that we forget (or are too young to have known) the travails of document design or book printing before the computer age.

The desire to produce aesthetically pleasing pages of text has been an important consideration from very early times. The key consideration for calligraphers and printers in the post-Gutenberg era was the form of a page: the ratio of page area to written area, and the sizes of the four margins. These proportions must be well chosen to create a visually appealing layout. In early times there were Pythagorean desires for special numerical harmonies to be reflected among the ratios of these distances, in addition to the purely practical issue of how to make the choices simple to implement.

Suppose that the ratio of the width (W) to the height (H) of the paper page is 1:R, where R will be larger than 1 for a "portrait" page layout but less than 1 for "landscape." There is a nice geometrical construction that will create a layout for the text on this page in which the inner (I), top (T), outer (O), and bottom (B) margins are in the ratios:

$$I:T:O:B = 1:R:2:2R$$

Notice that the proportions of the whole page area (height/ width = R) are in the same proportion as the text area because:

$$\text{Text height}/\text{text width} = (H - T - B)/(W - O - I) =$$
$$(RW - R - 2R)/(W - 2 - 1) = R$$

The recipe, or "canon," for book page design[1] in these proportions seems to have been a trade secret in the Middle Ages. Different traditions were reflected in particular choices for the paper-size variable R. A favorite one was for the height-to-width ratio of the paper to be 3:2, so R = ³⁄₂. The four page-margin factors would then be constructed in the ratio I:T:O:B = 1:³⁄₂:2:3. More specifically, this means that if the width of the inner margin is 2 then the top margin will be ³⁄₂ × 2 = 3, the outer margin will be 2 × 2 = 4, and the bottom margin will be 2 × 3 = 6.

Here is one simple recipe for this well-balanced page layout across a double spread, with two pieces of paper side by side,[2] shown in the figure below. Similar ones have been proposed that use simple constructions known and used in the Middle Ages.[3] They show how straightforward it was for the members of a scriptorium to lay out their page designs using only a straight edge.

First draw the diagonals joining the lower right and left corners to the opposite upper corners of the same page and then to the opposite upper corners of the other page. Draw a vertical line from the point where the two diagonals cross on the right-hand page up to the top of the page. Draw a line from the point where this vertical reaches the top of the right-hand page to the point where the diagonals cross on the left-hand page. Note where this line crosses the diagonal from top left on the right-hand page to bottom right on the same page. This intersection point gives the distance of the top margin from the top of the page. The four points where that horizontal top margin crosses the four diagonal lines gives the top corners of the text area on the two pages. That intersection point also fixes the inner margin. Dropping a vertical line down from the point determining the outer margin gives the bottom corner at the point where it intersects the diagonal. The picture illustrates the drawing sequence of six lines that are needed to create the R = ½ layout, in this case with I and O equal to ⅑ and ⅔ of the page width respectively, while T and B are ⅑ and ⅔ of the paper height. The resulting print and page areas are in the same ratio.[4] These principles still continue to inform modern book design[5] with its more complex possibilities and automatic computer control of layout.

# 10

# The Sound of Silence

On March 6, 2012, Ludovico Einaudi and I made a presentation together at the Parco della Musica in Rome about *La Musica del Vuoto*. I talked about the ancient and modern conceptions of the vacuum (the *vuoto* of the title) in science and music, and of zero in mathematics; and Einaudi performed piano pieces that showed the influence of silence, and hence timing, in musical composition and performance.

No conversation about "nothing" and music could fail to mention John Cage's famous *4'33"* ("Four minutes, thirty-three seconds") and Einaudi was able to provide the first-ever performance of this work at the Rome auditorium. It was composed in 1952 – the score says "for any instrument or combination of instruments" – and consists of 4'33" of silence in three movements. Cage specified that the movements could be of any length and they were chosen to be of length 33", 2'40", and 1'20" when first "performed" by the pianist David Tudor on August 29, 1952, at Woodstock, New York State.

Einaudi, following Cage's original directions, sat motionless, fingers poised over the keys, during each movement, and then closed the lid of the piano keyboard at its end, before reopening it for the next. My copy of the original score reads simply:

I

TACET

II

TACET

III

TACET

The "tacet" (silent) musical direction is usually employed to indicate that a particular instrument does not play during a section of the score, but here it indicates that *nobody* plays at any time during any of the movements!

It was very interesting to witness the audience reaction to this 4'33" of silence. Perfect silence is impossible to create and there was a continual low-level hum of fidgeting, coughs, and occasional whispers. However, after more than a minute the sonic invasions became more dramatic as some members of the audience succumbed to fits of giggling which grew louder and more widespread. Perhaps Cage's lesson was learned when we realized how abjectly we had failed to sustain the silence that was required.

On reflection the reason for the failure requires some explanation. It is all very well saying that silence is very hard to achieve and there is always background noise from the environment, but we do much better at achieving it on many other occasions. Sit in an examination hall or attend a Trappist monastery or a solemn church service of remembrance and you will experience a far better approximation of total silence than this musical work was able to achieve. Why? I think the answer is that Cage was seeking to impose silence for no reason and with no purpose. He was not excluding noise in order to focus concentration completely upon something else. When this focus is lacking the mind wanders and silence is not engaging.

Finally, what is the scientific link to Cage's composition? Could there be one? Look again at the unusual length of the silence that gives the piece its title. 4'33" is 273 seconds and to a physicist that is a number with a resonant meaning. Absolute zero of temperature lies at −273°C. This is where all molecular motion ceases and no action can reduce the temperature any further. Cage's composition defined for him the absolute zero of sound.

# 11

# A Most Unusual Cake Recipe

Icing wedding cakes is quite an art. Surfaces have to be smooth but strong enough to support the tiers above, and delicate sugar-iced flowers may have to be created in colors that match the bride's bouquet. We are going to consider the problem of baking and icing a very unusual wedding cake. It will have many tiers; each one is a solid cylinder that is one unit high. As we go upward from the first, to the second, to the third, and so on to the $n$th tier, they will diminish in size. The first will have radius 1, the second radius $\frac{1}{2}$, the third radius $\frac{1}{3}$, and the radius of the circular cylinder forming the $n$th tier will be $1/n$.

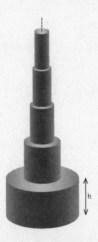

The volume of a cylinder of radius r and height h is just $\pi r^2 h$, because it is just a stack to a height h of circles of area $\pi r^2$. The

outside surface area of this cylinder is just that of a stack of circles of circumference $2\pi r$, and so equals $2\pi rh$. These formulae tell us that the volume of the $n^{th}$ tier of our special cake will be $\pi \times (1/n^2) \times 1 = \pi/n^2$ and its outside surface area to be iced will be equal to $2\pi \times (1/n) \times 1 = 2\pi/n$. These give the volume and area for the $n^{th}$ tier alone. To work out the total for the whole cake of n tiers we have to add together the values of the volumes and the areas for all the tiers $(1, 2, 3 \ldots n)$.

Now imagine a very unusual cake: one with an infinite number of tiers. Its total volume will be given by the sum of the volumes of the infinite number of tiers:

$$\text{Total Volume} = \pi \times (1 + \tfrac{1}{4} + \tfrac{1}{9} + \tfrac{1}{16} + \ldots)$$
$$= \pi \times \Sigma_{r=1}^{\infty} (1/n^2) = \pi^3/6 = 5.17$$

The remarkable thing about this infinite sum of terms is that it is a finite number. The size of successive terms falls off fast enough for the series to converge to $\pi^2/6$, which is approximately 1.64. We would only need a finite amount of cake mixture to create our infinitely tiered wedding cake.[1]

Next, we have to ice it. For this we need to know how much icing to make, so we should calculate the total outside surface areas. (We are going to ignore the small annular region of width $1/n - 1/(n+1)$ on the top of each tier that is left by the tier above resting on it – you will shortly see why it doesn't matter.) The total area to be iced is the sum of the areas of all the tiers in the infinite tower:

$$\text{Total Surface Area} = 2\pi \times (1 + \tfrac{1}{2} + \tfrac{1}{3} + \tfrac{1}{4} + \ldots)$$
$$= 2\pi \times \Sigma_{r=1}^{\infty} (1/n)$$

This sum is infinite. The series of terms $1/n$ does not fall fast enough to converge to a finite answer. By including enough terms in the sum we can make it as large as you wish. It is easy to see

this[2] because the sum of the series must be greater than that of the series $1 + (½) + (¼ + ¼) + (⅛ + ⅛ + ⅛ + ⅛) + \ldots$, where the next (. . .) will contain eight ¹⁄₁₆s and then the next (. . .) sixteen ¹⁄₃₂s. Each of the bracketed terms is therefore equal in total to ½. There are obviously going to be an infinite number of them and so the sum of the series is equal to 1 plus an infinite number of halves, which is infinity. Our sum is bigger than this so it must also have an infinite sum: the surface area of our infinite cake will be infinite. (This is why we didn't worry about adding in those annular rings of icing on the top of each tier.)

This result is very striking[3] and completely counterintuitive: our infinite cake recipe requires a finite volume of cake to make but it can never be iced because it has an infinite surface area!

# 12

# Designing Roller Coasters

Have you ever been on one of those "teardrop" roller coasters that take you up into a loop, over the top and back down? You might have thought that the curved path traces a circular arc, but that's never the case. If the riders are to reach the top with enough speed to avoid falling out of the cars at the top (or at least to avoid being supported only by their safety straps) then the maximum g-force experienced by the riders when the ride returns to the bottom would become dangerously high.

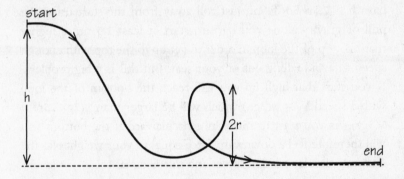

Let's see what happens if the loop is circular and has a radius r and the fully loaded car has a mass m. The car will be gently started at a height h (which is bigger than r) above the ground and will then descend steeply to the base of the loop. If we ignore any friction or air-resistance effects on the motion of the car then it will reach the bottom of the loop with a speed $V_b = \sqrt{2gh}$. It

will then ascend to the top of the loop. If it arrives there with speed $V_t$, it will need an amount of energy equal to $2mgr + \frac{1}{2} mV_t^2$ in order to overcome the force of gravity and ascend a vertical height $2r$ to the top of the loop and arrive there with a speed $V_t$. Since the total energy of motion cannot be created or destroyed, we must have (the mass of the car $m$ cancels out of every term):

$$gh = \frac{1}{2} V_b^2 = 2gr + \frac{1}{2} V_t^2 \; (*)$$

At the top of the circular loop the net force on the rider pushing upward, and stopping him falling out of the car, is the force from the motion in a circle of radius $r$ pushing upward minus his weight pulling down; so, if a rider's mass is $M$, the:

$$\text{Net upward force at the top} = M V_t^2/r - Mg$$

This must be positive to stop you falling out and so $V_t^2 > gr$.

Looking back at our equation $(*)$, this tells us that we must have $h > 2.5r$. So if you just roll away from the start using the pull of gravity alone you have to start at least 2.5 times higher than the top of the loop in order to get up to the top with enough speed to avoid falling out of your seat. But this is a big problem. If you start that high up you will reach the bottom of the loop with a speed $V_b = \sqrt{(2gh)}$ which will be larger than $\sqrt{(2g \times 2.5r)} = \sqrt{(5gr)}$. As you start to move in a circular arc at the bottom you will therefore feel a downward force equal to your weight *plus* the outward circular motion force, and this is equal to:

$$\text{Net downward force at the bottom} = Mg + MV_b^2/r$$
$$> Mg + 5Mg = 6Mg$$

Therefore, the net downward force on the riders at the bottom will exceed six times their weight (an acceleration of 6-g). Most riders, unless they were off-duty astronauts or high-performance

pilots wearing g-suits, would be rendered unconscious by this force. There would be little oxygen supply getting through to the brain. Typically, fairground rides with child riders aim to keep accelerations below 2-g and those for adults' use at most 4-g.

Circular roller-coaster rides seem to be a practical impossibility under this model, but if we look more closely at the two constraints – have enough upward force at the top to prevent falling out but avoid experiencing lethal downward forces at the bottom – is there a way to change the roller-coaster shape to meet both constraints?

When you move in a circle of radius r at speed V you feel an outward acceleration of $V^2/r$. The larger the radius of the circle, r, and so the gentler the curve, the smaller the acceleration you will feel. On the roller coaster the $V_t^2/r$ acceleration at the top is what is stopping you falling out, by overcoming the downward force of your weight, Mg, so we want that to be big, which means r should be small at the top. On the other hand, when we are at the bottom it is the centrifugal reaction force that creates the extra 4-g of acceleration, and so we could reduce that by moving in a gentler circle, with a larger radius. This can be achieved by making the roller coaster with a teardrop shape that is taller than it is wide, so it looks a bit like two parts of different circles, the one forming the top half with a smaller radius than the one forming

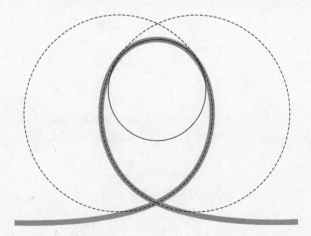

the bottom half. The favorite curve that looks like this is called a "clothoid" whose curvature decreases as you move along it in proportion to the distance moved. It was first introduced into roller-coaster design in 1976 by the German engineer Werner Stengel for the "Revolution" ride at Six Flags Magic Mountain, in California.

# 13

# The Beginning of the Universe Live on TV

One of the greatest discoveries of the twentieth century was finding the residual heat radiation left over from the apparent beginning of the universe – the so-called "echo of the Big Bang." Just as with any large explosion, you expect to find radiation fallout if you survey the scene of the explosion at a later date. In the case of the expanding universe the radiation can't escape anywhere. It is always present and it cools down steadily as the universe expands. The wavelengths of the photons of light are stretched by the expansion. They become longer, "redder," cooler, and of lower frequency. Today, the temperature is very low – about $3°$ above absolute zero, or about $-270°C$ – and the radiation frequency lies in the radio waveband.

This radiation was first discovered accidentally in 1965 by Arno Penzias and Robert Wilson, when it showed up as unexpected noise in a very sensitive radio receiver at Bell Labs in New Jersey, where it was designed to track the Echo communications satellite. Since that Nobel Prize–winning discovery by Penzias and Wilson, this Cosmic Background Radiation ("the CMB") has become the source of the most precise information we have about the past history and structure of the universe. Huge resources have been invested by space agencies in mapping its temperature and other properties across the whole sky using

satellite-borne receivers that can eliminate the confusing effects of the Earth's atmosphere.

Given the monumental importance of the CMB for our understanding of the structure and history of the universe, it is surprising that we can observe it at home while sitting on the sofa in front of the TV – but sadly perhaps not for much longer.

Old TVs picked up radio waves that were broadcast by the TV company's transmitter using frequency ranges that vary around the world. Those using the Very High Frequency (VHF) range make up the 40–250 MHz range, while those using the Ultra High Frequency (UHF) band use 470–960 MHz.

When you have tuned your set to receive the exact frequency of a station (for example, in the UK BBC2 would have been at a frequency of 54 MHz, so these radio waves have wavelengths of 5.5 m) then that dominates reception and your TV converts the information in the radio waves into sound and picture. Channel frequencies are allocated 6 MHz apart to avoid interference. However, if your reception becomes poor, or you detune the set by switching to a nonexistent channel on your control, then the screen will become covered in a familiar "snow." This is noise from various forms of interference which come to the fore when the receiver isn't tuned to a strong channel signal. Remarkably, about 1 percent[1] of this snowy interference on your old TV is provided by the CMB from the beginnings of the universe. Although the peak frequency of the spectrum of radio waves in the CMB is close to 160 GHz, there is significant energy across a very wide range from 100 MHz up to 300 GHz.

Alas, your chance to be an armchair cosmologist is rapidly fading. In many countries there has been a systematic shift from analogue TV signals to digital. Instead of receiving radio waves from the Big Bang to convert into snowy pictures, your TV will receive strings of binary digits that it will translate into sound and film. On older TVs you need to have a digital decoder ("digi box") that converts the digital signal into a language your old TV can

understand. If you unplug that box you can still get a screen of "snowy" interference that contains 1 percent of the cosmic background radiation. But if you have a new digital TV then, alas, your opportunity to be an observational cosmologist has faded away.

# 14

# Coping with Stress

Sharp corners are bad news if you are building anything that is going to be subject to stress. Look around your house. The little cracks in the plaster and brickwork all tend to begin at the corners. The greater the curvature of a boundary so the greater the stress it must bear. This is why our great cathedrals only became architecturally possible with the invention of the Gothic arch to spread stress around a curved structure rather than try to bear it at the corners of right-angled doorways. This enabled buildings to be higher without danger of structural collapse beginning at sharp corners. Medieval stonemasons absorbed this lesson very early and architecture continued to move onward and upward in relative safety.

This ancient wisdom was slow to penetrate some parts of modern technology. In 1954, two of the new Comet passenger jets built by de Havilland broke up in flight killing fifty-six people. After considerable investigation using high pressurizations of the cabin it was seen that the windows were the weak points that broke first. They were square in the passenger cabin and shaped like swept-back parallelograms in the pilots' cabin. They had sharp corners where stress built up and fractured the aircraft. The solution was very simple: round off the corners. Today, all the windows on aircraft have curved corners to spread stress more evenly and avoid the creation of highly curved (that is, sharp) corners where stress is unusually large. Other major

aircraft manufacturers hadn't noticed this problem before the Comet disasters and were thankful that they could incorporate this simple improvement before tragedy struck them too. Sometimes elegant lines are not purely aesthetic.

# 15

# Art Is Critical

Human beings are good at finding all the ways in which to be creative within prescribed limits – painting inside a rectangular frame, writing in iambic pentameters, or composing a sonnet. Scientists sometimes like to study how that creativity occurs, what it achieves, and where else to look for inspiration. Many artists are nervous about scientific analysis. They fear its success, worried that art might lose its power, or they might be diminished, if the psychological roots of their work and its impact on us were exposed. They might even be right to be worried. Unbridled reductionism – music is nothing but the trace of an air-pressure curve – is a surprisingly common world view that should be given no encouragement. However, one also finds the equally mistaken contrary view that science has nothing to offer the arts: that they transcend all attempts to capture them objectively. Indeed, many scientists see the creative arts as entirely subjective activities but enjoy them no less for all that.

As science has started to come to grips with the study of complexity, it is natural that it will encounter artistic creations, like music or abstract art, because they have interesting things to teach us about the development of complexity in the forms that we find so appealing. E. O. Wilson has suggested that the link between science and art can be made closest when both are viewed from the vantage point of the study and appreciation of complexity: "The love of complexity without reductionism makes art; the love of complexity with reductionism makes science."[1]

There is a further interesting feature of complex phenomena that sheds light upon what it is we like about many forms of art that we value most. If we allow a stream of grains to fall vertically downward onto a tabletop then a pile will steadily grow. The falling grains will have haphazard trajectories as they tumble over the others. Yet, steadily, the unpredictable falls of the individual grains will build up a large orderly pile. Its sides steepen gradually until they reach a particular slope. After that, they get no steeper. The special "critical" slope will continue to be maintained by regular avalanches of all sizes, some involving just one or two grains but other rarer events producing a collapse of the whole side of the pile. The overall result is striking. The haphazard falls of the individual grains has organized itself into a stable, orderly pile. In this critical state the overall order is maintained by the chaotic sensitivity of the individual grain trajectories. If the pile was on an open tabletop then eventually the grains would start falling off the sides of the table at the same rate that they drop from above. The pile is always composed of different grains: it is a transient steady state.

The robustness of the overall shape of the pile that exists despite the sensitivity of the individual grain trajectories is very suggestive of what it is we like about many artistic creations. A "good" book, film, play, or piece of music is one that we want to experience again. The "bad" work is one that we don't. Why do we want to see a great theatrical work like *The Tempest*, or hear a Beethoven symphony, more than once? It is because small changes in production – different actors, new styles of direction, or a different orchestra and conductor – create a completely new experience for the audience. Great works are sensitive to small changes in ways that give you a new and pleasurable experience. Yet the overall order is maintained. They seem to exhibit a type of criticality. This combination of predictability and unpredictability is something that we seem to find very appealing.

# 16

# Culinary Arts

Around Christmastime there are many cookery articles in newspapers and magazines advising on how best to cook a large turkey or goose for the festive season. Some will even draw upon advice from old and revered cookery books like *Mrs. Beeton's*. For most cooks the key issue is cooking time. Get it wrong and all other embellishments will fail to impress the diners.

The tricky thing about advice on turkey cooking times is that there is so much of it and no two pieces seem to be the same. Here is one[1]:

Start temperature 160°C [325°F]:
Turkey weights of 8 to 11 lbs roast for 2.5 to 3 hrs.
Turkey weights of 12 to 14 lbs roast for 3 to 3.5 hrs.
Turkey weights of 15 to 20 lbs roast for 3.5 to 4.5 hrs
Each is then followed by a browning period of 30 mins at 220°C [425°F].

This advice is mathematically odd because the cooking times for 11 lb and 12 lb turkeys are both given as 3 hours. Likewise 3.5 hours is specified for 14 lb and 15 lb turkeys.

The British Turkey Information Service (BTIS) offers more elaborate advice and uses metric units (1 lb = 0.45 kg)[2]:

**Less than 4 kg weight?** Cook for 20 minutes per kg then add another **70** minutes cooking time at the end

**More than 4 kg weight?** Cook for 20 minutes per kg and add **90** minutes cooking time at the end

There is even a calculator that invites you to enter the weight and it gives the time and a tabulation of times for weights from 2 to 10 kg.

These BTIS prescriptions for the cooking time T, in minutes, for a turkey plus stuffing weight of W, in kilograms, are given by two formulae:

$$T_1 = 20W + 70 \text{ if } W < 4$$
$$T_2 = 20W + 90 \text{ if } W > 4$$

These formulae look suspicious. If we let the weight tend toward 4 kg then $T_1$ tends toward 150 minutes but $T_2$ approaches 170 minutes. The advice on cooking time lacks a crucial mathematical property – continuity. The values of $T_1$ and $T_2$ should give the same cooking time as W approaches 4. Worse still, as the weight approaches 0 there is still a cooking time of 70 minutes! There is something badly wrong here.

The National Turkey Federation gives the following cooking times for stuffed turkeys. They display a wide variation in the weight intervals and they don't agree with the BTIS formulae for W > 4 turkeys[3]:

| Weight kg | Time hrs |
|---|---|
| 8–12 | 3–3.5 |
| 12–14 | 3.5–4 |
| 14–18 | 4–4.25 |
| 18–20 | 4.25–4.75 |
| 20–24 | 4.75–5.25 |
| 24–30 | 5.25–6.25 |

In the face of this diverse advice, is there some way we can calculate what the trend in cooking time should be with increasing weight? Cooking requires the diffusion of heat from the outer surface of the turkey to the interior in order to raise the internal temperature to a level high enough to denaturize proteins. The diffusion of heat is a random process with the specific character of what mathematicians call a "random walk." Heat is passed from point to point in a process of steps of the same length in which the next step's direction for passing on heat by scattering particles is a random choice. As a result the time taken for heat to pass between two points which are N step lengths apart between scatterings is not proportional to N but to $N^2$. Imagine we have a spherical turkey. Its radius is R, its volume will be proportional to $R^3$ and so its weight W will also be proportional to $R^3$ if we assume it has a fairly constant density. The time T it takes the heat to diffuse from the edge to the center will be proportional to $R^2$, the square of the radius of the turkey. So our simple argument tells us that the turkey cooking time T will be proportional to $W^{2/3}$.

In other words, as a handy rule of thumb, the cube of the cooking time needs to increase in proportion to the square of the turkey's weight.

# 17

# Curved Triangles

A favorite little thought-inducing question, apparently liked by interviewers at one IT company a few years ago, is "Why are manhole covers round?" The same question might be asked of many other openings which have lids or covers placed on top of them. Of course, not all manhole covers are round, but there is an interesting general reason why round ones are a good idea. No matter which way you orient a circular cover it always has the same width[1] and it will not fall through the manhole into the murky depths below. A circle, because of its constant width, can be rolled easily along a flat surface whereas the square or elliptically shaped wheel cannot.[2] These are clearly nice properties, and the circle has other design advantages because it is easy to manufacture.

The nineteenth-century German engineer Franz Reuleaux was a great pioneering influence on our understanding of machines and their structure.[3] He recognized the significance of shapes like the circle, which had constant width and would roll smoothly. The simplest example, now called the Reuleaux wheel or triangle, is a triangle with curved sides. It is easy to construct. Begin with an equilateral triangle and then draw three circular arcs, each centered on one of the corners of the triangle, with a radius for the circle of which the arc is a part equal to the length of the side of the triangle. If the arcs begin and end at adjacent corners of the triangle they will enclose a curved triangle that has a constant width equal to any of its sides because all the points on one curved side are equidistant from the opposite vertex of the triangle.[4]

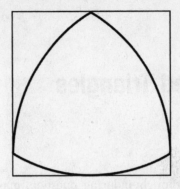

A manhole cover of this shape would never be able to fall down its manhole. This shape can be generalized to ones where curved arcs are added to regular polygons with any odd number of sides. In the limiting situation where the number of sides becomes very large the resulting shape looks increasingly like a circle. A picture of a water valve cover in San Francisco's Mission Bay area is shown on the next page.

The dimensions of the Reuleaux triangle are simple to calculate using elementary trigonometry. If the length of a side of the equilateral triangle, and hence the radius of the arcs and its constant width, is w, then the area inside the Reuleaux triangle is $\frac{1}{2}(\pi - \sqrt{3})\, w^2$. If we had just used a circular disc of width w then its area would have been smaller, just $\frac{1}{4}\,\pi w^2$. This shows that if you need to make a cover of constant width you can make more economic use of material by employing the Reuleaux triangle cross-section rather than the circular one because $\pi - \sqrt{3} = 1.41$ is bigger than $\frac{1}{4}\pi = 0.785$.[5] These curved triangles are occasionally seen as decorative items, in the form of small windows or beer coasters.

The seven-sided curved heptagon should be very familiar to British readers: it is the shape of the 20p and 50p coins. The constant width feature is advantageous both in saving metal and in creating shapes that work in slot machines. The older British pre-decimal 3d "three-penny bit" coin was not circular but neither was it of constant width – it had twelve sides – and spanned 21mm across the sides and 22mm across the corners.

The last nice feature of Reuleaux's curved triangle and its related curved polygons is that by rotating them you can make a very good approximation to a square.

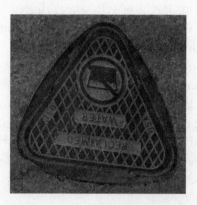

The Reuleaux triangle can be rotated freely inside a bounding square, whose sides equal the constant width of the curved triangular figure. It just fits and there is no room to spare. This means that a drill bit shaped like a Reuleaux triangle will *almost* exactly carve out a square hole if you let it turn for long enough. I say "almost" because there will always be some very small curving left at the corners and the wheel will eventually trace out only 98.77 percent of the area of the bounding square. If, instead, we rotate the Reuleaux curved polygons with more than three sides we will be able to carve out a polygonal shape with straight sides that has one more side than the rotated curved polygon. So, just as the rotated curved triangle produces a square, a rotated curved heptagon (the seven-sided British 50p piece) would carve out an almost straight-sided hexagonal hole. You really can have a round peg in a square hole . . . well, almost.

Alas, there is one downside that complicates the use of these shapes for drilling and ensures they are certainly not going to be used for bicycle wheels. Although they rotate nicely to trace out the area of a regular polygon they do not do so by turning around a single center. In the case of the "almost" square traced out by the Reuleaux triangle, the axis of rotation wobbles as the triangle

is rotated and follows four sides of an ellipse that creates an almost-square shape.[6] In engineering practice this problem is overcome by inventing a special type of moving chuck that is adapted to the wobbling motion. But a bicycle wheel shaped like a Reuleaux curved triangle spinning around a single fixed axis could not stay a constant height above the flat road.

Returning to our opening question, the Reuleaux curved triangle and its curved polygonal relatives would all make manhole covers that could not be lost down their manholes. The curved triangle is most economical on metal but the circular one still has the advantage of being more easily created; it can be simply locked in place by a short turn, and is more stable against compression forces from all directions.

# 18

# The Days of the Week

The names for the days of the week in the English language betray a mixed history. There are obvious astronomical names like Sun-day, Moon-day, Saturn-day, but some others are disguised. They derive from the ancient astrological week of the Babylonians. There were seven objects seen wandering through ancient skies. In descending order of the time period in earth years or days that they take to complete their orbital circuit around us in the sky they are: Saturn (929 years), Jupiter (12 years), Mars (687 days), the Sun (365 days), Venus (225 days), Mercury (88 days), and the Moon (27 days). Their number – seven – may be the source of the seven days that we have for our week. This is a completely arbitrary division of time and is not dictated by the motion of the Moon (which determines the "month"), the rotation of the Earth (which defines the "day"), or the orbit of the Earth around the Sun (which defines the "year"). In other cultural traditions the week has a different number of days: for example, the ancient Egyptians used a ten-day week, something that the leaders of the French Revolution tried unsuccessfully to reimpose upon the citizenry.[1]

The seven heavenly bodies determined the names of the days of the week. Away from the center of the Holy Roman Empire, some of the names were influenced by pagan religions. In English then we find that Mars day has become Tiw's day by changing the Roman god of war into the Norse one. Mercury's day (still *mercredi* in French) has been changed from the name of the Roman

god into that of the same god in Norse tradition, as Woden's day; and Jupiter's day (still *jeudi* in French) has turned into Thor's day after the Norse god of thunder (in German *Donnerstag* or "thunder's day"). Venus's day (still *vendredi* in French) became Friday, the day of Fre, the Norse god of virility and success. Sunday retained its astrological name in the pagan North but it switched to the Christianized Domine, or the Lord's Day, near the heart of the Christian world. We still see this in French (*dimanche*), Italian (*domenica*), and Spanish (*domingo*), where the astrological Saturn's day (Saturday) was replaced by the word for the Jewish Sabbath, for example *sabato* (Italian) or *samedi* (French).

The natural ordering of these seven heavenly bodies was given by their periods of orbital change. So why didn't that sequence end up defining the ordering of the days of the week? It is believed that the answer is part mathematical and part astrological. The sevenfold Saturn-Jupiter-Mars-Sun-Venus-Mercury-Moon sequence was used to determine which heavenly body was going to rule each hour of the day, starting with Saturn for the first hour of the first day. There are twenty-four hours of the day so you will run through the sequence of seven three times before attributing hours twenty-two, twenty-three, and twenty-four to Saturn, Jupiter, and Mars respectively, and then moving to the next, the Sun, to rule the first hour of the second day.

Run through the sequences again in the same manner and you find that the ruler of the first hour of day three is the Moon, for day four it is Mars, for day five it is Mercury, for day six it is Jupiter, and for day seven it is Venus. This is a modular arithmetic with a base of seven. The remainders after division by multiples of seven determine the planet that rules the first hour of the next day.

It is this sequence of astrological rulers of the first hour of each twenty-four-hour day that determines the sequence of the names of the days of the week as Saturn, the Sun, the Moon, Mars, Mercury, Jupiter, and Venus. This gives our ordering of Saturday, Sunday, Monday, Tuesday, Wednesday, Thursday, and

Friday, with the last four suffering a Norse name transformation. The French stays truer to its astrological roots and renders this astrological sequence as *samedi, dimanche, lundi, mardi, mercredi, jeudi,* and *vendredi* with only the Sun undergoing a Christian conversion to retain the Lord's Day label.

# 19

# The Case for Procrastination

There seems to be a view in the modern world's great drive for efficiency that delay is always bad. Entrepreneurs are portrayed as go-getters who always act as quickly as possible. No putting off decisions to the next meeting. No wait-and-see strategies. There must be action points: no committees of inquiry to look further into the matter and take all factors into consideration.

It is not so clear that procrastination is always undesirable though. Suppose that you are in the business of paying for the completion of a large task using a process that is getting steadily cheaper all the time. Maybe it could pay to slacken off and delay starting it because the overall cost will be cheaper in the future.

Actually, the most significant industry in the world is just like that. Computer processing has progressed in an inexorable and predictable way that was first recognized by Gordon Moore, the founder of Intel. This insight became codified into a rule of thumb called Moore's law. It says that the computational power that can be bought at a given price doubles roughly every eighteen months. This means that the speed of computation $S(t) = S(0)2^{t/18}$, where the time t is measured in months from now, when we set $t = 0$.

Let's look at what happens if instead of starting our big computing project today, we delay by D months, by which time S has increased from $S(0)$ to $S(0)2^{D/18}$. We ask how large we can let our delay D become and still get the same amount of computation done by the time the project would have finished if we had started now. The answer is found by simply equating the time

needed if we started now – call it A – with the time needed if we delayed D months:

$$A = D + (A \times D \times 2^{-D/18})$$

This tells us the longest we can procrastinate and still get the job done in the planned time. Reassuringly, not every task can be achieved in the same time by delaying its start; otherwise we might never embark on anything. Only computational tasks that currently take longer than $18/\ln(2) = 18/0.69 = 26.1$ months can be completed more cost-effectively by delaying their start. Any project that currently needs less than twenty-six months to finish is best started immediately: no future improvements in technology will help get it done sooner.

For the bigger projects that benefit from delay we see that our productivity, defined by the amount of processing divided by the time required, gets much better if we delay their start.[1]

# 20

# Diamonds Are Forever

Diamonds are very remarkable pieces of carbon. They are the hardest naturally occurring materials, yet their most sparkling properties are the optical ones. These are possible because diamond has a huge refractive index of 2.4, compared with that of water (1.3) or glass (1.5). This means that light rays are bent (or "refracted") by a very large angle when they pass through a diamond. More important still, light that is shone onto a diamond's surface at an angle more than only 24 degrees from the vertical to the surface will be completely reflected and not pass through the diamond at all. For light shone through air onto water this critical angle for reflection rather than transmission is about 48 degrees from the vertical, and for glass it is about 42 degrees.

Diamonds also treat the color spectrum in an extreme fashion. As Isaac Newton first made clear with his famous experiments with a prism, ordinary white light is composed of a spectrum of red, orange, yellow, green, blue, indigo, and violet light waves. These travel at different speeds through the diamond and get bent by different angles (red the least, violet the most) as white light passes through a transparent medium. Diamonds produce a very large difference between the greatest and the least bending of the colors, called its "dispersion," which produces the remarkable "fire" of changing colors when light passes through a well-cut diamond. No other gems have such large dispersive power. The challenge presented to the jeweler is to cut a diamond so that it shines as

brightly and colorfully as possible in the light it reflects back into the eye of the beholder.

The cutting of diamonds has gone on for thousands of years, but there is one man who contributed more than anyone to our understanding of how best to cut a diamond and why. Marcel Tolkowsky was born in Antwerp in 1899 into a leading family of diamond cutters and dealers. He was a talented child and after graduating from college in Belgium was sent to Imperial College in London to study engineering.[1] While still a graduate student there, in 1919, he published a remarkable book entitled *Diamond Design*, which showed for the first time how the study of the reflection and refraction of light within a diamond can reveal how to cut it so as to achieve maximum brilliance and fire. Tolkowsky's elegant analysis of the paths followed by light rays inside a diamond led him to propose a new type of diamond cut, the "brilliant" or "ideal," which is now the favored style for round diamonds. He considered the paths of light rays hitting the top flat surface of the diamond and sought the angles at which the back of the diamond should be inclined to it so as to reflect the light completely at the first and second internal reflections. This will result in almost all the light passing straight back out of the front of the diamond to create the most brilliant appearance.

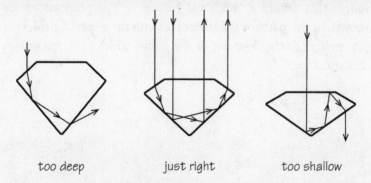

too deep          just right          too shallow

Tolkowsky went on to consider the optimal balance between reflected brilliance and the dispersion of its color spectrum, and the best shapes for the different faces.[2]

Tolkowsky's analysis, using the simple mathematics of light rays, produced a recipe for a beautiful "brilliant cut" diamond with fifty-eight facets: a set of special proportions and angles in the ranges needed to produce the most spectacular visual effects as a diamond is moved slightly in front of your eye. But you see there is more geometry to it than meets the eye:

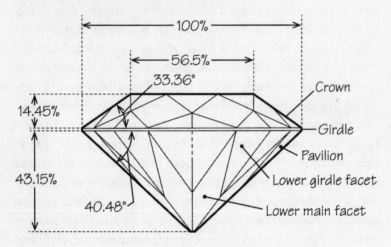

In this picture we see the classic shape that Tolkowsky recommended for an ideal cut with the angles chosen in the narrow ranges that optimize "fire" and brilliance. The proportions are shown for the parts of the diamond (with their special names) as percentages of the diameter of the girdle, which is the maximum diameter.[3]

## 21

# How Do You Doodle?

My encyclopedia says that "a doodle is an unfocused drawing made while a person's attention is otherwise occupied."[1] It was originally a rather uncomplimentary description of someone thought to be rather foolish and so "Yankee Doodle Dandy" was a derogatory song liked by the British troops before the American Revolution. Still, the closest that many people come to being a creative artist is doodling. All those aimless squiggles: are they forming freely like great abstract art on your scrap paper? Occasionally, I have wondered whether they are quite so aimless and I have even noticed some features common to my doodles and other people's. Is there a favored type of doodle? I think that there just might be so long as they are free-form and not directed by a desire to draw specific things like little dogs or human faces.

Tradition has it that Albrecht Dürer could draw a perfect free-hand circle over and over again. For most of us the circle is an awkward shape to draw. If we are free-form doodlers, we don't tend to draw circles – too much concentration is required.

We find it easier to draw little open loops that are teardrop-shaped. They look a bit like the loops of roller coasters or the transition lines followed by the highway as you exit around onto the off-ramp that crosses back over the highway. These prosaic comparisons arise because they are both situations where engineers look for the smoothest transition curve that can take you around a bend so that you feel a steady centrifugal reaction force. The prime shape that is employed is called the "clothoid," whose curvature is proportional to the distance along the curve. We met this shape in Chapter 12 when we discussed the designs of roller coasters. It is also the path followed by a car moving at constant speed when the driver turns the steering wheel at constant angular speed. If the highway exit followed a curve that was part of a circle then you would have to keep adjusting your speed if you wanted to turn the steering wheel at a constant angular speed. The ride would be a bit jerky and uneven. The clothoid-shaped road makes it smooth and even-paced.

Something similar might dominate our doodling. We like to sweep the pencil around in an arc at a constant angular speed as the point moves. This is only possible for a clothoid spiral – although there are lots of different ones depending on how fast we want to doodle. So our doodling would then show up lots of little open teardrop loops. This is the curve that "feels" best to draw; it requires a minimum of conscious effort to keep it on course and a minimum of variable force on the fingers.

# 22

# Why Are Eggs Egg-Shaped?

Why are real eggs egg-shaped? They aren't spherical; they aren't shaped like a rugby ball; they aren't often ellipsoidal. They are characteriztically "ovoid," or egg-shaped. One end, the base of the egg, is fatter and less curved than the other, more elongated tip of the egg. This asymmetry has one very important consequence. If you put the egg on a flat surface it will rest in a position of equilibrium in which the tip points slightly toward the ground because its center of mass is *not* at its geometrical center, but is offset slightly toward the fatter end. A perfectly ellipsoidal egg would have sat with its longest axis parallel to the ground because its center of mass *is* at its geometrical center.

Now slightly tilt by a few degrees the surface on which the egg-shaped egg is resting, until it starts to roll. (The surface must not be extremely smooth or the egg will slide rather than roll, or be unable to stop – and don't use a boiled egg because its solid contents behave differently from liquid ones. The slope must not be too steep, no more than 35 degrees, or the egg will just run away downhill.) What happens next is very significant. The egg doesn't just roll down the slope in the way that a spherical or an ellipsoidal egg would. It rotates in a tight curve and returns close to where it started from, like a rolling boomerang, with its elongated tip pointing up the slope and the broad base toward the bottom. This is the same behavior that you see when you let a cone roll down a shallow slope.

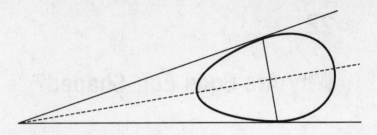

The distinctive behavior of the egg-shaped egg is important. If you were a bird looking after a clutch on a rough and rocky cliff side, your offspring would be doomed if your eggs were spherical or ellipsoidal. As you shifted them around during their incubation period, to keep their temperature uniform or protect them against winds and disturbances, the spherical eggs would keep on rolling down the gradient and over the cliff edge after they were disturbed. Egg-shaped eggs will tend to roll in an arc and survive.[1]

Not all birds' eggs are egg-shaped. They come in four general shapes with side-view cross-sections that are circular, elliptical, oval, and pear-shaped. When oval or pear-shaped eggs are nudged and start rolling in a tight circle on an uneven rocky surface they will roll back to where they started – these are the egg-shaped types – but the circular and elliptical-shaped eggs will not. Birds that lay eggs in rocky environments tend to have eggs that are oval or pear-shaped. They need to shift eggs around while they are incubating so as to maintain an even temperature and if one rolled far away they would have to leave the others in order to retrieve it. By contrast, birds that lay eggs in deep nests or holes, like some owls, tend to have the roundest and least pointed eggs. The spherical-shaped egg is the strongest because the curvature is the same all the way around and there is no weak point.

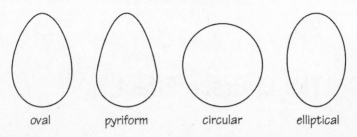

oval          pyriform          circular          elliptical

There are other geometrical factors that influence the shapes of birds' eggs. Birds that are streamlined and fly fast, like guillemots, tend to have long ellipsoidal eggs; and eggs with narrow pointed tops can be packed closely together, with less cold air in between, so that they can be more easily covered and kept warm during incubation.

There are also anatomical reasons to favor the egg-shaped eggs during the birth process. The egg begins its journey into the outside world down the bird's oviduct in a soft-shelled and spherical form. The forces that act upon it are applied by the sequence of contractions (behind) and relaxations (in front) of the egg. The contracting forces mold the rear of the egg into a narrower conical shape while the relaxing muscles keep the front almost spherical. This is the easy way to shoot something out by pressure – try firing a grape pip from between your fingers and then try it with a little cube or a frozen pea. Lastly, as the egg appears, the shell quickly calcifies and the egg's shape is fixed. Natural selection does the rest.

# 23

# The El Greco Effect

The Cretan artist Doménikos Theotokópoulos lived from 1541 to 1614. We know him by his Spanish name, El Greco ("the Greek"), and by the dramatic coloration and curious elongation of the figures in his paintings that captured the spirit of Spain in the Counter-Reformation era. In 1913, an ophthalmologist first suggested that the geometrical distortions found in El Greco's figures might be a consequence of astigmatism, an optical defect of the front surface of the eyeball, that may have led him to paint normally proportioned figures as tall and thin because these shapes "looked" normal to his distorted vision.[1] Similar ideas have been suggested at other times about the causes of the distinctive images painted by artists like Titian, Holbein, and Modigliani.

This idea reemerged in 1979 when Peter Medawar included it as a type of simple intelligence test in his book *Advice to a Young Scientist*. He noted what many had recognized before: that the ophthalmologist's theory failed a simple logical test. The easiest way to understand it is to imagine that because of a visual defect El Greco saw as ellipses what we see as circles. However, if he then faithfully portrayed what he saw when he painted a picture he would still have represented the circles as ellipses but we would still see them as circles. So, logically, imperfect vision cannot be the reason for El Greco's style because we also see his figures as distorted.

In fact, we know enough about El Greco's work to discount astigmatism as the explanation for other reasons. X-ray analysis

of his canvases has revealed preliminary pencil under-sketches in which his figures were normally proportioned. The elongations were introduced when the paint was applied. Also, not all the figures are elongated in the same way (angels get an extra stretch compared to mere mortals) and there are historical styles, like the Byzantine, that are able to provide a basis for his development in this direction.

Putting this evidence to one side, more recently the American psychologist Stuart Antis has carried out two instructive experiments.[2] First, he took five volunteers and fitted a specially modified telescope to one of each person's eyes, while blindfolding the other. The telescope was designed to distort squares into rectangles. The subjects were then each asked to draw a square from memory and afterward to copy a true square that Antis had drawn.

When asked to draw the square from memory each produced an elongated rectangle with a distortion approximately equal to that deliberately introduced by the telescope. Presumably this freehand drawing resulted from their reproducing the figures that appeared as squares on their retina. However, when they drew pictures by copying Antis's square they were always true squares.

Antis then continued the experiment with just one volunteer. He left the distorting telescope lens on this person's eye for two days, replaced by a blindfold at night, and asked the subject to draw a freehand square from memory again, four times per day. The result was quite striking. At first, as found from all the five volunteers, the result was a rectangle with the expected deviation from a square. Each successive drawing came progressively closer to being a square. After two days of drawing four squares per day the subject had completely adapted to the distortion being applied by the telescope and drew a true square.

So, again, we see that there is no reason to think that El Greco's drawing, whether working from memory, or from a model, would have produced a continuing distortion that could explain his style. It was a deliberate artistic expression.

# 24

# Eureka

Legend has it that the great Sicilian mathematician Archimedes of Syracuse (287–212 BC) ran naked through the streets shouting *Eureka* – "I have found it" – but, as with so many of those *1066 and All That* episodes in schooldays history, not so many know why. The story was told by the Roman architect Vitruvius in the first century BC. The legend has it that King Hiero II of Syracuse commissioned a goldsmith to make for him a ceremonial crown to offer to one of the gods in the temple. Such offerings were usually made like a golden wreath that was placed on the head of the god's statue. Hiero was not a trusting sort of fellow and he suspected that the goldsmith had replaced some of the gold he had been given to make the crown with a baser metal, like silver, and kept the "spare" gold for himself. Upon receiving delivery of the finished crown his challenge to Archimedes, recognized in his day from all his engineering inventions and mathematical discoveries as the greatest mind in the known world – his nickname among contemporary scientists was simply *Alpha* – was to determine if it was all made of gold. The goldsmith would have made sure the weight was exactly the same as that of the gold he had been given. How could you tell if it was pure gold without destroying the sacred object?

Archimedes didn't disappoint. The legend is that he realized how to do it while in his bath watching how the water was displaced by a submerged object. Gold is denser than silver and so, because density is determined by the weight divided by the volume of

metal, the crown would be made up of a larger volume of metal (silver + gold) than the same weight of pure gold. So, if the crown contained silver it would displace more water when submerged than the same weight of pure gold.

Suppose the crown was 1 kg in weight and the goldsmith substituted half of the gold he was given for silver. The densities of silver and gold are 10.5 gm/cc and 19.3 gm/cc respectively, so the volume of the 1 kg of pure gold would have been 1,000 gm/19.3 gm/cc = 51.8 cc. The volume of the half-and-half crown would have been $^{500}\!/_{19.3} + {}^{500}\!/_{10.5} = 73.52$ cc. The difference of 21.72 cc is significant. Now place 1 kg of pure gold in a square tank 15 cm x 15 cm = 225 sq. cm and fill it to the brim with water. Then remove it and place the crown in the water. If the tank overflows the goldsmith is in trouble! The extra 21.72 cc of water would create a rise in the level of $^{21.72}\!/_{225} = 0.0965$ cm – about 1mm – so it would flow over the brim.

Vitruvius tells us that Archimedes placed the crown and an equal weight of gold in a basin and checked the overflow. It has been suggested that Archimedes might have used a more ingenious method that drew on his explanations for buoyancy forces when bodies are immersed in liquids. Suspend the crown and the pure gold from each end of a fulcrum as shown in the figure.

Ensure that they will balance exactly in air. Now immerse them in water. The crown made of mixed gold and silver has greater volume and so it displaces more water than the pure gold. This means that it will be more buoyant and the balance will rise higher on the side of the crown and drop lower on the side of the equal weight of pure gold. Since the density of water is 1 gm/cc the volume difference will mean that the fraudulent crown will be raised by an extra force of 21.72 gm weight relative to the pure gold. This large imbalance is very easy to see.

# 25

# What the Eye Tells the Brain

The human eye is very good at seeing patterns. So good, in fact, that it sometimes sees them when they aren't there. People have claimed to see faces on the surface of the moon or canals on Mars, and the historical personification of the constellations is the outcome of vivid imagination and a desire to signpost the heavens.

In some ways, our propensity to see lines and patterns in confused scenes – even when they are not there – is not entirely surprising. It is a trait that helps us survive. Those who see tigers in the bushes are more likely to live long, prosper, and produce offspring than those who don't. In fact, even seeing tigers in the bushes when there aren't any will only make your family think you are paranoid, but a tendency not to see them when they are there will lead to your elimination. So over-sensitivity to seeing patterns can be tolerated better than under-sensitivity.

The pattern in the figure is composed of a collection of concentric circles. Each is traced by a dotted line, all of which have the same number of dots. Yet when you look at the picture face-on you see something else. Near the center there appear to be concentric circles, but as you look toward the outer parts of the picture it is dominated by curved crescents. What is going on? Why do you see crescent lines toward the outer part of the picture?

One of the ways in which the eye and the brain try to make sense of an array of dots is to link them up into lines. The simplest way to carry out that linking is to create an imaginary line between a dot and its nearest neighbor. Toward the center of the rings of concentric dots the nearest neighbor to each dot is to be found on the same circle, and so our mind's eye joins up the dots and we "see" circular patterns.[1] As we move outward the distances between neighboring dots on the same circle increase and eventually become larger than the distance to an adjacent dot on the next circle out. The pattern of nearest neighbors suddenly changes. The eye now traces new curves between nearest-neighbor dots on different circles and the crescents appear.

If you pick up the book and look at this picture again, but inclined at an angle, the appearance will change as you increase the angle of tilt. You are now looking at the dots in projection and the nearest-neighbor distances have changed. The eye "draws" different lines now and the appearance of the picture alters again. Also, if the picture had been printed slightly differently, with larger or smaller dots of ink, then the eye would have found it easier or harder to find the nearest neighbors and create the impression of the lines.

These simple experiments reveal one aspect of the eye–brain pattern-recognition "software." It shows how difficult it can be to evaluate whether a picture of data really contains significant patterns. The eye tries to find particular types of pattern – and is very good at it. My own encounter with this problem arose in the 1980s when astronomers created the first three-dimensional maps

of the clustering of galaxies in space. Previously they just had positions on the sky because the measurement of their distances away from us was a slow and tedious business. New technologies suddenly made it quick and easy. The three-dimensional maps that resulted were very surprising. Galaxies seemed to be strung out along lines and sheets in a great cosmic cobweb pattern rather than randomly clustered in a space-filling way. New measures of clustering pattern had to be devised and we needed to be aware also of the tricks that the eye could play on us.[2] In the world of art we see the most interesting use of this feature of human pattern-seeking propensities in the "pointillism" or "divisionism" of artists like Georges Seurat in the late nineteenth century. Instead of blending paints of different pigments to produce continuous coloration, the pointillists applied primary colors in small individual spots of varying sizes and allowed the eye to do the mixing. The result produced brightness of color at the expense of texture.

# 26

# Why the Flag of Nepal Is Unique

There is only one country's flag that is neither a square (like Switzerland's) nor a rectangle (like Great Britain's). The flag of Nepal, adopted in 1962 when the new constitutional government was formed, is a double triangle pennant. It marks the merger of two pennants of different branches of a ruling dynasty in the nineteenth century. Single pennants of this sort had been common in that region of the world for hundreds of years. Nepal's is crimson in color like the rhododendron, the national flower, a symbol of victory in battle. It is balanced by a blue border, the symbol of peace. Finally, to symbolize celestial permanence, stylized faces of the crescent moon and the sun appear on the faces of the two triangles. There has been much debate and controversy in the Nepalese parliament since the murder and overthrow of the royal family in 2007 about whether the flag should be changed to signal the country's new beginning, but proposals for a conventional rectangular flag were defeated.

The most striking thing about this unique flag design is that the two diagonal lines forming the hypotenuses of the triangles are not parallel. A pre-1962 version of the flag was simpler, with parallel diagonals, and the sun and moon then also possessed rudimentary inscribed faces. The later unusual geometric structure means that drawing the flag correctly is a tricky task and its

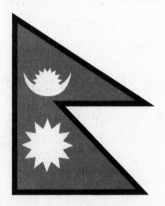

construction is prescribed in great geometrical detail in the Nepalese constitution. Below is an English translation (slightly improved by me) of Article 5 Schedule 1 of the Constitution of the Kingdom of Nepal, issued by the Supreme Court of Nepal, where this twenty-four-stage mathematical construction is carefully specified.[1] Try it yourself and see if you can work out the two angles at the points of the pennants.[2] There are much lengthier geometrical instructions for steps 6 to 24 which are needed to construct the moon and the sun.

National Flag

*(A) Method of Making the Shape Inside the Border*

(1) On the lower portion of a crimson cloth draw a line AB of the required length from left to right.

(2) From A draw a line AC perpendicular to AB making AC equal to AB plus one third AB. From AC mark off D making line AD equal to line AB. Join BD.

(3) On the line BD mark off E making BE equal to AB.

(4) Through point E, draw a line FG, starting from the point F on line AC, parallel to AB to the right-hand side. Mark off FG equal to AB.

(5) Join CG.

The perimeter of the flag is traced by the straight lines joining C → G → E → B → A → C. Nepal is perhaps the only country in the world demanding some geometrical understanding of all its citizens. And that is not a bad thing at all.

# 27

# The Indian Rope Trick

The Indian rope trick has become a byword for the hardest and most fantastic magic trick or feat of deception,[1] although professional magicians in the nineteenth century regarded stories of its performance in India as merely a hoax. Supposedly, a coiled rope could be made to rise upward toward the sky and the magician would then send a young boy to climb up it until he vanished from sight (presumably into the low fog concealing overhanging branches). The Magic Circle offered substantial cash prizes for a verifiable demonstration of the trick in the 1930s but the prize was never awarded. An analysis of the variants of the trick and the history of apparently fraudulent claims to have performed it was published in *Nature* as recently as 1996 by two authors who have spent considerable effort on investigating paranormal phenomena.[2]

There is an interesting aspect of it with an amusing mathematical counterpart. The surprising thing about the claimed "trick" is the idea that a rope can remain in a stable vertical position without any support at its top. If we take a rigid rod and allow it to rotate freely about a support at the bottom like an upside-down clock pendulum, we know that if we hold it in a vertical position with the support at the bottom it will immediately fall down until it comes to rest hanging vertically downward from its support. The initial upright position is *unstable*. However, if we add a very rapid up-down vibration to the rod's support then it can remain standing vertically in a stable position (push it away

from the vertical slightly and it will just swing back!) so long as the base oscillates up and down with a high enough frequency. In practice this could be set up by holding the rod's support in a jigsaw which was then set jigging up and down with the rod in a vertical position.

Why does this happen? The center of mass of the rod feels a gravitational force of its weight mg (where m is its mass and g = 9.8 m/s² is the acceleration due to Earth's gravity) acting vertically downward and also a continually changing up-or-down force which acts along the line of the rod. The resultant of these two forces makes the center move along a curved path, and the center of mass will oscillate back and forth along a small bit of this curved path as though it is performing a little part of a circular motion. The center of motion will therefore be moved in the direction of the center of this motion by a centrifugal force. This force is mv²/L, where 2L is the length of the rod; this depends on v², the average of the square of the speed of the up-down oscillations, and if it is big enough it will exceed the gravitational force mg seeking to pull the rod's center of gravity downward. So, if v² exceeds gL the rod will stay upright.

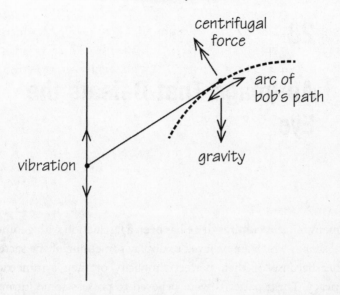

So there are circumstances in which the rod could be made to stand upright and remain there even when pushed to the side. This is the nearest thing there is to a realization of the idea of the Indian rope trick. If the rod had been a ladder, you might even have climbed it! This remarkable property of a randomly perturbed upside-down pendulum rod was first discovered by the Nobel Prize–winning physicist Peter Kapitsa in 1951 and then elaborated by Brian Pippard in 1987. It is indeed a tale of the unexpected.[3]

# 28

# An Image That Defeats the Eye

In many ancient cultures there has been a fascination with geometrical shapes which are believed to display something of the sacred, either because of their perfect simplicity or their symmetrical intricacy. These patterns were believed to possess some intrinsic meaning and could act as a meditational guide into deeper realities that were consonant with the geometry they displayed. Even today, New Age authors and mystical thinkers remain drawn to some of these ancient figures that once attracted thinkers and artists like Leonardo da Vinci.

One remarkable example is impressive because when it is drawn in black and white it presents a significant challenge to the human visual system. The "Flower of Life"[1] is like an odd type of emergent structure. One can take it in globally at a glance, but try to analyze it by counting the circles it contains and your eye cannot remain glued to the task. It is overwhelmed by the kaleidoscope of intersecting circles and arcs that offer a confusing selection of nearest-neighbor distances and visual cues, like those we saw in Chapter 25, that dominate over the patterns which were deliberately drawn.

The Flower of Life is found in ancient Egyptian and Assyrian decorations and takes its name from the flower-like pattern it displays. The construction is made by placing six symmetrically spaced overlapping circles, as shown in the picture, inside a larger

bounding circle. They just touch each other in a ring around the inside of the outer enclosing circle. The center of each circle lies on the circumference of six circles of the same diameter that surround it. The large bounding circle contains nineteen circles and thirty-six circular arcs.

It is very hard to count the subcomponents that create this design when it is complete. The easy place to start is with the six touching points where the six circles meet the inside of the bounding circle. Inside the inner perimeters of all these circle boundaries fits another identical circle with its center also at the center of the bounding circle. The six points where these circles touch each other then define the centers for six more circles. The six places where these circles touch then define the centers for six more circles and we have a total of 6 + 6 + 6 + the one at the center, which equals nineteen circles. You will find it easier to count them if you outline the circumferences of each set of six circles with a different color to distinguish them.

Finally, if you incline the page, the eye will gradually see a completely different dominant pattern. There are seven parallel straight lines of teardrop shapes. Rotate the inclined page and you will find four of these sets of lines. They completely dominate the circles because when you view the picture in projection the apparent distances between points and lines change and the eye

follows a different set of nearest-neighbor distances to "join up the dots" and register a pattern. If you bend the paper over a curved surface, like the side of a glass, then you will see a new set of dominant patterns; when you look at it on an incline the lines fan out into V-shapes spanning ellipses.

A simpler version of this form of sacred geometry, employed as both a pagan and a Christian symbol, is the Borromean rings, sometimes also called the Tripod of Life. The intersection point of two equal circles is used as the center for a third identical circle.

This design can be found in ancient Buddhist and Norse art, and has been used in Christian iconography since the time of St. Augustine as a symbol of the Holy Trinity.[2] It became more famous, however, as the coat of arms of the aristocratic northern Italian Borromeo family, dating from before the twelfth century, and from whose ranks came many popes, cardinals, and archbishops of the Catholic Church – even today one member of the family is heir to the Agnelli business empire. The arms were presented in 1442 by Francesco Sforza in recognition of the family's role in the defense of Milan; they represent the unity of the families of Visconti, Sforza, and Borromeo who had set aside their incessant feuding and become interlinked by marriage. Their influence is still much in evidence in the city of Milan. Subsequently, the rings became a more widespread symbol of solidarity and unity.

# 29

# It's Friday the Thirteenth Again

Triskaidekaphobia,[1] or fear of the number thirteen, seems to be deeply embedded in Western traditions. I have found old streets with houses numbered 12½ instead of 13 and tall buildings that have no thirteenth floor, such is the imperative to avoid the stigma of this unlucky number. Some believe the prejudice against it derives from the number of diners present at the Last Supper.

Worse still, if the thirteenth of the month should fall on a Friday then we are prey to the greater linguistic challenge of paraskevidekatriaphobia[2] – fear of Friday the thirteenth. Again, the roots are a collection of religious traditions that Eve's Fall in the Garden of Eden, the destruction of Solomon's Temple, and the death of Christ all took place on Fridays. Friday the thirteenth was therefore what we might call a pessimist's double whammy. As a result, in past centuries there was nervousness about setting sail across the ocean on that day, or embarking upon momentous projects that might tempt the intervention of the paraskevideka-triaphobic fate. Even today, superstitious people tend to notice when the thirteenth falls on a Friday and believe it to be a rare and special calendrical occurrence. Alas, this suspicion is not true. In fact, it could not be more untrue: the thirteenth day of the month falls more frequently on a Friday than on any other day of the week.

In past centuries mathematicians were greatly in demand to

calculate matters related to the calendar: determining when particular dates fell in the past and would in the future, most importantly that of Easter Sunday, which was specified to be the first Sunday after the first full moon to occur after the vernal equinox on March 21. The great German mathematician, astronomer, and physicist Karl Friedrich Gauss devised a beautifully simple formula in 1800 which gave the day of the week corresponding to any date in the Gregorian calendar.[3] He changed all the words into simple numbers by allotting a number, $W = 1$ for Monday, 2 for Tuesday, etc. up to $W = 7$, to label the days of the week; then $D = 1, 2, \ldots 31$ to label the days of the month; and $M = 1, 2, \ldots 12$ for the months of the year, beginning with $M = 1$ for January. Y labeled the year in four-digit form, like 2013; $C = \lfloor Y/100 \rfloor$ is the label of the century, where the half brackets denote the biggest whole number less than or equal to the quantity inside them (so $\lfloor {}^{2013}\!/_{100} \rfloor = 20$). The year in the century Y is then given by $G = Y - 100C$ and lies between 0 and 99. A quantity F is defined to be the remainder after C is divided by 4. If the remainder is equal to 0, 1, 2, or 3 then F is equal to 0, 5, 3, or 1, respectively. Finally, there is an index E which labels each of the twelve months $M = 1, 2 \ldots 12$ by the correspondences $(M,E) = (1,0), (2,3), (3,2), (4,5), (5,0), (6,3), (7,5), (8,1), (9,4), (10,6), (11,2),$ and $(12,4)$.

After all that, Gauss's "super formula" tells us that the number of the day of the week W is the remainder when[4]

$$N = D + E + F + G + \lfloor G/4 \rfloor$$

is divided by 7. Let's try it out. If today is March 27, 2013, then $D = 27$, $E = 2$, $Y = 2013$, $C = 20$, $F = 0$, $G = 13$, and so $N = 27 + 2 + 0 + 13 + 3 = 45$. When we divide N by 7 we get 6 with a remainder of $W = 3$. This remainder gives the day of the week correctly as Wednesday. You can also work out the day of the week when you were born or when Christmas Day is going to fall next year.

The formula can now be used to determine the frequency with which the thirteenth day of each month falls on each day of the week. It is only necessary to do this for a span of 400 years because the Gregorian calendar repeats itself after 400 years since there are 146,097 days in 400 calendar years.[5] This is divisible by 7 and so is an exact number of weeks. Over any 400-year cycle there are $400 \times 12 = 4800$ months and the same number of thirteenth days of the month. They fall most often, 688 times, on a Friday, 687 times on a Wednesday and a Sunday, 685 times on a Monday and a Tuesday, and just 684 times on a Thursday and a Saturday. Friday the thirteenth is not so special after all.

# 30

# Strip Friezes

Friezes have been popular adornments for buildings, inside and out, for thousands of years. They come in many styles and colors nowadays to match our traditional wallpaper, but despite the apparent diversity on offer in catalogues, the range of real alternatives is very small. At root, there are only seven different repeating frieze patterns.

If we draw with a black pen on white paper to create a repeating frieze pattern then we have only got four tricks to play in order to turn our starting shape into a repeating pattern. The first is "translation," simply moving the pattern en bloc along the frieze. The second is the "reflection" of the pattern about a vertical or horizontal axis.

A pattern with vertical reflection

A pattern with horizontal reflection

A pattern with rotation

A pattern with a glide reflection

The third is a "rotation" of the pattern by 180 degrees around some point. The fourth is a "glide reflection" which combines a forward translation with a reflection of the pattern about a line parallel to the translation direction. This last move creates mirror images that are slightly offset from each other rather than vertically aligned. These four building blocks are shown acting on a starting shape on the previous page.

They can be combined to produce just seven distinct types of repeating design from an initial shape. We can act on our initial shape by (a) translation, (b) horizontal reflection, (c) glide reflection, (d) vertical reflection, (e) rotation by 180 degrees, (f) horizontal and vertical reflection, and (g) rotation and vertical reflection. The results are shown here:

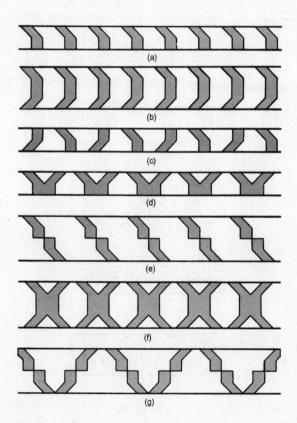

Every frieze in the world with a repeating pattern and one color must fall into one of these seven basic types. Here is an example of each from a different cultural tradition. Of course, there will be some elaboration in the basic shape that is being acted upon in one of the seven ways. It could be a simple V shape or something more ornate:

Dragon and phoenix carpet, Asia Minor

Masonry fret, temple at Milta, Mexico

Greek fret with a vase

Greek fret

Pompeian mosaic

Chinese ornament painted on porcelein

Modern rug

We have been restricting our attention to friezes with one color (black on white paper). If we introduce more colors then there can be more possibilities. When the number of colors is odd (like the case of one color, black, that we used) the number of distinct frieze patterns remains at seven; when the number of colors is exactly divisible by four there are nineteen possible friezes, but when the number of colors leaves a remainder of two (or minus two) when divided by four then the number of different friezes drops to seventeen.

# 31

# The Gherkin

The most dramatic modern construction in the City of London is 30 St. Mary Axe, once commonly known as the Swiss Re building before it was sold in 2006 for $962 million, and now as the Pine Cone, or simply the Gherkin. Prince Charles sees it as symptomatic of a rash of carbuncular towers on the face of London. The architects, Norman Foster and Partners, heralded it as a signature building for the modern age and received the 2004 RIBA Stirling Prize for their spectacular creation. It succeeded in putting the Swiss Re insurance company in the public eye (and they made a profit of $480 million on the sale) and has stimulated a wide-ranging debate about the desirability of towers on the traditional horizons and sight lines of the City of London. Alas, while there is an ongoing debate about the aesthetic success of the Gherkin, there is not much doubt that it was originally a bit of a commercial disappointment for Swiss Re. They occupied just the first fifteen of the thirty-four floors and failed to let the other half of the building to any other organizations.

The most obvious feature of the Gherkin is that it's big – 600 feet high. The creation of towers on such a scale creates structural and environmental problems that mathematical modeling has helped to alleviate. Its elegant curved profile is not just driven by aesthetics or some mad gherkin-loving designer's desire to be spectacular and controversial. Today, engineers create sophisticated computer models of big buildings which enable them to study their response to wind and heat, take-up of fresh air from the

outside, and effect on passersby at ground level. On September 2, 2013, a new London skyscraper at 20 Fenchurch Street, dubbed the Walkie-Talkie, produced such powerful reflections of sunlight that it melted parts of the bodywork on a Jaguar car parked opposite.[1] Tinkering with one aspect of the design, like the reflectivity of its surface, will have effects in many other areas – changing the internal temperature and air-conditioning requirements – and all the consequences can be seen at once using sophisticated computer simulations of the building. It is no good following a "one thing at a time" approach to designing a complicated structure like a modern building; you have to do a lot of things all at once.

The tapering shape of the Gherkin, starting narrowest at street level and bulging most at the sixteenth floor before narrowing again steadily toward the top, was chosen in response to those computer models. Conventional tall buildings funnel winds into narrow channels around them at street level (it's like putting your finger partly over the nozzle of a garden hose – the increased pressure brought about by the constriction results in a higher velocity of water flow) and this can have a horrible effect on passersby and people using the building. They feel as if they are in a wind tunnel. The narrowing of the building at the base reduces these unwanted wind effects because there is less constriction of the air flows there. The tapering of the top half also plays an important role. If you stand at ground level beside a conventional straight tower block and look upward you will feel dwarfed by the building, which blots out a large portion of the sky. A tapering design opens up more of the sky and reduces the dominating effect of the structure, because you can't see the top from close by on the ground.

The other striking feature of this building's exterior is that its cross-section is round, not square or rectangular. Again, this is advantageous for smoothing and slowing the air flow around the building. It also assists in making the building unusually eco-friendly. Six huge triangular wedges are cut into each floor level

from the outside in. They bring light and natural ventilation deep into the heart of the building, reducing the need for conventional air-conditioning and making the building twice as energy efficient as a typical building of the same scale. These wedges are not set immediately below each other from floor to floor but are slightly rotated with respect to those on the floors above and below. This helps increase the efficiency of the air suction into the interior. It is this slight offsetting of the six wedges that creates the exterior spiral pattern so noticeable from the outside.

Looking at the rounded exterior from a distance, you might think that the individual surface panels are curved – a complicated and expensive manufacturing prospect – but in fact they are not. The panels are small enough compared with the distance over which the curvature is significant that a mosaic of flat four-sided panels is quite sufficient for the job. The smaller you make them the better they will be able to approximate the covering of the curved outside surface. All the changes of direction are made at the angles joining different panels.

# 32

# Hedging Your Bets

When you deal with two or more people who have different expectations about the outcome of an event it may be possible to enter into separate bets with them so that you are a net winner regardless of the actual outcome. Suppose Anton believes that United will win the Cup Final with probability ⅝, while Bela believes that City will win with probability ¾. Anton and Bela will both take bets on the outcome that offer each a positive expectation of winning.

Say you bet Anton that you will pay him $2 if United wins and he will pay you $3 otherwise. Anton accepts this offer because it means his expected payoff is $2 \times ⅝ - 3 \times ⅜ = \$0.125$, which is positive. Now offer Bela $2 if City wins and she will pay you $3 otherwise. Again, Bela takes the bet because her expected payoff is positive: $2 \times ¾ - 3 \times ¼ = \$0.75$.

You can't lose here. Whether City or United wins the Cup Final you will receive $3 from either Anton or Bela and pay out just $2 to the other. You always receive $1 because you have "hedged" your bets[1] in such a way that a loss of one is always compensated by a bet on the opposite outcome. This is the basis of hedge fund financial investments, although they operate on a far bigger scale and in a more complex way at high speed using computers. At root, they exploit differences in expectation about the same events to hedge against the risk of any overall loss. Unfortunately, when this strategy is made plain to the public it

can seem very unsatisfactory, if not downright unscrupulous, as Goldman Sachs discovered when it was revealed that they were encouraging clients to invest in options that Goldman Sachs themselves were hedging against – in effect, betting that they would fail.

# 33

# Infinity at the Theater

An enterprising theater decided to attract a new audience by giving away a voucher with every ticket sold. Collect just two of these vouchers and you get a free ticket for any show. This tells us that when we buy a ticket it is really worth a ticket and a half, but that extra half a ticket will also get half a voucher and so is really worth another quarter of a ticket, which is worth another eighth of a ticket and so on for ever. The special offer means that the one original voucher is actually worth $\frac{1}{2} + \frac{1}{4} + \frac{1}{8} + \frac{1}{16} + \frac{1}{32} +$ . . . tickets, where the series has a never-ending sum of terms; each one is half as big as its predecessor. We can deduce what the sum of this infinite series must be without doing anything more mathematical than paying a visit to the theater box office with two friends.

If I take two friends with me to the theater and pay for two of the tickets, then the two vouchers I receive will enable me to get a third ticket for the price of two. This means that the two vouchers are worth one ticket and so the sum of the infinite series we gave above must equal 1. Therefore we must have $1 = \frac{1}{2} + \frac{1}{4} + \frac{1}{8} + \frac{1}{16} + \frac{1}{32} +$ . . .

You can also visualize this with a square piece of $1 \times 1$ paper. Its area is $1 \times 1 = 1$. Now divide it in half and then divide one of the halves in half again and imagine that you keep on halving like this forever. The total area of pieces will be our $\frac{1}{2} + \frac{1}{4} + \frac{1}{8} + \frac{1}{16} + \frac{1}{32} +$ . . . series again, so it must equal 1, the area of the square.

# 34

# Shedding Light on (and with) the Golden Ratio

The disappearance of single 100-watt light bulbs[1] has been bad news for those who, like me, do a lot of reading. There are alternative flexi bulbs which offer different brightnesses from the same bulb. They do this by having two filaments that support, say, 40- and 60-watt filaments singly or in combination inside the bulb. This allows for a third brightness of 60 + 40 = 100 watts to be produced if both are switched on together. The key design point here is to make the choice of filament wattages so that the three settings (high, medium, and low) seem as different as possible. It is no good having 100 and 120 watts as outputs because we don't really judge them to be very different. Older options I have seen use 60- and 100-watt filaments as the low and medium brightnesses, so the third (high) is 160 watts. What is the optimal choice for the filaments powers?

Let's take the power outputs of the two filaments to be A, B, and A + B watts, respectively. In order to maintain a nicely proportioned spacing of brightnesses[2] we want the ratio of A + B to B to be the same as the ratio of B to A, so:

$$(A+B)/B = B/A$$

This means:

$$(A/B)^2 + (A/B) - 1 = 0$$

We can solve this simple quadratic equation for the quantity $A/B$. The solution is:

$$A/B = \frac{1}{2}(\sqrt{5} - 1) = 0.62$$

This famous irrational number,[3] which we label $g - 1 = 0.62$ keeping only two decimal places, g is called the "golden ratio" and has a long, and sometimes rather mystical, history. It appears here as the ideal proportion for the creation of three distinct but harmoniously different brightnesses in the three-way light bulb. If we had bulbs with 62 and 100 watts then this would give an exact sequence of 62, 100, and 162 watts of output. In practice, rounding 62 to 60 watts gives a very good approximation of the golden ratio sequence, with settings of 60, 100, and 160 watts.

Suppose we wanted to create a five-way light using three different bulb strengths. Can we use the same principles to arrive at the best choice of basic bulbs? If we label them A, B, and C, then we are looking for a well-proportioned sequence of values for the five values A, B, C, A + B, and B + C. Since we already know that we want $A = gB$ we only need to complete our requirements by choosing $B/C = (A + B)/(B + C)$.

This requires $B = g^2C = 0.38C$ and so the new bulb should be chosen with C = 263 watts and our "golden" sequence of five proportioned brightnesses is A = 62, B = 100, A + B = 162, C = 263, and B + C = 425 watts. Each is equal to 0.62 times the brightness of the next faintest illumination level.

The principle at work here is bigger than light bulbs. It sheds light on harmonious constructions in many aspects of music, architecture, art, and design.

# 35

# Magic Squares

In 1514, Albrecht Dürer's famous picture *Melancholia I* introduced a magic square into European art for the first time. These "magic" constructions can be found as early as the seventh century BC in Chinese and Islamic culture and were elaborated in early Indian art and religious traditions. A number square is a square array of the first n numbers, so for n = 9 = $3^2$ the numbers 1 to 9 are arranged in a 3 × 3 grid; for n = 16 the first sixteen numbers are arranged in a 4 × 4 grid, and so on. The squares become "magic" if they can be arranged so that the sums of the numbers along all the rows, columns, and diagonals are all the same. Here are two 3 × 3 examples:

| 4 | 9 | 2 |
|---|---|---|
| 3 | 5 | 7 |
| 8 | 1 | 6 |

| 2 | 7 | 6 |
|---|---|---|
| 9 | 5 | 1 |
| 4 | 3 | 8 |

We see that all the rows, columns, and diagonals in these examples sum to 15. In fact, these squares are not really different. The second

is just a rotation of the first by 90 degrees in a counterclockwise direction and this is the only distinct 3 × 3 magic square that exists.

If an n × n magic square can be created then the sum of its lines will be equal to the "magic constant"[1]:

$$M(n) = \tfrac{1}{2} \, n(n^2 + 1)$$

and we see it is 15 when n = 3, as in our example. Although there is only one 3 × 3 magic square, there are 880 distinct 4 × 4 examples and 275,305,224 magic squares of size 5 × 5 and more than $10^{19}$ of size 6 × 6.

When we move to 4 x 4 squares the construction is rather more demanding, although ancient examples were known in several cultures. There is a famous tenth-century example in the Parshvanath Jain temple in Khajuraho, India. Its presence is witness to the cosmic and religious significance that was ascribed to meditating upon these harmonious and self-validating mathematical objects. Dürer's famous artistic example in his work *Melancholia I* is also a 4 × 4 square[2] with a magic constant (line sum) equal to M(4) = 34:

| 16 | 3 | 2 | 13 |
|----|----|----|----|
| 5 | 10 | 11 | 8 |
| 9 | 6 | 7 | 12 |
| 4 | 15 | 14 | 1 |

His square also contains another elegant detail. The two middle numbers in the bottom row combine to give the date of the work, 1514, while the outer two, 4 and 1, are the fourth (D) and first (A) letters of the alphabet, the initials for Dürer, Albrecht.

The reverence for the magic square in religious art and symbolism continues to this day. In Barcelona, the famous unfinished Sagrada

Familia cathedral features a sculpted *Passion* facade by Josep Subirachs which, at first sight, appears to be a magic square.

| 1  | 14 | 14 | 4  |
|----|----|----|----|
| 11 | 7  | 6  | 9  |
| 8  | 10 | 10 | 5  |
| 13 | 2  | 3  | 15 |

All the rows, columns, and diagonals sum to 33, the traditionally assumed age of Jesus at the time of the Passion that is being portrayed in the accompanying sculptures. But look again. The square isn't magic (or this sum would have been 34). The numbers 10 and 14 appear twice at the expense of 12 and 16, which are missing.

Subirachs could have done something different here and avoided the duplication of numbers. If you add the same quantity, Q say, to every entry in a magic square then the rows, columns, and diagonals will still have the same sums but the square will not be composed of the first N consecutive numbers anymore. If you add Q to every entry in a 3 × 3 magic square[3] then the new magic number will be 15 + 3Q and this can be made equal to 33 by choosing Q = 6. These new squares avoid duplications, but they use the nine consecutive numbers that start with Q + 1 = 7. Here is the new square constructed by adding 6 to each entry in our first 3 × 3 example on page 94. The deduction of any further numerological significance is left as an exercise for the reader. Meanwhile, if you attempt the sudoku puzzle in today's newspaper you will see how pervasive and addictive magic squares seem to have become for millions of people.

| 10 | 15 | 8  |
|----|----|----|
| 9  | 11 | 13 |
| 14 | 7  | 12 |

# 36

# Mondrian's Golden Rectangles

The Dutch artist Piet Mondrian (or Mondriaan[1]), born in 1872, lived and worked through a period of great change in the history of art. After beginning his career as a painter of landscapes, he was influenced initially by cubism, Fauvism, pointillism, and other forms of abstraction but pioneered an approach to artistic geometry and color that is almost axiomatic in its prescriptive constraints. Nevertheless, his work became increasingly popular in the later twentieth century and often attracts the attention of mathematicians interested in pattern structure because of its relative simplicity. Mondrian's interest in other artistic styles was soon completely overtaken by his own devotion to the cult of theosophy. From this collection of religious ideas a philosophy of art emerged in 1906 that he, and others, called The Style (*De Stijl* in Dutch). Mondrian laid down a number of aesthetic rules for creating work in The Style. These were the principles of a form of nonrepresentational art that he called neoplasticism, and he applied them to architectural and furniture design, and to stage-set production as well:

1. Only use the primary colors red, blue, and yellow or black, gray, and white.
2. Only use rectangular planes and prisms for surfaces and solid shapes.
3. Compose using straight lines and rectangular planes.
4. Avoid symmetry.
5. Use oppositions to create aesthetic balances.

6. Use proportion and position to create balance and a sense of rhythm.

These principles led to a quest for a pure geometrical art form composed of pure colors.

After two years in London during the early years of the Second World War, Mondrian worked in Manhattan for the last years of his career and died there in 1944.

Mondrian's paintings are dominated by thick black horizontal and vertical lines. Their intersections create rectangles and in this network the use of the golden ratio (see Chapter 34) is a very common device of Mondrian's. His work contains many golden rectangles whose dimensions approach those of the famous golden ratio $\frac{1}{2}(1+\sqrt{5}) = 1.618$. Looking at the picture above we can search for approximations to golden rectangles. These rectangles have sides in the ratio of successive numbers in the never-ending Fibonacci sequence:

1, 1, 2, 3, 5, 8, 13, 21, 34, 55, 89, 144, 233, 377 . . .

in which each number after the second is generated by the sum of its two predecessors. These successive ratios get closer and closer to the golden ratio as you move further down the sequence (e.g., $\frac{3}{2} = 1.5$, $\frac{21}{13} = 1.615$, and $\frac{377}{233} = 1.618$). So, in practice, the thickness of the painted lines means that almost all Mondrian's rectangles appear golden if they use successive Fibonacci numbers to define their side lengths. In fact, this feature of the Fibonacci sequence is a particular case of a more general property. If you look at ratios of Fibonacci numbers a distance D apart in the sequence (so picking successive ones just corresponds to taking D = 1), their ratios will tend quickly to the $D^{th}$ power of the golden ratio, $1.618^D$ as you move down the sequence.[2]

Using this knowledge you can now dissect the rectangles in Mondrian's paintings and make your own versions of them on paper or on screen – a nice activity for children! Mondrian colors some of his rectangles, but leaves most of them white. Coloring is where his principle of balance must be brought into play; different colors are in opposition and do not cluster, so as to confine the eye's attention to one part of the canvas. The result is a curious combination of creativity self-constrained by numerology.

# 37

# Monkey Business with Tiles

We are familiar with the types of tile that are available for tiling the floor or the walls of a bathroom or garden patio. Typically, they are squares or rectangles and there is no great challenge in arranging them, unless they have a picture that has to be matched up across each side. This is the case with an old children's puzzle that was the flat predecessor of the Rubik's Cube and its modern computer-based extensions.

A "monkey puzzle" consists of nine square cards on which four halves of a monkey's body are printed with different colors and two possible orientations.

The idea of the game is to match up the two halves of each monkey so that the squares are arranged with complete monkeys formed of the same color. Most of us can solve these problems

after a little trial and error, but it can be quite a lengthy process for a beginner. Consider how many possibilities you have to deal with. There are nine ways to pick the first card, then for each of those choices there are eight ways to choose the second card, seven ways to choose the third card, and so on. But when each card is chosen it can be put down in one of four different orientations, so there are $9 \times 4 = 36$ ways to choose the way the first card looks. Overall, this means there are $9 \times 4 \times 8 \times 4 \times 7 \times 4 \times 6 \times 4 \times 5 \times 4 \times 4 \times 4 \times 3 \times 4 \times 2 \times 4 \times 1 \times 4 = 362{,}880 \times 4^9 = 362{,}880 \times 262{,}144 = 95126814720$ (more than 95 billion) possible ways to arrange the cards in a $3 \times 3$ grid.[1]

These numbers show that when we attempt (and often succeed) to solve one of these problems we don't do it by systematic search through all the 95 billion-plus possibilities to see which ones have all the monkeys' bodies matched up in the same color. We place a first card and then try to match up other cards. As we move on we might sometimes go back and remove a card that we used at the previous step in order to make the puzzle fit together at the next stage as well. So we are learning something at each step and not merely searching randomly through all the possibilities.

The numbers of possibilities that are generated in this simple puzzle are truly astronomical, close to the number of stars in our Milky Way galaxy. If we take a bigger puzzle with a $5 \times 5$ square of 25 pieces then the fastest computer on earth would take billions of times longer than the age of the universe to explore them all one by one.

Decorative strategies that embark upon an exploration of the permutations possible for tiling patterns have access to similarly enormous numbers; they are for all practical purposes inexhaustible explorations for the human mind even before other colors or textures are introduced. However, they illustrate how something can be computationally long or hard to complete without being terribly interesting. There is little

novelty being generated at each step. Most interesting of all is the fact that once you have found the correct solution to the monkey puzzle it takes only a split second's examination to confirm that it is the solution.

# 38

# Pleasing Sounds

The Greeks are credited with the first quantitative understanding of what we like about sound. Wide practical experience with stringed instruments led to the discovery that if you divided the length of a plucked string into two halves then it produced an appealing musical interval which we call the "octave." The ratio of the frequencies of the sound waves is 2:1 in this case. If one-third of the string was taken, then another appealing interval, called the "perfect fifth," is created and the sound frequency ratio is now 3:2.

The Pythagorean school of philosophy and mathematics treated numbers differently from mathematicians today because they felt that there was an intrinsic meaning attached to the numbers themselves. So, for example, there was a meaning ascribed to seven-ness and all sevenfold quantities in Nature were linked by it. The discovery that there were numbers deeply embedded in musical sound was for them a profound truth. It was natural that they should ask whether a whole number of octaves could be made from the perfect fifth alone by simply using the frequency ratio ³⁄₂ over and over again. This is the same as asking whether whole numbers of powers of 2 can be made equal to whole numbers of powers of ³⁄₂; that is, whether there are positive whole numbers p and q which solve the equation:

$$(3/2)^p = 2^q$$

Alas, this is impossible because no power of 2, like $2^{p+q}$ (which must be an *even* number), can equal a power of 3, like $3^p$ (which must be an *odd* number). However, while there are no exact solutions to the equation there can be approximate solutions to very high accuracy and we write a wiggly equals sign to indicate this approximate equality:

$$(3/2)^p \approx 2^q \; (\star)$$

In particular, the Pythagoreans noted that the choices $p = 12$ and $q = 7$ give a very good "almost solution" because $2^7 = 128$ and $(3/2)^{12} = 129.746$, and the error we make by assuming they are approximately equal is less than 1.4 percent. A nice feature of the choices 7 and 12 is that they do not share any divisors (other than 1) and so the repeated action of multiplying by the ½ factor will not produce a frequency already generated until it has been applied twelve times and the so-called "circle of fifths" then closes. The twelve different frequencies that will be produced by the multiplications by ½ will all be powers of the basic frequency ratio given by $1:2^{1/12}$, which is called the "semitone." The fifth is approximately seven semitone intervals as $2^{7/12} = 1.498 \approx$ ½, and the small difference between 1.5 and 1.498 is called the "Pythagorean comma."

The almost-equality provided by the choices $p = 12$ and $q = 7$ seems like a lucky guess but we now understand that there is a systematic method to generate better and better guesses by producing increasingly accurate fractional approximations to irrational numbers.[1] Our equation above ($\star$) for p and q is the same (taking logarithms) as:

$$(q+p)/p = \log 3 / \log 2$$

If we expand log3/log2 as a continued fraction it will continue forever. The first eight steps in the expansion look like this:

$$\cfrac{1}{1 + \cfrac{1}{1 + \cfrac{1}{1 + \cfrac{1}{2 + \cfrac{1}{2 + \cfrac{1}{3 + \cfrac{1}{1 + \cfrac{1}{5 +}}}}}}}}$$

We can end the staircase of numbers at any point and tidy it up to get a single fraction. This rational approximation will get more accurate if we keep more terms in the expansion. If we end it after five terms then we get[2]:

$$^{19}\!/_{12} \approx \log 3 \,/\, \log 2$$

This means we need to choose $(q+p)/p = {}^{19}\!/_{12}$ and so $p = 12$ and $q = 7$ are the choices we want. If we took the next more accurate rational approximation by cutting after six terms then we would have $(q+p)/p = 65/41$ and the choices $p = 41$ and $q = 24$ would work. We could keep going, getting better and better approximations for p and q by taking more terms in the continued fraction before tidying it up into a single fraction.

# 39

# New Tiles from Old

Sometimes more interesting solutions to complicated problems can be found by simply modifying a known solution to a simpler one. Take the problem of tiling a flat plane surface (like your patio wall or floor) with a lattice-like arrangement of identical tiles. Square or rectangular tiles will do the trick but are not very interesting. Slightly more adventurous would be tiling with equilateral triangles or hexagons:

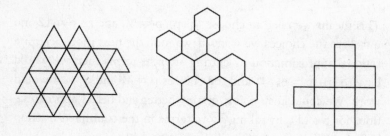

Alternative tilings exist if you are allowed to rotate the tiles; for example, cutting your square or rectangular tiles diagonally will produce a triangular tiling. You can even alternate the diagonal that you cut across to add more variation. I have noticed that this type of pattern is common in fabric design among some Native American cultures.

There is another more unusual way to move from the simple square or rectangular tiles, allowing you to use tiles of any shape so long as you maintain a certain constraint. Start with a rectangle (a square is just a particular type of rectangle with four equal

sides); remove any shape from the bottom and add it to the top; similarly remove any shape from the left-hand side and add it to the right-hand side. Here is an example:

You can see that a set of copies of this weirdly shaped piece will always fit together and keep on tiling any flat surface. The only difficulty arises when you want to end the pattern. If you want the edges to be straight you can easily do it by just taking a top- or side-slicing or filling in of one of these tiles to create a straight edge and the overall pattern comes nicely to an end.

This very straightforward recipe for passing from a simple to a complicated tiling was impressively used by Maurits Escher in some of his great tessellation patterns. See, for example, the *Black and White Knights* design, where the tiles are shaped like knights on horseback moving in alternate rows: white knights from left to right and black knights from right to left. All the interlocking shapes are in effect tiles of a single shape.

# 40

# The Nine-Degree Solution

Simple geometry can create beautiful designs but it can also provide unexpectedly elegant solutions to awkward design problems. An interesting example of a far-reaching simple idea is the problem of how to design an aircraft carrier's flight deck. When the US and Royal Navies first trialed the idea of launching and landing aircraft from stationary and moving ships during the period 1910–17, it was a pretty hazardous business. The first person to land an aircraft on a platform fixed to a moving ship also became the first person to be killed in an aircraft-to-ship landing accident later the same day. By 1917, large ships like HMS *Argus* each had an additional top landing deck fitted like a flat roof covering its whole length. This gradually evolved into the more familiar floating runway configuration that was the norm for all Second World War aircraft carriers. Every one of these carriers used a single floating runway for both takeoffs and landings and so only one operation could happen at a time. The biggest problem they faced was stopping incoming aircraft quickly enough, so they didn't crash into the line of planes waiting to take off. At first, deck hands would rush out and grab bits of the aircraft as it touched down, to help it decelerate. This is only sensible when aircraft are slow-moving and lightweight, and as they grew heavier and faster, wire nets were spread across the landing deck to trap them. Eventually lines of cable (typically 4 spans at 6-meter intervals) were introduced to catch the wheels and rapidly slow them down. Unfortunately, there were still frequent disasters because incoming

aircraft could easily bounce over the cables – and even the nets – and collide with stationary aircraft. Worse still, increasingly powerful aircraft needed ever greater stopping distances: the collision risk was getting worryingly high and the nets themselves often damaged the planes.

The answer was simple. On August 7, 1951, Captain (later Rear Admiral) Dennis Cambell of the Royal Navy had the idea that the landing deck should be angled to the side – 9 degrees would become the most commonly used angle – so that aircraft could land along its whole length while aircraft awaiting takeoff could sit out of harm's way.

This really was a good idea. Takeoffs and landings could now happen simultaneously. If an incoming pilot thought he was going to overshoot the runway he could just accelerate and relaunch without meeting anything in his path, while changing the shape of the deck near the bow could add symmetry and extra space for aircraft waiting to take off. Cambell thought this up while waiting to take part in a committee meeting to discuss carrier landing safety. Later, he recalled that he prepared an enthusiastic little presentation of his new idea: "I admit I did this with something of a flourish, and was accordingly somewhat miffed at not getting the expected gasps of gratifying amazement. In fact, the

meeting's reaction was a mixture of apathy and mild derision."
Fortunately, Lewis Boddington, a technical expert from the Royal
Aircraft Establishment who was at the meeting, immediately appre-
ciated the importance of Cambell's idea and it was soon part of
the Navy's planning.

Many aircraft carriers had this angled deck retrofitted in 1952–3.
The first to be built to this design was the *Ark Royal* in 1955 –
under the command of Cambell himself – with a 5-degree offset
at first that was later altered to 10 degrees.

One further geometrical trick was still to come. The Royal
Navy introduced an upward curvature to the end of the takeoff
deck, typically of about 12–15 degrees, to facilitate upward lift
at the moment of takeoff when the upward speed would other-
wise be at a minimum. This "ski-jump" ramp, so called because
it is just like the upward curve at the bottom of an Olympic
ski-jump descent, enables heavier aircraft to be launched from
shorter takeoffs and can almost halve the runaway length needed
for jets to get airborne from the carrier.

# 41

# Paper Sizes and a Book in the Hand

In our look at text layout in old manuscripts and the canon of page design for books in Chapter 9 we mentioned a favorite medieval height-to-width ratio, R, equal to ³⁄₂. Later, when paper makers produced pages another favorite choice was R = ⁴⁄₃. When the sheet is folded in half the result is called a "folio."

We see that the (top) half-page that results has height 3 on its long side and width 2, so R = ³⁄₂. If we fold or cut this again (the dotted line) then the resulting page has height 2 and width ³⁄₂, so we are back to R = ⁴⁄₃ again. If we keep folding, the R values of successive pages will continue, alternately, as R = ³⁄₂ or R = ⁴⁄₃.

Today, a different, and in some ways optimal, choice of R is used with R = $\sqrt{2}$ = 1.41. This use of the square root of 2 ensures that, when we fold an initial piece of paper with height-to-width

ratio $\sqrt{2}$ in half, we get a new page with the same value of R. This nice property continues no matter how many times we fold the paper in half: the height-to-width ratio is always $\sqrt{2}$. This is the only choice of page-size ratio for which this is true.[1] Say we choose the initial width to be 1 and the height h, giving us R = h; cutting the page in half gives a new sheet with height 1, width h/2, and R = 2/h. This is only the same as R = h if 2/h = h, or $h^2 = 2$.

The familiar A-series for paper sizes that is now an international standard everywhere (except the USA) starts with an A0 size with an area equal to 1 square meter ($m^2$) and so its height is 2¼m and its width is 1/2¼m. The succession of paper sizes, labelled A1, A2, A3, A4, A5, etc., all with the same aspect ratio, R = $\sqrt{2}$, are then as shown:

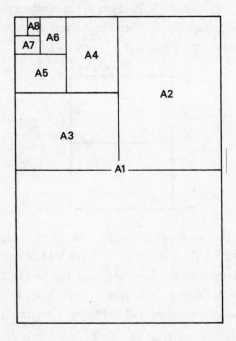

When it comes to books we find that the preferred height-to-width ratios change again. The A-series paper sizes will not generally be found there unless a book has been self-published by being

downloaded from the Web or a word processor using a conventional printer (which will always have A-series paper sizes[2] unless you are in the USA).

There are two situations to consider. If a book is always going to be read while laid flat on a table or a lectern – as is the case for bulky reference books, large church bibles, encyclopedias, and landscape-format picture books with $R < 1$ – then any R ratio is convenient for handling. But if a book is going to be held in your hand while you read it then a lighter weight is preferred. The page height needs to exceed the page width ($R > 1$) or you soon develop very tired fingers and wrists – even if you continually swap the supporting hand to alleviate the strain. The $R = 1.5$ choice, or the famous "golden" ratio[3] of $R = \frac{34}{21} = 1.62$, approximately, both produce books that are easily balanced in the hand without awkward torques being produced by having excessive width.[4]

# 42

# Penny Blacks and Penny Reds

The invention of the adhesive postage stamp by Rowland Hill in 1840 was one of those wonderfully simple ideas that seem so obvious in retrospect that you wonder how things could ever have been different. But they were. The mail service in Britain until then was a mixture of unsatisfactory and inefficient practices. The rich and privileged had their mail delivered by hand for nothing, while the general public were the victims of rampant profiteering. In 1837 Hill laid out his plans for a better service in a pamphlet entitled *Post Office Reform, Its Importance and Practicability*, pointing out that a letter from London to Edinburgh currently cost the sender 1s 1½d but cost the Post Office less than ¼d to deliver[1] – a markup of a factor of 54!

The cost of postage was determined by the number of sheets of paper sent; envelopes were not commonly used as they were charged for as additional sheets. The postage charge was always borne by the recipient, and if he or she declined to take the letter there was nothing to pay. This system was wide open to fraud. Unscrupulous correspondents could put marks or other indicators (size, color, shape) on their letters so that the recipient would get the message without accepting and paying for the letter: its mere arrival might be all that was needed to pass on the message.

Hill's new proposals to solve all these problems were simple but novel: "A bit of paper just large enough to bear the stamp, and covered at the back with a glutinous wash which the user

might, by applying a little moisture, attach to the back of the letter." In other words, he had invented the idea of the adhesive postage stamp. It would be paid for by the sender and it would cost only one penny per half ounce for all deliveries between any two points of the British Isles. This payment in advance and the increased use of the mail, together with the avoidance of free and fraudulent uses of the delivery system, would still bring in a good profit. As a final insight, he also invented the front-door letterbox to increase the efficiency of deliveries: "There would not only be no stopping to collect the postage, but probably it would soon be unnecessary even to await the opening of the door, as every house might be provided with a letterbox into which the Letter Carrier would drop the letters; having knocked, he would pass on as fast as he could walk."

Despite initial opposition from the Postmaster General, who feared loss of the unjustifiably high income from overpricing, and the aristocracy, who feared the loss of their free service, Hill's proposals met with universal public support. The opponents reluctantly had to change their minds, and on August 17, 1839, the Postage Duties Bill was given Royal Assent and became law.

A competition was held by the Treasury to find the best design for the new 1d stamp. In a matter of months the design was chosen, the paper, inks, and gums determined, and the classic penny black design completed. Stamps first went on the market on May 1, 1840, and 600,000 were sold on that day alone although they could not be used until May 6.[2]

The stamps had no perforations at first and had to be cut out by hand from a large sheet of 240 stamps (there were 240 old pennies in one pound). The sheet had twenty rows and twelve columns, and each stamp had two check letters which indicated its position on the sheet – that in the bottom left giving the row and that in the bottom right giving the column.

The postal authorities were very worried about fraud. They

needed to apply a cancellation when a stamp was used in order to prevent reuse. Unfortunately, the black stamp was not the best color choice in this respect as a cancellation mark in black ink might be hard to see, allowing the stamp to be reused. One attempt to solve this problem was to apply a red-brown Maltese-cross style cancellation mark, but the red ink was not hard to remove or obscure. The second stamp to appear, the 2d blue for heavier letters, was a better color for a black cancellation. Later, in 1841, the 1d black was succeeded by the 1d red, on which simple black postmarks were easily visible.

Another type of fraud was of concern to the authorities. If a stamp's cancellation mark only covered a part of the stamp then determined thieves could accumulate lots of used stamps, soak them off the envelopes, cut off the cancelled parts, and assemble new clean stamps from the parts – and they did! The reassembled stamps were put on new envelopes with glue. Equally worrying was the possibility that simple solvents might remove the cancellation marks without noticeably defacing the underlying stamp, and Hill was much involved in experiments to find the best ink for postmark cancellations.

One simple solution was to apply an overwhelming obliteration mark that covered almost the whole stamp. The other solution proposed was more elegant.

The original system of placing plate letters in only the bottom two corners of the stamp to indicate its position on the sheet (with decorative symbols in the top two corners) was changed in 1858. After some unnecessarily complicated suggestions, William Bokenham and Thomas Boucher came up with an elegantly simple idea. Put the two plate letters in the top corners and the same letters in reverse order in the bottom: so A B in the top left and right corners (with A denoting the position on the sheet while B would denote the second stamp in the top row) would have B A along the bottom, as shown here:

This was a nice trick because it stopped the fraudster simply joining together unmarked parts of two different cancelled stamps to create a new one. The two joined pieces would not have matching corner letters. As an extra check against the possibility that different stamps might be found on different sheets with the same top and bottom check letter pairs, the sheet number was engraved discreetly into the stamp design in the middle down both vertical sides of the stamp. This whole arrangement was the forerunner of modern check-digit codes that are used to authenticate banknote serials, national insurance numbers, airline booking reference numbers, and other official "numbers" which might be falsified or simply mistyped. A simple internal check of the digits on a ticket number – for example, multiplying each by a number and then adding the results up and requiring the remainder after dividing by 9 to always be the same – can ensure against many errors and falsifications.

Despite the simplicity of the new check-letter system for stamps, and its instant approval by Sir Rowland Hill, the making of new plates for the 1d stamps was a huge task because of the large number of them (225 in all) required to meet the huge demand for stamps, with millions being printed from each plate. As a result, the new 1d red stamps did not appear until 1864. The less used 2d blue stamps could be printed on just fifteen plates, and by June 1858 printing could commence after the first eight had been costed and made. Subsequently, after 1864, the new check-letter system

was used on all Victorian stamps. Indeed, its legacy continues to the present day, with specialist collectors of British postage stamps seeking out all the different plate numbers of each stamp and even seeking to reconstruct whole sheets of 240 stamps using the letter pattern. A used example of the rarest of all – a 1d red from plate 77, of which only four unused and five used copies are known,[3] on a piece of an envelope with another common 4d stamp – was recently advertised on Stanley Gibbons's website and sold for £550,000. They reported that it was the most valuable single stamp they had ever sold. Forgers, still at it, now presumably specialize in trying to remove the "1" from plate 177 penny reds!

# 43

# Prime Time Cycles

Many festivals and sports events are organized periodically every few years. The Olympics, the World Cup, and other major international sporting events are obvious examples but there are also conferences, concerts, arts festivals, and exhibitions. If you are involved in organizing a periodic event like this you will know that there are special problems that do not arise with one-off events. Their periodic cycle must be maintained irrespective of clashes with other big events that might be on a similar cycle. For example, in 2012 we saw the consequences of the European athletics championships moving to a two-year cycle; the championships took place just a few weeks before the Olympic Games and only a handful of competitors did both.

The general problem of event clashes is simple. If one event occurs every C years (or months or days) then it runs the risk of clashing with events whose periodic cycle is a factor of the number C. So, if C = 4 you might occur in the same year as events with one- or two-year cycles; if C = 100 then you have to worry about locking in to cycles of 2, 4, 5, 10, 20, 25, or 50. This means that the recipe for avoiding a clash is to pick your periodic cycle, C, to be a prime number. It will then have no divisors (other than 1) and this minimizes the chance of a clash. Strangely, it is very hard to find recurrent events which do that. The grandest sports events like the Olympics, the Commonwealth Games, and the World Cup go for C = 4, never C = 5.

There is an interesting counterpart of this problem in the

biological realm. The small grasshopper-like insect called the cicada feeds on plant matter and tree leaves. Cicadas spend most of their lives underground, emerging for only a few weeks to mate, sing their song, and then die. There are two American types, both belonging to the genus *Magicicada*, which in particular lavish a remarkable period of time on this life cycle. The type found in the south of the USA remains underground for thirteen years, while the other, found in the east, does so for seventeen years. They all lay their eggs in trees and, after the eggs have fallen to the ground, the hatchlings go underground, where they attach themselves to the tree roots. Then, thirteen or seventeen years later, they will all emerge on cue in huge numbers over a surface area of about 100 square miles during a narrow period of just a few days.

This remarkable behavior raises many questions. The unusual cycle times of thirteen or seventeen years are distinctive because both are prime numbers. This means that parasites and other predators with shorter life cycles (many of them have two- to five-year cycles) will not be able to develop in step with the cicada and wipe them out. If one cicada had a fourteen-year cycle, then it would be vulnerable to predators with two- and seven-year life cycles.

What happened to the prime numbers smaller than thirteen? Biologists believe that the tendency to reproduce so infrequently is a response to the hazardous sharp frosts that are common in their habitats. Breeding less often is a response to being in a dangerous environment. It also ensures that the common predators, notably birds, can't develop a total reliance on eating them if they only appear every thirteen or seventeen years.

Finally, why do they all emerge at once, within just a few days? Again, this may be a strategy that has won out in the long run because cicadas that do it tend to survive with greater probability than those who don't. If they all emerged in their millions over a long period of time the birds would happily eat them in modest

quantities day by day. The result would be that they would all get eaten. But if they almost all emerge in a very short time the birds will quickly be sated and huge numbers of cicadas will survive because the predators are just too full to eat any more.[1] Evolution evidently discovered by trial and error the existence of prime numbers, as well as the benefits of keeping people guessing.

# 44

# If You Can't Measure It, Why Not?

Politicians, social scientists, medical researchers, engineers, and managers all seem to love the idea of measuring the effectiveness of things. Their aim is laudable: they want to make things better through weeding out the bad and enhancing the good by giving them a numerical score. Yet we feel intuitively that there are some things, like beauty or unhappiness, that don't lend themselves to being uniquely quantified. Is there a way to see why this might be?

The American logician John Myhill gave us a useful way to think about this question.[1] The simplest aspects of the world are those which have the attribute of "computability." This means that there is a mechanical process for determining whether something possesses this attribute or not. Being an odd number, being a conductor of electricity, or being triangular are all computable properties in this sense.

There are also properties of things which are a bit more subtle than this. Familiar properties like "truth," or "being a genius," are more elusive than computable ones and can only be listed. "Listability" means that you can construct a process for systematically listing all cases which have the desired property (although it might take an infinite time to complete the listing if there is no end to the number of examples). However, there is no way to list all the cases that do not possess the desired attribute. If you could

also do that then the attribute would become computable. It is easy to see that the listing of things without a given property can be a real challenge – just think of listing all the things in the universe that are *not* bananas – it's quite a challenge to know what they are.

Many properties of things (or people) are listable but not computable.[2] Myhill next recognized that there are attributes of things which are neither listable nor computable. These he called "prospective" properties: they can be neither recognized, nor generated, nor measured, in a finite number of deductive steps. These are things that cannot be completely captured by any finite collection of rules, computer printouts, classification systems, or spreadsheets. Simplicity, beauty, information, and genius are all examples of prospective properties. This means that there can be no magic formula that generates or ranks all possible examples of these attributes. No computer program can generate all examples of artistic beauty, nor can any program recognize them all when it is shown them. The best that can be done with prospective properties is to approximate them by a few particular features that can be computed or listed. In the case of beauty, for example, we might look for the presence of some type of facial or body symmetry; in the case of "genius" we might pick on some intelligence test measure, like IQ. Different choices of these particular features will give different results. By definition there is no way to characterize, or even recognize, all of these possible subfeatures. This is why sciences of complex systems, including those featuring people, are so difficult. No "Theory of Everything" will explain or predict the works of Shakespeare. None can ever be complete.

# 45

# The Art of Nebulae

The bread-and-butter images of glossy astronomy magazines and picture books are neither stars nor galaxies, but nebulae: exploded stars that radiate energy out into their surroundings at high speed. The results are spectacular. The radiation interacts with clouds of gas and dust to produce a rainbow of colors that suggests all manner of mysterious cosmic events. Dark clouds of intervening dust add to the display by creating sharp dark boundaries that allow our imaginations to see what they want to see – an ink-blot test of significance on a cosmic scale. Look at the names that these nebulae have conjured up: the Tarantula, the Horsehead, the Egg, the North American, the Necklace, the Triffid, the Dumbbell, the Cat's Eye, the Pac-Man, the Apple Core, the Flame, the Heart and Soul, the Butterfly, the Eagle, the Crab – no imaginary stone is left unturned.

There is a fascinating subtext to these modern astronomical images that has been noticed by Elizabeth Kessler, an art historian now at Stanford University. Looking at the Hubble Space Telescope images of nebulae through the eyes of an art historian rather than those of an astronomer, Kessler saw echoes of the great nineteenth-century romantic canvases of the old American West by artists like Albert Bierstadt and Thomas Moran. They expressed the grandeur of a landscape that inspired the pioneering spirit of the first settlers and explorers of these challenging new frontiers. Their representations of places like the Grand Canyon and Monument Valley created a romantic tradition of landscape art that played on important psychological "hooks" within the human psyche.

Artists accompanied the groundbreaking expeditions into the West to capture the natural wonder of the new frontier and convince the folks back home of the importance and greatness of the adventure; an honorable tradition continued by war artists and photographers today.

How can this be, you ask? Surely astronomical photographs are astronomical photographs. Not quite. The raw data that is gathered by the telescope's cameras is digitized information about wavelength and intensity. Often those wavelengths lie outside the range of sensitivity of the human eye. The final pictures that we see involve a choice about how to set the color scales and create an overall "look" for the image. Sometimes images in different color bands are combined. Various aesthetic choices are made, just as they were by the landscape artists of old because these special high-quality pictures have been made for display, not for scientific analysis.

Typically, the Hubble observers take three different filtered versions of the raw image data in different color bands, removing flaws or unwanted distortions, and then adding the color chosen for the photographic representation before reducing everything to a nice four-square image. This needs skill and aesthetic judgment. The Eagle Nebula is a famous Hubble image.[1] It has a double claim to fame. The great pillars of gas and dust it shows stretching upward like stalagmites in space are places where new stars are forming out of gas and dust. Here, Kessler recalls Thomas Moran's painting *Cliffs of the Upper Colorado River, Wyoming Territory*,[2] painted 1893–1901 and now in the National Museum of American Art. The representation of the Eagle Nebula could be oriented any way "up" or "down." The way it has been created and the colors which have been used are reminiscent of these great Western frontier landscapes, like Moran's, which draw the eyes of the viewer to the luminous and majestic peaks. The great pillars of gas are like a Monument Valley of the astronomical landscape; the twinkling, overexposed foreground star a fortuitous substitute for the Sun.

Indeed, one can venture further than Kessler along this line. We especially appreciate one particular type of landscape image that dominates galleries of traditional Western art, one which we find so appealing that it informs the creation of our ornamental gardens and parks. It enshrines a deep-laid sensitivity and desire for environments that are safe. Millions of years ago, when our ancestors were beginning the evolutionary journey that would find its way to us, any liking for environments that were safer or more life-enhancing than others would tend to survive more frequently than the opposite tendencies. We see this evolved psychology in our liking for landscapes that allow us to see without being seen. These environments are therefore known as "prospect and refuge" landscapes. They allow the observer to see widely from a vantage point of safety and security.[3] Most landscape art that we find appealing has this motif. Indeed, the imagery extends beyond representative art as well. *The Little House on the Prairie*, the inglenook, the tree house, the resonance of "Rock of Ages cleft for me" are all examples of prospect and refuge. This is the signature of the African savannah environment within which our earliest ancestors evolved and survived for millions of years. Wide-open plains interspersed by small clumps of trees – just like our parks – allow us to see without being seen.

By contrast, the dense, dark forest with its winding paths and dangerous corners where who knows what dangers lurk is the complete antithesis, like a 1960s tower block of flats with its uninviting walkways and dark staircases. These are not environments that are inviting. Prospect-and-refuge environments are those which you feel drawn to enter. This test is one you can apply to all sorts of pieces of modern architecture. The beautifully created astronomical pictures from the Hubble Space Telescope lack this prospect and refuge imperative but arguably they have been influenced by other artistic resonances with a human yearning to explore the unknown.

# 46

# Reverse Auctions: Going Backward for Christmas

Auctions are strange events. Economists, art houses, and mathematicians tend to analyze them logically under the assumption that everyone behaves rationally. This assumption is unlikely to be correct in practice and we are aware of our own asymmetrical attitudes to risk – we are far more worried about losing $1,000 than gaining the same amount. Financial traders start taking much bigger risks when trying to stem their losses than they will when trying to increase their profits when trading successfully. Our natural aversion to risk tends to make us overbid in auctions because we would rather pay more than run a risk of losing the item. When lots of bidders are drawn to overbid in this way there is a runaway effect. In other circumstances this illogical aversion to risk is socially beneficial. The parking warden may come very infrequently to check who is parked without displaying a ticket yet almost everyone will buy one from the machine.

There is a tendency for bidders in auctions to think they are "different" from everyone else in some way – that no one else will bid as high or as low – in defiance of the statistics of large numbers of independent choices. An interesting example is to create a reverse auction in which potential buyers are asked to bid for an object (in a whole number of dollars) and the winner will be the person who bids the lowest amount not bid by anyone else.

How does your thinking go? The best choice would be to bid zero or one maybe. But then everyone would think that and not do it, so maybe I should outsmart them and do it anyway! This is a classic example of thinking that assumes you are special and don't think in the same way as others. Another approach might be to say that you should just pick a "smallish" number. No one will pick a very small one because they will think it's too obvious and won't be unique. No one will pick a very large one because it most likely won't be the smallest. So in practice there is quite a narrow range of numbers, say from about eight to nineteen, depending on how many bidders there are, which seem to have a good chance of being the smallest unique choice. Logically, there is an infinite number of bid amounts that could be chosen, but in practice we see that there is a finite horizon for any individual's range of choices.

Could there be an optimal strategy that tells us what the best amount to bid is? Well, suppose there is and it says, taking into account the number of participants, you should bid thirteen. But that optimal strategy would also be the optimal strategy for all your rival bidders. If they bid thirteen as well, however, then you will all lose. So there cannot be an optimal strategy of this sort.

Another interesting type of auction is one in which there is a cost to bidding. These are called "all-pay" auctions. The losing bidders might have to pay the largest losing bid they made (or perhaps some specified fraction of it). In some cases only the top two bidders pay. This certainly encourages bidding to continue, and the more you have bid the more you have to lose if you don't continue. Such auctions sound crazy but they exist in slightly disguised form all around us. A raffle is like this. Everyone buys a ticket but there is only one winner. Look at the US presidential elections. In effect the candidates are bidding (even the word is the same) to be president and put in huge amounts of money to

fund their bid. If they lose the election then they lose all that money. Likewise, throughout the animal kingdom we find males fighting for the right to mate with females or to dominate a large collection of fellow animals. When two hippopotami or stag deer fight, the cost to the health of the loser of his failed "bid" can be very great.

# 47

# Ritual Geometry for the Gods

There are ancient links between geometry and religious ritual. Both respect symmetry, order, and pattern. The most extensive of these connections can be found in the ancient Hindu manuals called the *Sulba Sûtras* ("the Books of the Cord"). The Sanskrit name derives from the practice surveyors have of marking out straight lines close to the ground with cords joined by pegs. We still see bricklayers doing this today if they want to be sure that a wall is straight.

The *Sulba Sûtras* were written between 500 and 200 BC and provide detailed prescriptions for the geometrical constructions needed to create ritual altars. Altars existed in family homes where they might be nothing more than an arrangement of simple bricks or marks drawn on the ground. More elaborate structures would serve for communal purposes. The altars were themselves viewed as the things with power to change events for better or worse and had to be respected and appeased in appropriate ways.

It is clear from these books of instructions that a considerable understanding of Euclid's famous Greek geometry existed in these early Indian societies. Pythagoras' theorem and its like were clearly needed to write the instructions for the construction of ritual altars.

The most interesting and geometrically challenging aspect of altar construction was the belief that if things went badly for you, your family, or your village, then some evil force had begun to dominate your life and you had to take steps to overcome it.

Increasing the size of your altar was the necessary step to take. "Size" meant surface area and this posed a tricky geometrical problem for the authors of the *Sulba Sûtras*.

The most common style of altar, in the shape of a falcon, was made from many small straight-edged bricks of varying shapes. Typical altar building bricks had top surfaces in the shape of a parallelogram, a triangle, or a rectangle with a triangular notch removed. An example is shown here:

The altar would have been built up in many layers, with about 200 bricks forming each layer in the most important altars. The overall shape had to follow stringent constraints dictated by religious ritual. You can see from the example shown that a requirement to ward off trouble by doubling the area of the altar's surface was a very complicated geometrical directive. The *Sulba Sûtras* gave step-by-step instructions for carrying out operations like this for the straightforward shapes and showed how to extend them to area-doubling patterns.

As a very simple example, suppose you have a square brick whose sides are each 1 unit and you need to double this. The starting area is $1 \times 1 = 1$ unit of area. In order to increase it to 2

units of area there is an easy way and a hard way. The easy way is to change the shape into a rectangle whose sides are of length 1 and 2. The hard way is to keep it square and make each side equal to the square root of 2, equal to roughly 1.41. The little parallelograms in the wings of the falcon which make a large parallelogram from a block of 30 are easier to deal with than you might think. If you imagine straightening one out into a rectangle, then its area will be just the base length times its height. Doubling it is no harder than doubling the area of a rectangle. Another shape that can be seen down the center line is a trapezium:

If its height is h, its base is b, and the width of its top is a, then its area equals ½ (a + b) × h. Its area is therefore just its height times its average width.

This type of reasoning is quite sophisticated for rural farming communities and reinforced the position of priests and interpreters of the geometrical instructions. No doubt handy rules of thumb were developed, but this type of ritual geometry reinforced the remarkable early development of arithmetic and geometry in the Indian subcontinent. The very numerals that we use worldwide today, 0, 1, 2, 3 . . . 9, originated in India; they then diffused through the Arab centers of learning into Europe, where their utility was eventually appreciated, leading to their adoption for business and science in the eleventh century.

# 48

# Prize Rosettes

Leonardo da Vinci was interested in a specific type of symmetry that had consequences for his designs of churches. He had great respect for symmetry of all types for many reasons, not simply aesthetic, and was concerned to maintain that laid down for a church even when practical requirements necessitated the addition of alcoves, chapels, and storage niches. The basic problem he faced was what additions could be made to the exterior of a church building while still preserving a symmetry as you move in a circle around it. This is like asking what symmetrical patterns are possible for rosettes, windmill sails, or propellers; all are examples of patterns created by shifting a basic design by the same angle around a central axis again and again. Here is a very simple one where the shift is by 90 degrees:

The double arrowhead motif must be the same on the end of each arm; it is also symmetrically placed on a center line. However,

that double arrowhead could have been replaced by half of the shape, like this:

Now the repeated pattern is like that of a children's pinwheel, and the whole pattern of the first diagram could be generated by rotating the pattern by 90 degrees about the central point.

Leonardo recognized that these symmetric and asymmetric designs are the only two possibilities for creating symmetrical rosette patterns. They can of course contain many more arms than the four shown here, but in order to preserve the symmetry they must be equally spaced. For example, if there are thirty-six arms to the pinwheel they must all be separated by $360 \div 36 = 10$ degrees. Leonardo could now add on his chapels and niches around the central building circle like the arms of a pinwheel.

We also recognize these types of patterns quite often in the natural world. The head of a daisy will be close to a symmetrical rosette of white petals spraying out from its yellow center. Functional human creations with the asymmetrical rosette form can be found in ship propellers, the hubcap designs of car wheels, and national coats of arms like the three legs of the Isle of Man. The symmetrical forms are common in company logos and the traditional designs of many Native American cultures, which seem to have had a special liking for rotational symmetries on fabrics and pottery.[1]

# 49

# Getting a Handle on Water Music: Singing in the Shower

Many people, like me, can't sing at all. Put us in a big hall or out of doors and we fail to generate enough volume. We have no vocal range and we can't sing in tune – although I am comforted by the fact that some rather famous singers of popular music evidently share this latter attribute (see Chapter 5). Yet, as we all know from experience, if we sing in the shower the results are vastly better – maybe even good. Why can that little cubicle become such a transforming acoustic factor?

The impressive volume generated in the shower is aided by the hard tiled walls and glass door of the shower. They bounce the sound back with almost no attenuation. If you sing outdoors in Hyde Park then almost none comes back: it just gradually falls in intensity as it travels. Sing in a large room and some will come back but a considerable amount will be absorbed by furnishings, clothed people (the audience), carpets, and anything else that tends to damp and absorb sound. If a school or college dining room has hard floors, low ceilings, glass windows, and hardwood tabletops without cloths then conversation will be difficult to hear when lots of people are talking at once, but concerts could be very successful.

The next benefit that aids a poor voice is the high level of reverberation caused by the sound waves bouncing many times around the walls of the shower. This is because the sound waves

produced at many different times will arrive in your ear almost simultaneously. So each note you sing seems to be extended by all the versions of it arriving back in your ear at very slightly different times. This smooths and lengthens the notes, disguising the fact that you don't have perfect (or even average) pitch, and creating the effect of a full and rich sound. The steamy moisture in the air also helps to loosen the vocal cords so that they can vibrate more smoothly with less effort.

The last and most impressive effect of the shower is the creation of resonances. Many natural frequencies of vibration are available to the sound waves in the air between the three perpendicular walls, the door and the floor and ceiling of the shower cubicle. These can be resonated with by the singer. Many of them lie very close together within the frequency range of the human singing voice. The addition of two such waves produces a large "resonant" increase in the volume. A typical shower will have resonant frequencies close to 100 Hz with higher resonances being created at multiples of this frequency – 200, 300, 400 Hz, etc. Human voices sing from about 80 Hz up to very high frequencies of several thousand Hz, so it is the low, bass frequencies near 80–100 Hz that easily resonate and sound deeper and more voluminous.[1]

These factors combine together best in a small hard-sided enclosure like a shower. They should also be partially realized in the interior of a car so long as you keep the roof on your convertible.

# 50

# Sizing Up Pictures

Have you ever gone to see a painting and been surprised at how much bigger or smaller it was than expected, or that it was far less impressive than when viewed as a color plate in a book? Van Gogh's *Starry Night* is disappointingly small while some of Georgia O'Keeffe's canvases seem far too large, and less impressive than smaller reproductions. This suggests an interesting question. If we stick for simplicity with works of abstract art, is there an optimal size for a particular painting? As a corollary, we can then ask whether the painter has chosen it.

All the discussions I can find about the sizing of paintings are bound up with very pragmatic questions like how much they can be sold for, whether demand is greater for smaller and less expensive works, ease of storage, availability of wall space for large works, and so forth. These are important factors because they can determine whether artists can make a living or not, but they are not quite what we are interested in here.

Rather than try to answer my question, it is instructive to think in this connection about the works of Jackson Pollock. The later phase of his abstract expressionist work produced paintings of the greatest complexity made by a combination of throwing and dripping paint onto canvases fixed on his studio floor. Several studies[1] of the statistical distribution of the canvases' coverage by paint of different colors and types, as one looks from large to small scales, reveal that Pollock's works have significant fractal[2] structure. (We shall be looking at the evidence for and against this claim in Chapter 94.)

We see approximately fractal structures in many parts of the natural world, in the branching of trees or the head of a cauliflower, where lots of surface is needed without a commensurate increase in volume and weight. The recipe for creating a fractal is to take the same pattern type and repeat it over and over again on smaller and smaller scales. The illustration below shows how this works with an equilateral triangle sprouting smaller equilateral triangles from the middle third of each side at each step of the process, first conceived in 1904 by the Swedish mathematician Helge Koch.[3]

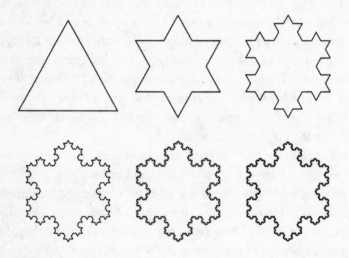

Allow this process to continue through a huge number of sproutings and we create something that doesn't appear to have a preferred scale. If we look at it under a magnifying glass we see the same structural pattern; increase the power of the magnifier and the pattern remains the same. It is "scale invariant."

Pollock's pictures were not created by applying a simple algorithm like the sprouting triangles. But Pollock intuitively sensed how to sprinkle paint on a canvas in an approximately scale-invariant statistical pattern through constant practice and

experience. As a result there is usually not a visually dominant underlying scale of structure in a Pollock painting and it looks equally good as a huge original on the gallery wall or as a small reproduction in the exhibition catalogue.

Pollock was notoriously reluctant to finish paintings and sign them off, preferring to tinker and overlap more structure which to the casual observer made no discernible difference. His eye was clearly very sensitive to the visual impact of the work when viewed at different distances and on a range of scales.

There is one alarming conclusion that I could draw from the discovery of the almost scale invariance of Pollock's pictures. If you own a big one then maybe the aesthetic impact would not be diminished (although your bank balance might be magnified) by cutting it into four quarters and selling three of them! Only kidding.

# 51

# Triquetra

Triangles are not the only things with three corners. Beautiful Celtic knotwork and many other manifestations of religious symbolism make use of a symmetrical three-cornered knot called the Triquetra. This was traditionally formed by the overlap of three almond shapes. Each almond was in turn created by two circles of the same radius that intersect in such a way that the center of each lies on the circumference of the other, as shown below:

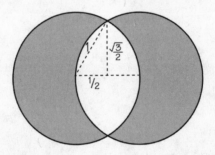

The almond-shaped intersection was also called the Vesica Piscis, which means "the bladder of a fish" in Latin. The fish was an early Christian symbol because the Greek world for fish (*ichthys*) was an acronym for the New Testament Greek words for *Jesus Christ, Son of God, Savior*. It can still be seen in wide use across the Christian world, not least on car bumper stickers, after it reemerged in the early 1970s as part of the countercultural movements in the USA and Europe. The fish also appeared in many pagan and

non-European traditions; this is not unexpected given its presence in the signs of the zodiac and the ancient plan of the constellations that were defined in the Mediterranean region by astronomers living between latitudes of 30 and 34 degrees North (presumably therefore in Babylonia) around the time of 500 BC.[1]

The Vesica Piscis has simple mathematical properties. If the two circles have radius 1 then the separation between their two centers is also 1. This is the width of the Vesica Piscis. To get the height we use Pythagoras' theorem around the right-angled triangle shown with dashed lines. The total vertical height between the two intersections of the circles is therefore $2 \times \sqrt{[(1)^2 - (\frac{1}{2})^2]}$ = $\sqrt{3}$. So, the ratio of the height to the width of the Vesica Piscis will always be equal to the square root of 3 regardless of the sizes of the two equal circles used.

The Triquetra is formed by three interlinked Vesica Piscis almonds that entwine with alternating over- and under-crossings to create what is known as a trefoil knot.

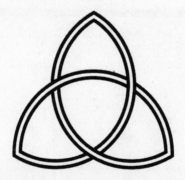

This knot can be found in many different Celtic objects, from the fabulous illuminated calligraphy of the *Book of Kells*, to works of thread, wood, stained glass, and iron. Its ubiquity within the bounds of the Holy Roman Empire arises because it served as a symbol of the Holy Trinity, three persons in one, united yet distinct. Sometimes it is still called the Trinity knot.

Mathematicians who study and classify knots according to their relative complexities know the trefoil as the simplest of all knots.[2] Two knots will be regarded as equivalent if one can be changed into the other by stretching (without cutting). The trefoil can be created by taking an open strip of ribbon which is turned over three times before the ends are stuck together. There is no way in which it can be unknotted to create a simple circle without cutting it. Incidentally, you might like to reflect upon the fact that if you look at it in a mirror you will see another distinct trefoil knot with the opposite handedness.

# 52

# Let It Snow, Let It Snow, Let It Snow

Snowflakes are some of Nature's most charming works of art. Many myths have grown up about them. In 1856, Henry Thoreau declared: "How full of the creative genius is the air in which these are generated! I should hardly admire more if real stars fell and lodged on my coat."[1] They are beautiful examples of the interplay of uniqueness and diversity. We have all heard it said that every snowflake is unique and each one possesses six identical arms. Alas, as we shall see, that is not true.

The first great scientist to be fascinated with explaining the snowflake's special symmetry was Johannes Kepler, the astronomer who between 1609 and 1619 discovered the laws governing the mathematical regularities in the orbits of planets in the solar system. He also made important contributions to mathematics, creating new types of regular polyhedra and formulating one of the great problems of mathematics (the "Kepler Sphere Packing Conjecture") about the best way to pack a collection of equal spherical balls in a crate so as to minimize the volume of empty space between them.[2]

In 1611, the same year that he made his famous packing conjecture, Kepler wrote a little book as a New Year's gift for his patron, the Holy Roman Emperor Rudolf II, entitled *On the Six-Cornered Snowflake*. He attempted, unsuccessfully (in retrospect) to explain why snowflakes have six arms, debating as to whether there was

an inevitable law of Nature that fixed this feature – whether it could have turned out otherwise but had been created in this six-armed form for some future purpose. "I do not believe," he wrote, "that in a snowflake this ordered pattern exists at random."[3]

Today, our knowledge is greater. Snowflakes are built up as water freezes around specks of airborne dust falling through the atmosphere. The six-armed pattern is inherited from the hexagonal symmetry that water molecules arrange themselves into, forming a lattice like a stack of six-sided tiles. This lattice structure is why ice is hard like a crystal. The snowflakes start to grow by accreting freezing moisture high in the atmosphere. The exact pattern that results will depend on the history of the flake as it falls to earth.

Atmospheric conditions of moisture, temperature, and pressure vary from place to place. As the snowflakes fall, each one experiences a different set of conditions for ice accretion and this is why they are all slightly different. In fact, if you look closely you will see that there are variations within a single snowflake. The arms are all slightly different and not quite symmetrical. This reflects the small differences in humidity and temperature of the fluctuating atmosphere across the snowflake. As the snowflake falls for longer, its arms will steadily grow by accretion and there will be more scope for microscopic diversity along the crenulations on the arm. There are so many molecules of water at the root of each growing snowflake pattern that in practice you would have to look at more than a thousand billion of them to have a good chance of finding two the same.

Our fascination with classic hexagonal snowflakes is interesting. They are by no means all like that but the beautiful six-sided examples that adorn Christmas cards and decorations also tend to be the ones most often photographed and displayed in books and magazines.[4] In fact, snowflakes come in about eighty distinct varieties determined by the temperature and humidity of the air in which they form. Snow is made artificially by snowblowers at winter sports sites by simply blowing fine droplets with compressed

air through a nozzle at high pressure. As they decompress, their temperature falls, and they freeze into rather uninteresting frozen water droplets with none of the arms and patterns of natural snowflakes. Likewise, when the moisture content of the air is low, natural flakes form with just rods or flat plates of ice and none of the elaboration, because of the lack of moisture to freeze into growing arms. As the temperature drops below about −20°C we also just see little columns or flat plates of ice without arms. This reveals why in some conditions it can be impossible to make snowballs. The snow will not bind together when the snowflake arms are missing. Rods and plates and columns of ice just roll past each other and don't stick together. This is why avalanche conditions change significantly with the properties of snow and the structure of the flakes.

# 53

# Some Perils of Pictures

One of the things that mathematics students are taught when they begin university courses is that you cannot prove something just by drawing a picture. Pictures help to show what might be true and how to set about proving it, but what they show might also be a special feature of the flat geometry of the picture itself. Unfortunately, there was a history to this view that goes back to 1935, when an influential group of French mathematicians determined to formalize all of mathematics and derive it from axioms in ways that emphasized the common structures to be found in superficially different areas.

Under their pseudonym of Bourbaki, the group's writings eschewed all use of pictures and none appeared in any of their publications. Emphasis was placed entirely upon logical rigor and general mathematical structures: individual problems and other types of "applied" mathematics were avoided. This approach helped clean up some messy parts of mathematics so as rigorously to display its common structures. It also led indirectly to an unfortunate influence on school mathematics education, leading to the so-called "New Math" curricula in many countries that introduced children to mathematical structures at the expense of understanding real-world applications and examples. Bourbaki and the New Math were thus extremely controversial in their different ways, although both seem long forgotten now. But Bourbaki's fear of proofs by picture has real substance. Let's look at an interesting example.

There is a theorem of mathematics, dating from 1912 and called Helly's theorem[1] after its formulator Eduard Helly, which proves (under much more general circumstances) that if we draw four circles[2] on a page, representing the sets A, B, C, and D respectively, then if the common three-fold intersections of A, B, and C, of B, C, and D, and of C, D, and A are each not empty, then the four-fold intersection of A, B, C, and D cannot be empty. This appears to be obvious when we look at the picture below. The intersection of A, B, C, and D is the central region with four curved sides.

This type of picture is familiar in the worlds of business and management where it might appear as a Venn diagram showing the intersection of various things like markets, product features, or geographical regions which are represented by the circles. However, when A, B, C, and D are collections of things ("sets") the conclusion of Helly's theorem about geometry does not necessarily hold. For example, if A, B, C, and D were related like the four faces of a pyramid (including the base), then any face intersects with three others but there is no place where all four faces intersect.

Another more human example would be provided by having four friends Alex, Bob, Chris, and Dave. There are four different subsets of three friends that can be formed: {Alex, Bob, and Chris},

{Alex, Bob, and Dave}, {Bob, Chris, and Dave}, {Chris, Dave, and Alex}. It is clear that any two of these subsets has a person in common, but there is no person who is common to all four subsets. You use the diagram showing the geometrical intersections of A, B, C, and D on a flat page to deduce properties of other relationships at your peril.

Understanding how such diagrams work is part of the quest to create effective forms of artificial intelligence that can recognize, manipulate, and devise pictures in unambiguous ways.[3]

# 54

# Drinking with Socrates

There is an old estimate of two very large numbers that leads to a conclusion that is always a surprise, even to aficionados of the surprises of probability. If you fill a glass with water from the sea how many of the molecules that make up the water in the glass would you expect to have been used by Socrates, or Aristotle, or his student Alexander the Great, to rinse his mouth? In fact, as you will see, the distinguished mouth we choose to rinse doesn't matter. You might think that the answer must be effectively zero. Surely there is no chance of us reusing even one of those distinguished men's atoms? Alas, you would be quite wrong. The total mass of water in the Earth's oceans is about $10^{18}$ metric tons, which is $10^{24}$ grams. A molecule of water[1] has a mass of about $3 \times 10^{-23}$ gm, so there are about $3 \times 10^{46}$ water molecules in the oceans. We can ignore the other components of sea water, like salts. We will see that these simplifications and the round numbers we are using are justified by the huge numbers involved.[2]

Next we ask how many molecules there are in a cup of water. A typical cupful has a mass of 250 gm and so contains approximately $8.3 \times 10^{24}$ molecules. Therefore, we see that the oceans contain approximately $(3 \times 10^{46})/(8.3 \times 10^{24}) = 3.6 \times 10^{21}$ cupfuls of water – far less than the number of molecules in a cupful of water. This means that if the oceans were completely mixed and we drew out a random cupful today then we could expect it to contain about $(8.3 \times 10^{24})/(3.6 \times 10^{21}) = 2300$ of the molecules

that Socrates used to rinse his mouth out with back in 400 BC. More striking still, each of us might expect to be made of a considerable number of the atoms and molecules that made up Socrates' body. Such is the enduring power of large numbers.

# 55

# Strange Formulae

Mathematics has become such a status symbol in some quarters that there is a rush to use it without thought as to its appropriateness. Just because you can use symbols to re-express a sentence does not necessarily add to our knowledge. Saying "Three Little Pigs" is more helpful than defining the set of all pigs, the set of all triplets, and the set of all little animals and taking the intersection common to all three overlapping sets. An interesting venture in this direction was first made by the Scottish philosopher Francis Hutcheson in 1725, and he became a successful professor of philosophy at Glasgow University on the strength of it. He wanted to compute the moral goodness of individual actions. We see here an echo of the impact of Newton's success in describing the physical world using mathematics. His methodology was something to copy and admire in all sorts of other domains. Hutcheson proposed a universal formula to evaluate the virtue, or degree of benevolence, of our actions:

Virtue = (Public Good ± Private Interest)/(Instinct to Do Good)

Hutcheson's formula for a "moral arithmetic" has a number of pleasing features. If two people have the same instinct to do good then the one who produces the largest public good at the expense of his or her private interest is the more virtuous. Similarly, if two people produce the same level of public good involving the same

level of private interest then the one of lesser natural ability is the more virtuous.

The third ingredient in Hutcheson's formula, Private Interest, can contribute positively or negatively (±). If a person's action benefits the public but harms him- or herself (for example, doing charitable work for no pay instead of taking paid employment), then Virtue is boosted to Public Good + Private Interest. But if those actions help the public and also the perpetrator (for example, campaigning to stop an unsightly planning development that blights the person's own property as well as that of neighbors) then the Virtue of that action is diminished by the factor of Public Good − Private Interest.

Hutcheson didn't attribute numerical values to the quantities in his formula but was prepared to adopt them if needed. The moral formula doesn't really help because it reveals nothing new. All the information it contains has been plugged in to create it in the first place. Any attempt to calibrate the units of Virtue, Self-Interest, and Natural Ability would be entirely subjective and no measurable prediction could ever be made. Nonetheless, the formula is handy shorthand for a lot of words.

Something strangely reminiscent of Hutcheson's flight of rationalistic fantasy appeared 200 years later in a fascinating project completed in 1933 by the famous American mathematician George Birkhoff, who was fascinated by the problem of quantifying aesthetic appreciation. He devoted a long period of his career to the search for a way of quantifying what appeals to us in music, art, and design. His studies gathered examples from many cultures and still make fascinating reading. Remarkably, he boils it all down to a single formula that reminds me of Hutcheson's. He believed that aesthetic quality is determined by a measure that is determined by the ratio of order to complexity:

$$\text{Aesthetic Measure} = \text{Order}/\text{Complexity}$$

He sets about devising ways to assign numbers to the Order and Complexity of particular patterns and shapes in an objective way and applies them to all sorts of vase shapes, tiling patterns, friezes, and designs. Of course, as in any aesthetic evaluation, it does not make sense to compare vases with paintings: you have to stay within a particular medium and form for this to make any sense. In the case of polygonal shapes, Birkhoff's measure of Order adds up scores for the presence or absence of four different symmetries, and subtracts a penalty (of 1 or 2) for certain unsatisfactory ingredients (for example, if the distances between vertices are too small, or the interior angles too close to 0 or 180 degrees, or there is a lack of symmetry). The result is a number that can never exceed 7. The Complexity is defined to be the number of straight lines that contain at least one side of the polygon. So, for a square it is 4, but for a Roman Cross it is 8 (4 horizontals plus 4 verticals):

Birkhoff's formula has the merit of using real numbers to score the aesthetic elements, but unfortunately aesthetic complexity is too diverse for such a simple formula to encompass. Like Hutcheson's cruder attempt, it also fails to create a measure that

many would agree on. If one applies his formula to modern fractal patterns that appeal to so many (not just mathematicians) with their repeating patterns on smaller and smaller scales (see Chapters 58 and 94, for example) then their order can score no more than 7 but their complexity becomes larger and larger as the pattern explores smaller and smaller scales and its Aesthetic Measure tends rapidly to zero.

# 56

# Stylometry: Mathematics Rules the Waves

There are many actors in the world of art appreciation, evaluation, and authentication. Art historians know the symbolism and detailed signature of an artist's brush strokes. Restorers know the nature of the paints and pigments, and the surface material on which they were laid down. They can often frame them in time and confirm their historical integrity. Mathematicians have now joined these traditional experts to add a third approach to the challenge of distinguishing real from fake.

We have already seen in Chapter 5 how patterns in sound can be described and reproduced to high accuracy by modeling them as collections of sine waves of different frequencies. Although this old method of Joseph Fourier, first introduced in 1807, is usually very effective, it does have its limitations and can give a poor fit to signals that rise or fall very sharply in places. It can also require a very large number of waves to be added together to get a good description of a signal and this can be computationally rather expensive.

Mathematicians have responded by developing an analogous, more powerful modern method for analyzing patterns by adding families of different types of waves (called "wavelets") together. Unlike the Fourier method, these wavelets allow more individual variation than is possible just by adding sine and cosine waves of different frequencies. They allow for extra variations in amplitude

and time to create more detailed descriptions of abruptly changing signals that require fewer wavelets to be combined and so are computationally quicker and cheaper to use.

In recent years there have been several promising applications of wavelet analysis to the study of paintings with a view to capturing an artist's style mathematically, so that doubtful works can be more reliably authenticated. Considerable attention was focused on this approach when the Dutch TV program *NOVA* issued a challenge to the participants at a 2005 conference in Amsterdam devoted to Image Processing for Art Investigation. The challenge was to distinguish a real Van Gogh painting from five other copies of Van Gogh originals created by the specialist art restorer and reconstructionist Charlotte Caspers.[1] All three different teams, using wavelet analysis of the pictures, correctly identified the copies.

The strategy adopted by each of them focused upon the fact that the investigators expected an original to be painted with a faster sequence of rapid brushstrokes than a copy. The copyist would concentrate hard on getting the reproduction exactly right, using the same number of brushstrokes as the original artist in areas of special detail and exactly the right pigments and paint thicknesses. This is a much slower process than painting the original. Further challenges followed, with mathematicians trying to pick out forgeries from original works by other famous artists. Most interesting was a challenge from Caspers to distinguish her own finely detailed original paintings of birds from her own copies of those works. This revealed that sometimes the simple idea of looking for fluency in the brushwork didn't succeed in distinguishing copies when particular types of brush were employed, or when the resolution of the scan used for analysis was not high enough. All these discoveries presented new variables to get under control.

This Van Gogh challenge led to a productive ongoing collaboration between art experts like Caspers and the wavelet

community of mathematicians. What they began with in practice was a very high resolution scan of a painting. Then, they produced a wavelet description of the patterns and colors present in the picture down to a very small scale. In effect, this is a numerical representation of all the fine-grained information – what colors neighbor other colors, what changes in texture and color occur, what clusters and patterns of attributes are present, and so forth, repeated over very many variables. The result is like a digitized multidimensional fingerprint of the picture down to the scale on which the artist applied single paintbrush hairs of paint. A map is produced of the artist's movements and construction processes that can reveal repeatedly used individual patterns and offer help in identifying the artist's style. By studying the originals, and copies made by the same artist, a far more powerful analysis is possible to distinguish differences between the processes of producing original and copied work. It also highlights effects of great subtlety, like the texture of the brushes being used at different points in the artwork, or how a skilled copyist tries to capture the overall atmosphere of the painting, rather than merely reproducing the fine-scale detail.

Another interesting application of this type of detailed small-scale analysis of an artist's style is to the problem of reconstructing original works that have been damaged or degraded by the ravages of time. It helps produce the most sympathetic repair by providing an idea of what a faded or damaged original might have looked like – or even what a current version of a work like Leonardo's *Last Supper* is going to look like as it degrades in the future.

This type of analysis complements the insights of the art historian and the restorer. It gives a new reproducible way of classifying aspects of an artist's style in very fine detail, aspects of which even the artist might be unaware. The mathematics makes intensive use of fast computers to produce increasingly fine representations of what human artists are doing. Maybe one day they will even be used to create particular styles of artistic work.

# 57

# Getting It Together

If you are addressing an audience seated at desks in a lecture theater then there is a striking demonstration that you can perform with their help. Just ask them to keep randomly tapping their fingers on the tabletops in front of them. For a few seconds there is no coherent overall sound pattern at all, just a cacophony of independent random tappings. Within about ten seconds this situation changes quite dramatically. The separate tappings tend to become synchronized and almost everyone seems to be tapping in time. The same phenomenon can often be detected when members of an audience clap their hands. A random collection of different claps tends to become "locked" into a synchronized pattern.

This type of sound synchronization can be seen in other situations as well, visual as well as aural. Large numbers of fireflies in one small area will tend to flash in sync, but out of phase with the synchronized flashing of another separate band of fireflies some distance away.

As a third example, we notice that when many people walk across a bridge or stand on a boat that is rocking slightly from side to side, they will all end up swaying in unison. This can have disastrous effects in a small boat or on a moving bridge (like the first version of the Millennium Bridge in London) if the swaying is not adequately damped down by weights or ballast.

What is going on in these examples? The individual tappers and flashers are surely independent. No one is tutoring them to

tap in time. They seem to be completely independent of everyone except their immediate neighbors. And even if they concentrate on their neighbors it is hard to keep up a copycat strategy without losing their rhythm.

In all of these examples there are lots of periodic events occurring (tapping fingers or flashing flies or swaying pedestrians). They are what mathematicians call "oscillators." But despite what you might have thought, they are not totally independent of one another. Each person tapping his or her finger hears the average results of all the other people in the audience around them tapping their fingers. The frequency and timing of the individual's own finger-tapping responds to this average sound of many fingers. Everyone hears the same average background noise of all the fingers tapping and so their own pattern is that of an oscillator driven by the same average of all the other oscillators. If it is strong enough, this drives all the tapping fingers to quickly follow the same pattern and all the fireflies to flash in unison.[1] In any seemingly spontaneous reaction to a show or concert you can often detect this collective response to the average sound producing a spontaneous ordering of the audience's response.

In practice, the speed and degree of synchronization depends on the strength of any participants' link (and hence, response) to the average signal. If it is reasonably strong and the clapping frequency is slow then the spectrum of clapping sound frequencies will be quite narrow and everyone will become synchronized. This is particularly noticeable with slow handclapping. However, if the audience starts to applaud more enthusiastically, and each member doubles the frequency of his or her applauding so as to up the noise level, then the spectrum of clapping sound frequencies broadens and synchronization becomes impossible.[2] Such is the sound of many hands clapping.

# 58

# When Time Has to Reckon with Space

Human creativity has a habit of filling in every gap that is left for it to exploit. One of the useful things about trying to classify human artistic exploration is that the classification can reveal if there are any gaps that could be filled. Here is a very simple way of classifying what we do. We work in space, S, and time, T. In space we can create things in a range of dimensions – one, two, or three. Let's label this $S^N$, where $N = 1$, 2, or 3 according as we work in a line, S, an area, $S \times S$, or a volume, $S \times S \times S$. When we think about spatial exploitation we have three possible dimensions to choose from. Here are the simplest static art forms that can then be characterized:

| Space dimension $S^N$ | Art form |
|---|---|
| $N = 1$ | frieze |
| $N = 2$ | painting |
| $N = 3$ | sculpture |

Now, if we use time and space together, we can expand our repertoire to include more complex activities. Here is one example of each:

| Space dimension $S^N \times T$ | Art form |
|---|---|
| N = 1 | music |
| N = 2 | film |
| N = 3 | theater |

Notice that all the possibilities are populated and even within this scheme there is scope for unusual subdevelopments and complex substructure because theater can contain film and music. Time need not be linear and periodicity in music is a common pattern-forming device. In the cinema or theater, this nonlinearity is a more adventurous avenue to follow because it leads to time travel, first introduced into literature by H. G. Wells in 1895. In art, the dimensionality of space can be generalized to fractional values in a way that mathematicians also found out about and classified. A straight line has one dimension, but if we draw an intricately wiggly line then it can cover a whole area. The complicated wiggly line almost covers the whole area even though it only has one (N = 1) geometrical dimension.

It is possible to classify the "busy-ness" of the line by giving it a new type of dimension, called the fractal dimension. It can lie between 1, for the simple straight line, and 2, for the completely filled area. But in between, a curve with fractal dimension 1.8 would be more intricate and space filling than one with fractal dimension 1.2. Likewise a complicated folded or crenulated surface area can substantially fill a whole geometric volume and we can give it a fractal dimension that lies between 2, that of a geometric area, and 3 for a geometric volume.

Fractal geometry was pioneered by mathematicians like the Swede Helge Koch in 1904, but it only became famous when it was taken up by Benoit Mandelbrot in the early 1970s. He also invented the word "fractal." Aided by the huge computational capabilities of his employers, IBM in Yorktown Heights, Mandelbrot

was able to explore the intricacy of many fractal curves and make some dramatic discoveries about their structure. This type of fractal structure can be envisaged in the other artistic genres that populate the space part of our classification with finely divided intervals or duration, divided stages and fine-scale structure in sculpture packing in more layers of meaning. Even time can be fractionalized to create stories which have divergent points so that a different choice can be taken by the reader each time he or she reads the book and a different story results.

# 59

# How to Watch TV

If you have bought a new TV recently you might have been surprised by the picture size. The screen on your expensive new high-definition (HD) television was advertised as being the same size as on your old antique set. But when you got it home that wasn't quite true, was it? So what went wrong?

TV screen sizes are defined by a single measurement: the length of the diagonal from the bottom corner to the opposite top corner of the rectangular screen. However, this is not the whole story. Your antiquated TV and your new HDTV may have the same screen "size" defined by a diagonal of length 38" listed in the catalogue. But the screens are different shapes. The picture screen on your old set would be 19.2" high and 25.6" wide, so the picture area is 19.2" $\times$ 25.6" = 491.52 sq. inches. Pythagoras' theorem around the triangle confirms (to our one decimal place accuracy) that the square of the width plus the square of the height equals the square of the diagonal (38") size. Unfortunately your new set's screen will be wider, at 28", but less high at 15.7". Again, recalling what we said back in Chapter 3, Pythagoras confirms that the square of the width plus the square of the height equals the square of the diagonal size, just as before. But now the area of the wider screen is only 28" $\times$ 15.7" = 439.60 sq. inches. This is 100(491.52 − 439.60)/439.60 = 11 percent smaller!

This is doubly bad news. Not only does screen area determine the amount of picture being beamed at you but it also determines the cost to the manufacturer who gives you less at a greater profit

margin because there are fewer pixels in the screen area. To keep the same screen area you need to replace your old TV with a new HDTV that has a diagonal screen size bigger by a factor of the square root of 1.11, which is 1.054. If my old TV was a 32" this means I will need a new $32 \times 1.054 = 33.73$" or a 34" model.

It gets worse if you watch a lot of old movies, because they have a different picture size. You will notice when one comes on that two unused bands appear down each side of the new TV screen. Instead of filling the 28" width of your HD screen with its 32" diagonal, it will just cover the middle 21" of the screen. The height will still be 15.7" but the filled screen area is now only $21 \times 15.7 = 329.7$ sq. inches and your picture is now 33 percent smaller than it was on your old TV. If your old set was 34" you would need a 42" HD screen for old films to look the same height on screen. Things are indeed not always as they appear.

# 60

# Curvaceous Vase Profiles

One of the most admired symmetrical art forms is the vase. Rendered in porcelain and exquisitely painted, this art form reached its high point in ancient China, but is found in similar forms and different materials throughout the world. Vases are functional but they are also ornamental and the aesthetic appeal is the shape of their profiles. Traditional designs without handles are symmetrical in shape as one spins them around on a potter's wheel. What are the geometrical features of the two-dimensional profile of the vase that most appeal to the eye?

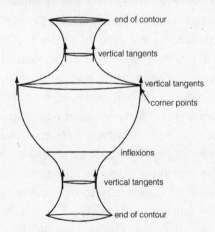

We assume that a lateral (right ↔ left) symmetry exists about a central vertical line. There will always be a circular top and a circular base and sides that can have parts with different curvatures.

A simple goldfish bowl has just positively curved, or outward bulging, sides that extend from the top lip to the circular base. A more complicated design could start curving inward from a broad top, in a concave shape, passing through a minimum size below the neck before curving outward to reach a maximum radius and then curving inward in a convex shape down to a minimum radius again before curving outward once more down to the base. This undulating shape has a number of visually arresting points where the curvature of the profile changes. A tangent to the curvature of the vase's surface would be vertical at the minimum and maximum radii. The tangents can change direction very abruptly at the corners where the vase is widest. There are also places where the curvature changes smoothly from positive to negative. These points of "inflexion," as they are called, are visually very impressive. They can be smooth and extended or more abrupt. The more wiggles there are in the profile the more inflexion points there will be.

In 1933 the American mathematician George Birkhoff tried to devise a simple scoring system to grade aesthetic appeal, called "Aesthetic Measure," which we mentioned in Chapter 55. Birkhoff's Measure was defined as the ratio of Order to Complexity. His rough intuition was that we like ordered patterns but if the complexity associated with them becomes too great then our appreciation is reduced. As a general gauge of aesthetic impact Birkhoff's measure is rather naive and at odds with our liking for particular types of complex structure in Nature, like leafless trees in winter and landscapes. However, for a simple, well-controlled family of similar creations it might be instructive. For vase shapes, Birkhoff defined their Complexity to be equal to the number of points where the tangent to the profile is vertical, and has inflexions, corners, or end points. The measure of the Order is more involved, and again he defined it to be the sum of four factors. These count the number of horizontal and vertical distance relations that are in the ratio 1:1 or 2:2, plus the number of different

parallel and perpendicular relations between tangents. While one can numerically score different vases and even design new shapes that score highly on Aesthetic Measure, its merit is that it makes one think carefully about what is most aesthetically impressive about a vase profile.

# 61

# All the Wallpapers in the Universe

We have seen in Chapter 30 that the number of basic designs that can be adopted for a frieze is just seven. This refers to the basic symmetry pattern of the frieze. Of course, they can be manifested in an unlimited number of color variants and shapes. This magnificent seven is an unexpectedly small family of possibilities and it reflects the limited freedom of action for a one-dimensional periodic pattern. When we move to periodic patterns in two dimensions the number of options increases to seventeen, a discovery that was first made by the Russian mathematician and crystallographer Evgraf Fedorov in 1891. This set of options is known as the collection of "wallpaper" patterns because it classifies the only basic combinations of symmetries available for a symmetrical wallpaper design on a plane surface. Again, as with the frieze patterns, these basic symmetries can be represented in an unlimited number of different colors and motifs, but no one is going to discover a new type of wallpaper pattern.

The seventeen patterns are classified by asking for the smallest rotation (60, 90, 120, 180, or 360 degrees) that leaves the pattern the same. Next, ask if there is a reflection symmetry; then ask if there is a glide reflection either in the reflection axis (if there is one), or in another axis. The other questions that exhaust the possibilities are whether there are reflections in two directions, whether there are reflections in lines that intersect at 45 degrees,

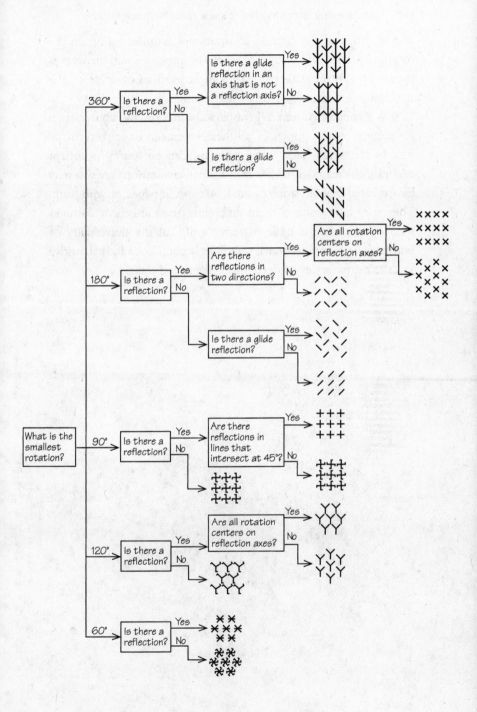

and whether all the centers of rotational symmetries lie on the rotation axes. A flow diagram of these questions and answers is shown on the previous page, flowing toward an example of the seventeen different possibilities that it unfolds.

It is a tribute to human geometrical intuition and appreciation for pattern that examples of all these seventeen basic patterns, as well as the seven basic frieze patterns, can be found in ancient decorations created by a variety of human civilizations.[1] Artists may have created them in stone or sand, on cloth or paper, or with paint. They may have colored them differently, used angels or demons, stars or faces as the basic pattern motif, but the universality of human pattern appreciation is surprisingly ubiquitous and exhaustive in its quest for styles of decoration. We found them all.

# 62

# The Art of War

Sun Tzu's great Chinese manual of military strategy was written in the sixth century BC. Its thirteen chapters, each devoted to a different aspect of warfare, have influenced military commanders ever since and *The Art of War* is supposedly required reading for both CIA and KGB intelligence officers, as well as negotiators, business executives, and a variety of sports team coaches. It gathers together all the ancient strategic wisdom and tradition of a great military power.[1]

Surprisingly, we don't find a similar modern professional manual that moves on to provide a quantitative analysis of military strategy. It was not until a talented Victorian engineer called Frederick Lanchester began to develop the mathematical study of the most efficient way to carry out sequences of interlinked tasks – what eventually became known as "operations research" – that mathematical insights entered the theater of war. Lanchester, incidentally, also found time to build the first petrol-fueled car and invent power-steering and disc brakes.

In 1916, midway through the First World War, Lanchester devised some simple mathematical equations to describe conflicts between two armies. Despite their simplicity they revealed some surprising facts about warfare which continue to inform military strategists today. In retrospect, some of the revelations had been appreciated intuitively by great strategists of the past like Nelson and Wellington. They should also dictate some of the design principles inherent in creating war games that still seem to endure as board games and their computer counterparts.

Lanchester provided a simple mathematical description of a battle between two forces, which we will call the Goodies (who have G fighting units) and the Baddies (who have B fighting units). Start measuring time, t, from when they start fighting at zero hour when t = 0. We want to know how the numbers of units G(t) and B(t) change as time passes and the fighting proceeds. These units can be soldiers, tanks, or guns, for example. Lanchester assumed that each of the G (or B) fighting units destroyed g (or b) of the enemy's units: so g and b measure the effectiveness of each force's units. The rate of depletion of each side's units is assumed to be proportional to the number of opposing units and their effectiveness. This means that:

$$dB/dt = -gG \text{ and } dG/dt = -bB$$

If we divide one of these equations by the other we can easily integrate them[2] to obtain the following important relation:

$$bB^2 - gG^2 = C$$

where C is a constant quantity.

This simple formula is very revealing. It shows that the overall fighting strength of each side is proportional to the square of the number of units they possess but depends only linearly on their effectivenesses. You would need to quadruple the effectiveness of each soldier or piece of equipment in order to make up for the opposition having twice as many units. Bigger armies are better. Likewise, a strategy of dividing your opponents' forces into smaller groups, and stopping allied forces joining up to create a single opposing force, are important tactics. This was what Nelson did at the Battle of Trafalgar and in other engagements against the French and the Spanish navies. More recently, the 2003 Iraq War policy of the American defense secretary, Donald Rumsfeld, was puzzling. Instead of using large invasion forces he used small

groups of heavily armed forces (small G, large g) which could be defeated by bigger B even with smaller b.

Lanchester's square law reflects the fact that in modern warfare one fighting unit can kill many opponents and be attacked from many sides at once. If hand-to-hand fighting occurred with each soldier engaging with only one opponent then the final result of the battle would depend on the difference of bB and gG, not the difference between $bB^2$ and $gG^2$. If the hand-to-hand fighting was a melee in which all the fighting forces could engage with all of the opposing numbers then the square rule would apply. If you are outnumbered you should avoid this!

If we look at Lanchester's formula again we see that at the outset of the battle we can use the numbers b, B, g, and G to calculate the constant C. It is just a number. If it is positive then $bB^2$ must be bigger than $gG^2$ at all times and is never possible for B to fall to zero. At the end of the battle, if the units are equally effective (b = g), the number surviving is the square root of the difference between the squares of the number of units on each side, so if G = 5 and B = 4 then there will be three survivors.

There are many much more sophisticated variations of Lanchester's simple models.[3] One can mix forces of different effectiveness, include support units to supply the main fighters, introduce random factors that alter the interactions between forces,[4] or include fatigue and attrition by allowing the effectiveness factors b and g to diminish with time. However, all begin from Lanchester's simple insights. They tell us interesting things, some of which Sun Tzu would have appreciated, but they open the door for increasingly sophisticated modeling. See if it works when you play soldiers or computer games with your children or grandchildren. If you design games then these rules will help create well-balanced opposing forces, because you will recognize how and why it is that numbers alone are not the deciding factor in a war game.

# 63

# Shattering Wineglasses

One part of musical folklore is the singer who can shatter wineglasses, chandeliers, or even windows, by hitting a powerful high note. I have never seen this done by a singer (as opposed to a directed beam of ultrasound in the physics lab[1]) and although there are video clips of demonstrations[2] available on the Web some of the staged demonstrations seem to be treated with suspicion by experts. Why and how is it even a possibility?

The rim of a wineglass can be made to oscillate by being tapped. Some parts of the rim move inward while others move outward and in between them there is always a point that doesn't move. These movements push the air to create a sound wave, and the "ring" of the glass is easy to hear. If your wineglasses are made of thick glass then they can be rung like this without danger of breaking because the glass won't move much. When the glass is very thin, or contains a crack, setting up a strong oscillation in the glass around the rim can break it. The oscillations of the rim of the wineglass will have a natural frequency at which they want to oscillate when the rim is slightly disturbed. If a singer can create a sound wave with this particular frequency then it can resonate with the glass rim and produce an amplified oscillation that stretches the glass so much that it breaks.

In order for this to happen the wineglass needs to be made of thin glass (a few faults help too). The singer needs to generate very high volume to push the air molecules hard against the glass and hold the note on the required frequency for two or three

seconds so as to maintain the resonance. A professional singer ought to be able to tune her voice to the required frequency by striking the glass as if it were a tuning fork. This reveals the resonant frequency. Now she has to generate the sound intensity needed to create an oscillation with shattering amplitude and keep the frequency very sharply defined for a few seconds. A little more than 100 decibels might be enough to break a piece of fine crystal. Opera singers train for many years to generate and sustain that level of sound, which is about twice our normal speaking volume. Hitting this frequency with the required volume intensity is fortunately not an easy thing to do, inadvertently or deliberately, and it is a very rare occurrence – outside most people's experience. However, if the voice is very greatly amplified then the intensity alone would be sufficient to break the glass without the need to find the resonant frequency for amplification. Over forty years ago, an American TV commercial showed Ella Fitzgerald using her voice to break glasses with ease – but was her voice greatly amplified through the speakers? In practice, it is the presence of flaws in a glass that offer the best chance of breaking it without amplification. American voice coach Jamie Vendera did a controlled demonstration on the Discovery Channel's *Mythbusters* television show in 2005. He needed to try twelve glasses before he found one that he could shatter. Perhaps wineglasses were just thinner and contained more tiny flaws in the great Caruso's day.

# 64

# Let the Light Shine In

Windows, especially ornamental ones in old buildings, come in a variety of shapes and orientations. The amount of light that a window allows into a building is just proportional to its surface area of transparent glass if we ignore any form of blind, tinting, or curtaining. Suppose that the bounding shape for your cathedral window is a square, with each side of length S, then the amount of light coming through will be determined by its transparent area $S^2$. If you now think that the interior is too bright and want to reduce the amount of light to a half of its present level without introducing any unsightly blinds or curtains, what should you do? The most elegant solution to the problem is to use a square window in the same S x S wall space but rotated by 45 degrees into a diamond orientation. It will be smaller.

The side of the new diamond window, L, is given by Pythagoras' theorem, since:

$$L^2 = (\tfrac{1}{2} S)^2 + (\tfrac{1}{2} S)^2 = \tfrac{1}{2} S^2$$

This gives L = 0.71S. The original window glass area was $S^2$ but the new diamond window area is $L^2 = \tfrac{1}{2} S^2$. Neatly, we see that it is always half as much, regardless of the size of the square.

If we had to work with a rectangular window opening, the same nice property remains. Change the horizontal side of the square to length T, with the other still equal to S. Then the area of the rectangular window is ST. Create a symmetrically placed diamond window in the same space. The area of the diamond is just ST minus the areas of the four triangles in the corners. Each of them has base length ½ T and height ½ S, so the area of the four is $4 \times \tfrac{1}{2} \times \tfrac{1}{2} T \times \tfrac{1}{2} S = \tfrac{1}{2} ST$. Again, the area of the diamond is exactly half the area of the original rectangle. It isn't only relevant for windows either: make a square or rectangular cake in the diamond configuration and you will only need half the amount of cake mixture as in the configuration that fills the cake board.

# 65

# Special Triangles

We have seen that there are a variety of special ratios, like the golden mean, that have traditionally exerted an important influence on designers, architects, and artists throughout history. There is a conceptually simpler special shape that is equally appealing as an atom of design because of its natural invitation to continue producing a hierarchy of similar copies of itself. The basic motif is an isosceles triangle with its two base angles equal to 72 degrees, so that the angle at the apex is 180 − (2 × 72) = 36 degrees. Let's call this situation the "Special" triangle. Since the apex angle of a Special triangle is one half of the base angles we can create two new Special triangles by bisecting the two base angles (with a solid and a dotted line as shown below). The two new Special triangles have their apexes in the base corners of the original. Because they were constructed by bisecting the base angles of the original special triangle their apex angles will be ½ × 72 = 36 degrees, as required for a special triangle.

This process can be continued as many times as you wish, creating two more Special triangles from each of the two we have just made by bisecting their base angles. The result is a tower of zigzagging Special triangles, as shown below. Each is smaller than its predecessor.

Sometimes our Special triangle is called the "Golden" (or

"Sublime") triangle – although this term now seems to be used to describe tourist, or commercial, networks with three focal points. There is good reason for the mathematical gilding. Since the base angles of our Special triangle are equal to 36 degrees, the ratio of the long side of the triangle, S, to the length of the base, B, is equal to the golden ratio[1]:

$$S/B = \tfrac{1}{2}\,(1+\sqrt{5})$$

Hence, our Special triangle is a "golden" triangle.

# 66

# Gnomons Are Golden

Our look at the special golden triangle leads us to introduce a closely related isosceles triangle for which the ratio of the lengths of the two shorter, equal sides to the length of the third, longer side is the reciprocal of the golden ratio, g, and so is equal to $1/g = 2/(1 + \sqrt{5})$. This is a flatter isosceles triangle in which the apex angle is greater than 90 degrees. It is known as the "golden gnomon." The triangle is the only one whose angles are in the ratios 1:1:3 and the two base angles are each equal to 36 degrees, the same as the apex angle of the Special "golden" triangle of Chapter 65, while the apex angle is 108 degrees. In the figure below, we show a golden gnomon AXC adjacent to a golden triangle XCB, with the lengths of the sides labelled in terms of the golden ratio $g = \frac{1}{2} (1 + \sqrt{5})$.[1] The two base angles of the triangle AXC and the apex angle of the golden triangle XCB are all equal to 36 degrees.

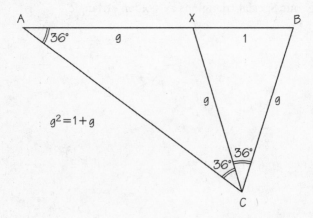

From this picture we can easily see that a golden triangle ABC can always be divided into a smaller golden triangle XCB and a golden gnomon AXC whose pairs of equal sides have the same length (g in the figure). These two triangles have been used as the basic ingredients in the creation of fascinating nonperiodic designs, like the famous Penrose tiling. The golden triangle is used to make the "kite" and two golden gnomons are used to make the "dart" in Roger Penrose's never-ending tiling of a plane surface by a jigsaw of interlocking kites and darts. Although he and Robert Ammann discovered this independently in 1974,[2] it also appears to have been used by Islamic artists in the fifteenth century[3] as part of their aesthetic quest for intricate space-filling tiling patterns.

# 67

# The Upside-down World of Scott Kim

We know that there are some letters, like O and H, and some numerals, like 8, that look the same when they are inverted. This means that you can string together sequences of these symbols to produce a word like OXO that will look the same upside down. A greater challenge is to carry out a different type of inversion, for example writing something back to front as a palindromic phrase (like "never odd or even"), that is identical, or at least still retains meaning. Mozart wrote musical pieces with a score that could be inverted or played back to front and still form a pleasing musical piece. In the world of graphic design Scott Kim is famous for creating scripts which, while not invariant under inversion, retain or even enhance their meaning by a form of reflective reinforcement. Douglas Hofstadter gave these figures the name "ambigrams." The late science fiction writer Isaac Asimov once described Kim as the "Escher-of-the-Alphabet" because of his unexpected use of shape and inversion. A collection of Kim's work can be found in his book *Inversions*.[1] Here is one of his classic inversions, created in 1989 (turn the page upside down to appreciate it fully):

# 68

# How Many Words Did Shakespeare Know?

The production of books and newspapers has always been bedeviled by the gremlin of typographical errors. Even in the age of automatic spelling checkers, typos are always present. Indeed, sometimes those automatic spell-checks just introduce different types of spelling error. How do you estimate how many errors there are in an article?

A simple estimate can be made if you set two proofreaders to work independently and then compare their findings. Suppose the first reader finds A mistakes and the second reader finds B mistakes, of which C were also found by the first reader. Clearly, if C is very small you tend to think that they are not very observant proofreaders, but if C is large then they are both eagle-eyed and there is a smaller likelihood that there are lots more mistakes that neither of them found. Remarkably, by just knowing the three numbers denoted by A, B, and C, we can get a good estimate of how many unfound errors still remain in the proof pages. Suppose the total number of mistakes is M, then the number still to be found after the two proofreaders have looked independently is $M - A - B + C$, where the $+C$ is added to avoid double-counting the ones that they both found. Now suppose the probability that the two readers find a mistake is a and b, respectively. This means that statistically $A = aM$ and $B = bM$, but because they search independently it also means that the probability that they both

find a mistake is simply obtained by multiplying the individual probabilities together, so that C = abM. These three formulae can be combined to eliminate the a and b factors, which we don't know, because $AB = abM^2 = C/M \times M^2$, and so our estimate of the total number of errors in the proofs is M = AB/C. Thus the total number of errors that neither of the two proofreaders have yet found is likely to be:

$$M - A - B + C = (AB/C) - A - B + C = (A - C)(B - C)/C$$

The number of mistakes still to be found is therefore just the number only found by the first reader times the number only found by the second, divided by the number they both found. This matches our intuition. If C is small when A and B are large then both readers are missing a lot of mistakes and there are likely to be many more that neither of them found.

This simple example shows how the independence of the two readers is a very powerful assumption. It enables the effectivenesses, a and b, of the two proofreaders to be removed from the calculation. It can be used to attack other problems where different amounts of information are available. For example, there might be more than two readers, or one might assume a reasonable probability formula for the likelihood that they find a certain number of mistakes and use their actual performances to pin down the formula describing each reader in more detail. Statisticians have also shown how this whole approach can be applied to other interesting sampling problems, like determining how many species of birds there are from lots of independent surveys by members of the public who count how many different types of bird they see in their garden over a specified period.

A particularly intriguing application has been to estimate how many words Shakespeare knew by examining the words used in each of his plays. In this case we are interested in the number of words that are unique to one play, or just used only in two, or

three, or four plays, etc. We also want to know how many words are used in all the plays. These quantities are the counterparts and extensions of the A, B, and C of our simple proofreading example. Again, it is possible to estimate the total number of words that Shakespeare could draw upon when writing his plays without needing to know the probabilities that he used particular words. Of course, he was especially adept at inventing telling new words, many of which, like "dwindle," "critical," "frugal," and "vast," are mainstays of everyday usage today. It is claimed that the text of *Hamlet* alone introduced 600 new words to its audiences. The philologists who counted all the words in Shakespeare's works for his concordance tell us that he used 31,534 different words and a grand total of 884,647 words, including repetitions. Of these, 14,376 are used once, 4,343 are used twice, 2,292 are used three times, 1,463 are used four times, 1,043 are used five times, 837 are used six times, 638 are used seven times, 519 are used eight times, 430 are used nine times, and 364 are used ten times. This information can be used to estimate how many new words should appear if we found new samples of Shakespeare's works of the same length as the total already known. Doing this over and over again leads to an estimate that converges toward about 35,000 as the best estimate for the number of words that Shakespeare knew but didn't use in his writings. If we add this to the total of 31,534 different words known to be used in his works then the best estimate for his total working vocabulary is 66,534.

Some years after these word-frequency analyses were first done by Efron and Thisted in 1976,[1] a new Shakespeare sonnet was discovered. It contained 429 words and offered the interesting possibility to use the analyses of the known works to predict how many words should appear in the sonnet that did not appear in all his other works, or just appeared once or twice there. Using the analysis of word frequencies from the complete earlier works it was predicted that there should be about seven words in the sonnet that appeared nowhere else (in fact there were nine), about

four words that appeared only once elsewhere (there were seven), and about three words that appeared twice elsewhere (there were five).[2] The accuracy of these predictions is quite good and confirms that the underlying statistical model of Shakespeare's word use is a sound one. The same approach could be used to study other authors, or to investigate cases of disputed authorship. The longer the text, the bigger the sample of words and the more convincing the results.

# 69

# The Strange and Wonderful Law of First Digits

One of the most striking pieces of simple mathematics is a rule known as Benford's law, after the American engineer Frank Benford who wrote about it[1] in 1938, although it was first pointed out by the American astronomer Simon Newcomb[2] in 1881. What they had both noticed was that very many collections of numbers, apparently assembled at random, like areas of lakes, baseball scores, powers of two, numbers in magazines, positions of stars, price lists, physical constants, or accountancy entries, had first digits that followed a very particular probability distribution to good accuracy regardless of the units that were used to measure them.[3]

How odd; you might have expected the digits 1, 2, 3 . . . 9 to be equally likely to appear first, each with a probability approximately equal to 0.11 (so that the nine probabilities sum to 1 to good accuracy). But Newcomb and Benford found that the first digits, d, in a good-sized sample tended to follow another simple frequency law[4] (if there are decimal points in the numbers then just take the first digit after the decimal point in each case, so 1 is the first digit in 3.1348):

$$P(d) = \log_{10}[1 + 1/d], \text{ for } d = 1, 2, 3 \ldots 9$$

This rule predicts the probabilities for P(1) = 0.30, P(2) = 0.18, P(3) = 0.12, P(4) = 0.10, P(5) = 0.08, P(6) = 0.07, P(7) = 0.06, P(8) = 0.05, P(9) = 0.05. The digit 1 is the most likely to occur, with a frequency

0.30, that is far in excess of the equally likely expectation of 0.11. There are various quite sophisticated ways of arriving at the formula for P(d), which is telling us that the probabilities of the different digits are uniformly distributed on a logarithmic scale. But it is good to understand more simply why there is a bias toward the lower digits. Think about the chance of the first digit being 1 as we let the list of numbers grow. Take the first two numbers, 1 and 2 – the probability of 1 being the first digit is obviously just ½. If we include all the numbers up to 9 then the probability P(1) falls to 1/9. When we add the next number, 10, it jumps to ⅕ because two of the numbers (1 and 10) start with 1. Include 11, 12, 13, 14, 15, 16, 17, 18, 19 and suddenly P(1) jumps to ¹¹/₁₉. But now go on to 99 and there will be no new numbers with first digit 1 and P(1) keeps falling: after 99 numbers it is only P(1) = ¹¹/₉₉. When we reach 100 the probability is going to increase all the way up to 199 because every number between 100 and 199 begins with a 1. So we can see that the probability P(1) of the first digit being equal to 1 goes up and down with increases after we reach 9, 99, 999, and continues in a sawtooth pattern. The Newcomb–Benford law is just the averaging out of all those ups and downs in the sawtooth graph of P(1) over a very large count. That average comes out at about 30 percent.

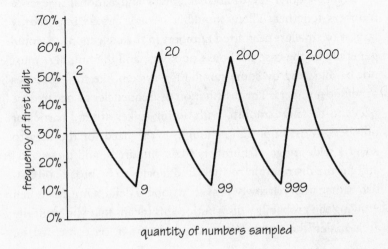

The ubiquity of the Newcomb–Benford law is very striking. It has even been used as a tool for identifying potentially suspicious tax returns – if the numbers are artificially concocted or produced by a random-number generator, rather than arising "naturally," then the Newcomb–Benford law will not be followed. This idea was introduced into accountancy in 1992 by Mark Nigrini, a PhD student at the University of Cincinnati,[5] and was used quite effectively to identify fraudulent data. The chief investigating officer for the Brooklyn DA's office tried Nigrini's method retrospectively on seven cases of fraudulent accounting and it successfully identified them all. (It was even run on Bill Clinton's tax returns but found nothing suspicious!) The weak point in these analyses is if any systematic rounding off of numbers has occurred which skews the raw data.

Despite the ubiquity of the Newcomb–Benford law, it isn't universal: it isn't a law of Nature.[6] Distributions of human heights or weights, IQ data, telephone numbers, house numbers, prime numbers, and lottery-winning numbers *don't* seem to follow the Newcomb–Benford law. What are the conditions needed for it to describe a distribution of first digits?

The data that you are using should just use quantities of the same sort – don't try to add lake areas and national insurance numbers together. There shouldn't be any cutoffs imposed by largest or smallest permitted numbers in the collection, as would generally be the case for house numbers, and the numbers must not be allocated by some numbering system like for postcodes or phone numbers. The distribution of frequencies of occurrence needs to be fairly smooth, with no big spikes around particular numbers. Most important, though, is the need for the data to cover a wide range of numbers (tens, hundreds, and thousands) and for the distribution of their frequencies to be broad and flattish rather than narrowly peaked around a definite mean. When drawing the probability distribution this means that you want the area under the curve for some interval of outcomes to be

determined largely by the width of the distribution rather than by its height (as in example a below). If the distribution is relatively narrow (as in example b), and determined more by its height that its width – as it is for the frequency of adult weights – then the first digit of those weights will not follow the Newcomb–Benford law.

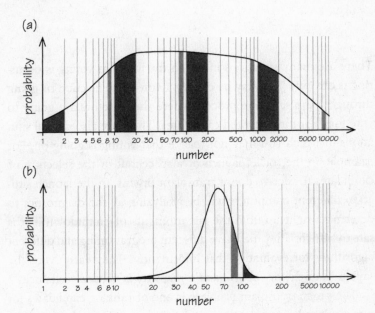

# 70

# Organ Donor Preferences

There are many situations in which the fact that voting is occurring is obvious. You may be casting a vote in an election or going through a job selection process where the selectors are going to vote for their most favored candidates. There are also critical situations in which you may not realize that voting is going on. For example, in the rocket launch of a spacecraft or the selection of candidates to receive donor transplant organs. In the launch situation different computers will be analyzing all the diagnostics to determine right up until the last moments of countdown if it is safe to launch. They may have different programming and different algorithms for evaluating that information. They each "vote" by saying "launch" or "abort" and a majority is needed to launch.[1]

The organ transplant problem is one of ranking candidates for a transplant by scoring them according to different criteria, like how long they have been waiting, the degree of antigen matching between donor and recipient, and the fraction of the population whose antibodies exclude a tissue match. Some system of points scoring will be invented for each of these criteria and the scores totalled to produce a ranking list to determine the first-choice recipient for a heart or kidney that has become available. Thus we have a problem similar to that found in politics arising in a life-or-death medical situation.

This system can have some odd outcomes. The antigen and antibody compatibility measures are determined by fixed rule; say two points for each antigen match between prospective donor and

recipient. There is obviously an issue about how this is weighted relative to the other factors – how many points do you give? That will always be partly a subjective choice. The waiting-time factor is more awkward. For example, suppose that you give each potential recipient a score equal to the fraction of people on the waiting list who are equal or below them on the list (we assume there are no tied positions) times 10. This means that in a list of five candidates (A to E) they will score 10, 8, 6, 4, and 2 respectively. For example, the second candidate has four of the five candidates equal to or below him and so scores $10 \times \frac{4}{5} = 8$. Assume that their other criteria give them total scores of A = 10 + 5 = 15, B = 8 + 6 = 14, C = 6 + 0 = 6, D = 4 + 12 = 16, E = 2 + 21 = 23. So the next transplant organ goes to E, and if two arrived together then the second one would go to D.

Now suppose the second arrived just slightly after the first one.[2] Long enough for the waiting-time points to be recalculated with E now removed from the queue and in surgery. The antigen and antibody scores would stay the same but the waiting-time scoring changes. There are now only four in the queue and the waiting-time scores will now be A = 10, B = 7.5, C = 5, and D = 2.5 (for example, B has 3 of the 4 people equal or behind him and now scores $\frac{3}{4} \times 10 = 7.5$). Totalling the scores again we find that now A = 15, B = 13.5, C = 5, and D = 14.5 and the first choice for the organ becomes A, not D as we thought before. This is a typical example of how strange results can emerge from a voting system designed to produce a single winner. The scoring and the criteria can both be tinkered with to avoid this seeming paradox but a new paradox will always spring up to replace it.[3]

# Elliptical Whispering Galleries

There are a number of great buildings in the world which contain rooms or galleries with unusual acoustic properties that lead to them being dubbed "whispering galleries." There are several varieties, but the most interesting one from a geometrical point of view is the elliptical room. The most famous example is the Statuary Hall in the American Capitol Building, which served as the old House of Representatives. When future President John Quincy Adams was a member of the House of Representatives in the 1820s he realized from experience that if he located his desk at one of the focal points of the ellipse then he could easily hear whispered conversations that his colleagues were having on the floor at the other focal point.

This whispering-gallery effect derives from the specific geometry of the ellipse. An ellipse is the path traced out by a point such that the sum of the distances from two fixed points is always equal to a constant value.[1] The two fixed points are called the *foci* of the ellipse.

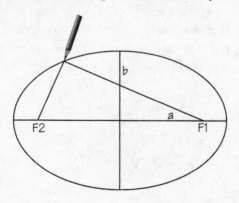

If a line is drawn from one of the foci and reflects back from the boundary of the ellipse then the reflected path will pass through the other focus.[2] So if we send out sound waves from the first focal point then all those waves will hit the wall of an elliptical room and reflect in such a way that they all subsequently pass through the other focus. Crucially, from the definition of the ellipse, the total length of all those paths will be the same no matter where they reflect from the elliptical wall. This means that they will all arrive at the other focus at the same time. This is illustrated in the figure below, where sound wave fronts move away from the left-hand focal point and then reflect and converge on the second focus, arriving simultaneously.

Many years ago, I gave an "evening discourse" lecture at the Royal Institution in London that included a demonstration of the chaotic sensitivity of cue games like billiards and pool. The demonstration used an elliptical billiards table with a hole located at one of the foci instead of a conventional pocket set at the table's edge. This ensured that I could hit a ball from the other focal point in any way I liked and after rebounding from any side of the table it would inevitably drop into the hole at the other focus.

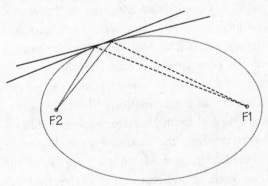

# The Tunnel of Eupalinos

If you visit the Greek island of Samos you can explore a little piece of one of the engineering wonders of the ancient world that lies close to Pythagorean, the principal town of the island and the claimed birthplace of Pythagoras. When I first visited it I was amazed by what had been achieved there 2,500 years before.

In ancient times, the town of Pythagorean was vulnerable to invading forces because they could cut off or pollute its water supply which had to run aboveground from the other side of the island. In response to this potential threat, Polycrates, the despotic ruler of Samos and that region of the Aegean, decided it might be possible to create a new protected water channel. He employed a great engineer, Eupalinos of Megarus, to excavate an underground aqueduct that would bring water from a concealed spring across to Pythagorean under Mount Kastro. The project began in 530 BC and was completed a decade later. It required Eupalinos to excavate (probably using Polycrates's slaves and prisoners) about 7,000 cubic meters of solid limestone to create a straight tunnel 1,036 meters long and about 2.6 meters square that lies on average about 170 meters below the mountain peak. If you went inside today you could be forgiven for not realizing that there was a water channel there at all because it is so cleverly hidden underneath the walkway, with only a narrow access gap to the underneath on one side.

This was a formidable engineering challenge. Eupalinos decided to halve the construction time by tunnelling from both

ends at once so that the two teams would meet midway. This is more easily said than done and Polycrates was not renowned for his forbearance. Nonetheless, ten years after they started, Eupalinos's two tunnelling crews met with a deviation of only about 60 centimeters and a height difference of about 5 centimeters. How did he do it? The Greeks did not have the magnetic compass or detailed topographic maps. The answer was an understanding of the geometry of right-angled triangles[1] two centuries before it was codified in Euclid's famous *Elements* – together with a clever trick. This geometry was clearly known to engineers of the period and the association of Pythagorean with Pythagoras may bear witness to a special tradition of geometrical knowledge.

Eupalinos needed to ensure that the tunnellers met at the same point and at the same height above sea level. The levels at the two start points on either side of the mountain can be compared by laying out long stretches of clay guttering with water in them to act like spirit levels. By running them around the mountain in a sequence of jointed lengths you can check that the level of the start point is the same as that of the final point. After that, you can then ensure that the end point near Pythagorean is lower than the starting point of the spring water so that it flows downhill to the town. This is the easy bit. But how do you also ensure that the engineers are tunnelling in the right directions to meet in the middle?

Suppose the two ends of the tunnel are at A and B, where the picture on the next page is a view of the underground tunnel from above. Now do some surveying on the surface to determine the horizontal distances BC and AC between the start point A and the end point B.

This is not so easy, though, because the ground is not level. Eupalinos might have used a sequence of straight edges, each at right angles to its predecessor, going to and fro between B and A.[2]

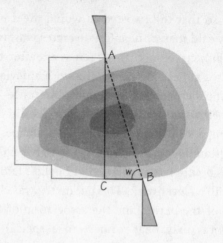

This would have enabled him to work out the net distance between A and B in the direction BC and the direction CA. Knowing these lengths, he could determine the angle w and hence the shape of the triangle. He could now set up a series of markers starting at A which point in the direction determined by the angle w. Next, he could go to B and set out a line of markers pointing in the direction determined by the angle 90-w degrees. If the tunnellers keep moving the markers on ahead of them, siting them along the past alignment in the direction of AB, then they will be on course to meet.

Eupalinos realized that it was possible for directional errors to accumulate over the years of excavating and so he wisely incorporated a trick near the end of the tunnelling to the halfway stage to increase the likelihood that the two teams would meet. He deliberately introduced a small change in the direction for both tunnels so that they would intersect in the horizontal plane and increased their height at this stage to make it harder for them to miss in the vertical plane.[3] We can see this dog-leg kink in the middle of the tunnel.

After a decade of work, and the assembly of more than 4,000 pieces of the channel, the tunnellers heard each other's hammering when they were about 12 meters apart and changed direction to meet at roughly 90 degrees to each other.

Although the existence of this remarkable tunnel was known from the works of the historian Herodotus[4] (who was living in Samos in 457 BC), it was only rediscovered in 1853 when the French archaeologist Victor Guérin found part of a conduit at the northern end. A local abbot subsequently persuaded the islanders to restore the tunnel and by 1882 a large part had been found and cleared by volunteers. Unfortunately, it was then neglected for nearly a century before the whole tunnel was uncovered, renovated, and eventually fitted with lights to allow tourists to explore part of its length from the entrance near Pythagorean.[5]

# A Time-and-Motion Study of the Great Pyramid

The Great Pyramid of Khufu at Giza is the most stupendous human construction of the ancient world and the oldest of the seven ancient wonders of the world. It was completed in 2560 BC, and originally towered 146.5 meters above the surrounding ground (like a 45-story skyscraper); no taller human structure would be erected until the spire of Lincoln Cathedral was raised in the fourteenth century.[1] What we see today is the under-structure of the pyramid which was originally encased in shiny white limestone. These casing stones were badly loosened following an earth tremor in AD 1356 and gradually collapsed. They were removed over the centuries to be reused for constructing forts and mosques in Cairo. Only a few remain at ground level.

The base of the pyramid is 230.4 meters on each side to within 18 centimeters and it contains about 7 million tons of limestone. The Pharaoh Khufu was in power for twenty-three years, from 2590 to 2567 BC, and so this is probably a good upper limit on the building time available to prepare a suitably grand burial chamber for him: this gives just 8,400 days to move about 2.3 million stones into place. Earlier large pyramids are known to have taken about eighty years. Of course, nobody knew at the outset when the pharaoh was going to die. Many of them lived to very great ages that must have made them seem even more godlike to the short-lived average Egyptian, but they also had to

survive disease, battles, and assassination attempts from jealous or ambitious relatives.

In 1996, Stuart Kirkland Wier of the Denver Museum of Natural History made a detailed time-and-motion study of this great construction project to get a feel for how many people must have been involved.[2]

Wier did some simple arithmetic. The volume of a pyramid is $V = \frac{1}{3}Bh$, where $B = 230.4 \times 230.4$ m$^2$ is the area of its square base and $h = 146.5$ m is its height, so $V = 2.6 \times 10^6$ m$^3$ for the Great Pyramid. For a solid pyramid (which we assume it was) the center of gravity is a distance $\frac{1}{4}h$ up the perpendicular from the base to the apex.[3] This means that the amount of work that has to be done raising its total mass M into place from the ground is $Mgh/4$, where $g = 9.8$ m/s$^2$ is the acceleration due to gravity, and $M = Vd$, where $d = 2.7 \times 10^3$ Kg/m$^3$ is the density of limestone. The total work required to raise the stones vertically is therefore $2.5 \times 10^{12}$ J. The standard wisdom is that an average manual worker can perform about $2.4 \times 10^5$ J of work in a day. However, having visited the pyramid sites in late April (which is before it gets *really* hot) I suspect that the working capacity of an Egyptian worker in the hot sun could be reduced to somewhat below this number. If the building project took the whole 8,400 days of Khufu's reign, then the number of men needed to do the work unaided would have to be at least:

Number of workers $= (2.5 \times 10^{12}$ J$)/(8{,}400$ days $\times 2.4 \times 10^5$ J/day$)$

$$= 1240$$

Wier considers a number of different building strategies in addition to the constant rate of build that we are assuming; for example, a rate that decreases with height built or one that goes more slowly near the end. This doesn't make much difference to the overall picture. Even if the overall working efficiency were only 10 percent of the maximum we have assumed, due to adverse weather for part of the year, impossibly hot weather, rest periods, accidents, and the

effort expended against friction when sliding heavy stone to the pyramid from the quarry, then the job could have been done in twenty-three years by 12,400 men.[4] That is a quite plausible scenario because it is only about 1 percent of the population of the country, which is estimated to have been around 1.1–1.5 million at the time. Indeed, a period of "national service" doing pyramid building doesn't even look likely to make a significant dent in any problem of male unemployment at the time, which has been suggested as a partial motivation for these vast construction projects.

It is still not fully understood how the pharaoh's engineers moved the quarried stones to the pyramid site and then pulled or hoisted them upward to form the horizontal layers of stone that built up the pyramid.[5] None of the devices used have survived intact. However, Wier has helped us understand that there is nothing unrealistic about these projects from a manpower planning perspective when simple math is applied to them. What was more challenging for the Egyptian administration was maintaining organizational focus and budgetary control over such a lengthy project, which was likely to have been just one of many in their portfolio – after all, you always need a spare smaller pyramid very close to completion in case the pharaoh dies unexpectedly.

# Picking Out Tigers in the Bushes

Any creator of abstract art must face the problem of the human eye's sophisticated pattern-recognition skills and susceptibilities. Our evolutionary history has made us good at seeing patterns in crowded scenes. Lines in the foliage could be a tiger's stripes; anything laterally symmetrical, like an animal's face, is likely to be alive and therefore either something to eat, a potential mate, or something that might eat you. Inanimate things don't often have this lateral symmetry and it is a good first indicator of an animate object. This ancient sensitivity is why we place so much onus on the external symmetry of the human body and face when judging its beauty, and why companies invest billions in finding ways to enhance, restore, or preserve external bodily symmetry. By contrast, look inside us and you find a big asymmetrical mess.

A heightened sensitivity to pattern and symmetry is therefore more likely to survive in a population than insensitivity. Indeed, we might even expect a certain degree of oversensitivity to be inherited, as we discussed in Chapter 25.

This useful ability has all sorts of odd by-products. People see faces in their tea leaves, on the surface rocks of Mars, and in the constellations of stars in the night sky. Psychologists have read much into our propensity for pattern recognition, and the famous ink-blot tests, devised by Swiss psychologist Hermann Rorschach in the 1960s, were an attempt to formalize certain critical elements

of an old idea that the patterns perceived in ink blots could reveal important personality traits (and defects).[1] Although Rorschach originally devised his test specifically as an indicator of schizophrenia, after his death it seems to have been used as a general personality test. The test consists of ten cards with patterns, some in black and white and some colored or with colors added. Each has lateral symmetry. The subject is shown the cards more than once and can rotate them to report free mental associations that come to mind. The significance of all this continues to be controversial. However, regardless of the interpretation of what they see, it is undeniable that almost everyone sees something in these inkblots: it is a manifestation of the brain's propensity to find patterns.

This tendency is very awkward for abstract artists. They generally don't want viewers to see anything as specific as the face of David Beckham or the numerals "666" in the middle of their abstract creations. Random patterns can have many properties that the eye will pick out because it is often more sensitive at seeing correlations of all sorts at once than computer programs that search with simple statistical indicators. Artists will need to look very carefully, from different angles and viewing distances, to ensure that they have not accidentally endowed their abstraction with a distracting pattern. Once that pattern is identified and publicized everyone will "see" it and the step can never be reversed.

You don't have to be an abstract artist to import an unwanted pattern into your work. Watch those portrait artists at the seaside and you will notice, even in the advertising works they put up to persuade you of their drawing skills, that many of the faces look strangely alike, and a number look rather like the artist. Even experienced artists tend to draw their own face if they are not portrait specialists. I was struck by a portrait of colleague Stephen Hawking created in 2012 by David Hockney for the Science Museum's celebration of Hawking's seventieth birthday.[2] It was an example of Hockney's new enthusiasm for "painting" with his iPad. Alas, I thought the resulting portrait looked just a little like David Hockney.

# 75

# The Art of the Second Law

There is a cartoonist's commentary on abstract expressionist art that shows two scenes. In the first the artist is preparing to hurl a large bucket of paint toward a blank canvas. In the second, we see the unexpected immediate result of the impact: a perfectly conventional portrait of a woman has emerged with just a few drips of paint falling from the bottom of the canvas.

Why is this funny? Well, it doesn't happen in practice of course, but if it did then Nature would indeed be conspiring against the abstract expressionists. It is the belief from experience that this could never happen in practice that is interesting. If the flying paint did end up forming a perfect portrait then no law of Nature would have been violated. But it still flies in the face of experience. Newton's laws of motion have solutions which describe haphazard paint particles all moving toward the canvas and striking it in a perfectly organized pose.

The same situation arises with a breaking wineglass. If we drop it on the floor it will end up as many fragments of glass. If we reverse the direction of time, running a film of the breakage backward, then we will see all those scattered fragments reconstituting into a glass. Both scenarios are allowed by Newton's laws of motion, but we only ever see the first one – the breaking of a glass into fragments – and never the second. Another familiar example is the development of your children's bedrooms. If left to themselves they tend to get increasingly untidy and disorganized. They never seem to get spontaneously tidier.

In all these examples – the flying paint, the falling wineglass, and the untidy room – we are seeing the second law of thermodynamics at work. This is not really a "law" in the sense that the law of gravity is. It tells us that without external intervention things will tend to become more disordered – "entropy" increases. This is a reflection of probability. There are so many more ways for things to become disordered as time passes than for them to become ordered that we tend to observe disorder increasing unless something (or someone) intervenes to reduce it.

In the case of the flying paint, the paint would only produce a nice portrait if every particle was launched with a very precise speed and direction so as to hit the canvas exactly as required. This very unlikely state of affairs never arises in practice. In the case of the wineglass, the falling and breaking into pieces requires starting conditions that are all too easy to create by accident, whereas the time-reversed scenario, with the fragments convening simultaneously to form a perfect glass, requires astronomically unlikely special starting movements. And thirdly, your children's bedrooms get increasingly untidy (if no one intervenes to clean them up) because there are simply so many more ways for them to become untidy than for them to become tidy.

Thus we will never see what the cartoonist imagined, even if we wait a billion years. The creation of order out of disorder requires work to be done, steering paint drop after paint drop into its chosen place. Fortunately, there are an awfully large number of different ways in which this can be done, even if it is dwarfed by the number of disordered ones.

# 76

# On a Clear Day . . .

". . . You can see forever," according to Alan Lerner's Broadway musical. But can you? Recently, I came across an exhibition of twenty photographs by Catherine Opie at the Long Beach Museum of Art entitled *Twelve Miles to the Horizon*.[1] The pictures were the result of a commission to photograph sunrises and sunsets for twelve days on a sea voyage from Busan in South Korea to the port of Long Beach, California. The title of the exhibition was chosen to evoke notions of solitude and separation, but did it also have a grain of metrological truth in it? Just how far away is the horizon?

Let's assume the Earth is smooth and spherical.[2] We are at sea with no intervening hills to obscure the view, and we ignore the effects of light refraction as it passes through the atmosphere, along with the effects of any rain or fog. If your eyes are a height H above the sea and you look toward the horizon, then the distance to the horizon, D, is one side of a right-angled triangle whose other two sides are the radius of the Earth, R, and H plus the radius of the Earth, as shown here:

Using Pythagoras' theorem for this triangle, we have:

$$(H + R)^2 = R^2 + D^2 \ (\star)$$

Since the average radius of the Earth is about 6,400 kilometers, and much greater than your height H, we can neglect $H^2$ compared to $R^2$ when multiplying out the square of H + R and $(H + R)^2 = H^2 + R^2 + 2HR \approx R^2 + 2HR$. Using equation above $(\star)$, this means that the distance to the horizon is just $D = \sqrt{(2HR)}$, to a very good approximation. If we put the radius of the Earth into the formula we get (measuring H in meters):

$$D = 1600 \times \sqrt{(5H)} \text{ meters} \approx \sqrt{(5H)} \text{ miles}$$

For someone of height 1.8 meters, we have $\sqrt{5H} = 3$ and the distance to the horizon is D = 4,800 meters, or 3 miles, to very good accuracy. Notice that the distance you can see increases like the square root of the height that you are viewing from, so if you go to the top of a hill that is 180 meters high you will be able to see ten times farther. From the top of the world's tallest building, the Burj Khalifa in Dubai, you can see for 102 kilometers, or 64 miles. From the summit of Mount Everest you might see for 336 kilometers, or 210 miles – not quite forever, but far enough. And if, like Catherine Opie, you did want it to be 12 miles to the horizon, you would need to be looking from a height of $^{144}\!/_5$ = 28.8 meters above sea level, which is quite realistic for passengers on cruise boats of modest size.

# Salvador Dalí and the Fourth Dimension

In the Metropolitan Museum of Art in New York hangs a striking painting of the Crucifixion painted by Salvador Dalí in 1954. Entitled *Corpus Hypercubus*, it shows Christ hanging in front of a cross that is composed of eight adjacent cubes, one at the center with a neighboring cube attached to each of its six faces and an additional cube added to the vertical.[1] In order to understand this picture and its title you need to know a little bit of the geometry that was first displayed just over a hundred years ago by the unusual math teacher and inventor Charles Hinton, late of Cheltenham Ladies' College, Uppingham School (whence he fled after being convicted of bigamy), Princeton University (where he invented the automatic baseball-pitching machine), the US Naval Observatory, and the American Patent Office.

Like many Victorians, Hinton was fascinated by "other dimensions," but rather than pursue a purely psychic agenda he thought about the problem in clear geometrical terms and wrote a book on the topic in 1904 after more than two decades of essays and articles devoted to the subject.[2] He was fascinated by visualizing the fourth dimension. He recognized that three-dimensional objects cast two-dimensional shadows and can also be cut apart or projected down on to two-dimensional surfaces. In each case there is a simple connection between the shapes of the 3-D solid

and its 2-D shadow or projection. By noting these connections we can show what we would see if we looked at a four-dimensional object in projection or unwrapped it. Take the case of a hollow 3-D cube made of paper. In order to unwrap it, we can cut the join between two of the outer corners and flatten out the faces of the cube to give the two-dimensional cross of squares shown below.

There is a pattern to this projection from three to two dimensions. The three-dimensional cube has six two-dimensional square faces which are bounded by twelve one-dimensional lines joining eight zero-dimensional corner points.

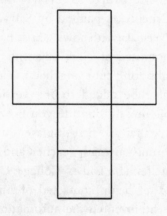

By analogy, Hinton constructs the appearance of an unwrapped four-dimensional hypercube, or *tesseract* (Greek for "four rays") as he first called it. Instead of a central square being surrounded on each side by four other squares with an extra one on one side, it consists of a central cube that is surrounded by six other cubes with an additional cube on one side. This shows what the hypercube would look like if it was unwrapped in three dimensions:

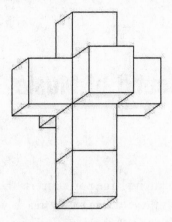

This object is what Dalí uses for the cross in his *Corpus Hypercubus* in his quest to capture the metaphysics of the transcendental. However, if you look closely at the painting you will find some modifications to the geometry in order to make the picture work. The body cannot be flat against the cross because of the central cubes protruding outward. The arms and hands do not rest against the cubes. The body is left levitating in front of the hypercube above a huge checkerboard background. Dalí's wife Gala is shown as Mary Magdalene looking upward in the foreground. There is no crown of thorns or any nails to support the arms, just four small three-dimensional cubes that appear to float in a square pattern in front of the body of Christ.

# 78

# The Sound of Music

If, unlike me, you attend large pop concerts then you know that the sound of the music doesn't only reach you directly from the onstage musicians and their speaker system. Other speaker towers are needed farther back, where those members of the audience who didn't get there early can be over 40 meters from the stage, to give everyone a similar (and very loud) acoustic experience. Classical concerts, outdoor theater, and opera "in the park" face the same problems, because sound doesn't travel instantaneously. The sound output from the towers needs to be synchronized with the live sound from the band onstage or the result will be cacophony.

This synchronization requires the audio engineers to make sure that the sound traveling directly to the audience at the front through the air has the same arrival time as the sound that goes through the electrical wiring systems to the towers at the back, before it goes a relatively short distance through the air to the nearby listeners. Sound signals travel much faster through the electronics (essentially instantaneously) than sound waves travel through air. If these arrival times are not well matched then a strange echo effect would arise with the same sound heard first from the speaker towers and then again directly from the stage.

If the musicians create sound from the center of the stage at the front, then at sea level the sound moves through the air at a speed of $331.5 + 0.6T$ m/s, where $T$ is the air temperature in centigrade. At a summer event where $T = 30°C$, we have a sound

speed of 349.5 m/s and the direct sound takes a time $40/349.5 =$ 0.114 s, or 114 milliseconds, to reach the audience seated 40 meters away. Setting the delay speakers to send out their version of the same sound after this interval would contribute to both sources simultaneously. However, this is not ideal. You don't want to feel that you are listening to a nearby speaker rather than the performance from the stage. Engineers therefore add a very small extra delay of about 10–15 milliseconds to the broadcast from the speaker towers to tip the acoustic balance – so your brain registers the direct sound from the stage first, but this is almost immediately reinforced by the louder indirect broadcast from the tower speakers. This total delay of about 124–129 milliseconds makes you think that all the sound is coming directly from the stage. The speed of sound will increase by about 11.5 m/s if the air temperature rises from 20°C to 40°C, but as this changes the arrival time to the listeners in the 40-meter seats by only 3 milliseconds the effects are minimal.

# 79

# Chernoff's Faces

Statistics can be deceiving – sometimes deliberately so. There is a need for correct analysis of data to find out if economic claims by governments and companies are correct, but there is also a need to present statistical information in a way that is clear, accurate, and compelling. In so doing, we can exploit the eye's remarkable sensitivity for certain types of pattern or deviance. As we have discussed already, this sensitivity has been honed by a long process of natural and sexual selection that rewards a certain type of visual sensitivity. We are very sensitive to faces and evaluate many aspects of people whom we meet, at least initially, by their faces. Considerable amounts of money are spent on enhancing and restoring facial symmetry if it is lost or reduced by accident or the aging process. If we look in our newspapers we will find the work of cartoonists and caricaturists who have a genius for distorting people's features so that they look quite different but are nonetheless instantly recognizable. Starting from the true original they increase the prominence of some features so that they become dominant rather than just small perturbations to an almost average face.

In 1973 the statistician Herman Chernoff proposed using cartoons of faces to encode information about something that had a number of varying features which differed from the average.[1] Thus, the spacing between the eyes might represent cost, nose size show length of time a job took, eye sizes how many workers were employed, and so on. In this way, Chernoff produced an

array of faces all slowly deviating from the average face in slightly different ways. Other variables he could use were the size and shape of the face and the position of the mouth. He initially suggested up to eighteen variables that could be coded in small facial pictures. They were all symmetrical. By introducing asymmetries – for example, different eye sizes – the information content could be doubled.

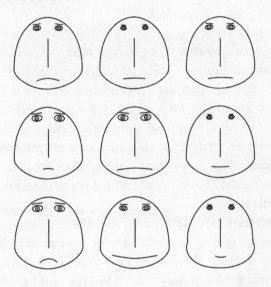

Our sensitivity to different facial features varies and so it is possible to encode information in accordance with our need to sense small changes. Chernoff's gallery gives a vivid impression of the so-called normal distribution of statistical variation around a particular mean value. By increasing the number of facial variables and the number of dimensions of variation, the brain's most sensitive pattern-seeking programs can be simultaneously brought to bear on the data. This facilitates a quick appraisal of its variability.

# 80

# The Man from Underground

Once I saw two tourists trying to find their way around central London streets using an Underground train map. While this is marginally better than using a Monopoly board, it is not going to be very helpful. The map of the London Underground is a wonderful piece of functional and artistic design which has one striking property: it does not place stations at geographically accurate positions. It is a *topological* map: it shows the links between stations accurately but for aesthetic and practical reasons distorts their actual positions.

When Harry Beck first introduced this type of map to the management of the London Underground railway, he was a young draftsman with a background in electronics. The Underground Railway was formed in 1906, but by the 1920s it was failing commercially, not least because of the apparent duration and complexity of traveling from its outer reaches into central London, especially if changes of line were necessary. A geographically accurate map looked a mess, both because of the higgledy-piggledy nature of inner London's streets, which had grown up over hundreds of years without any central planning, and because of the huge extent of the system. London was not New York, or even Paris, with a simple overall street plan. People were put off using the Underground in its early years.

Beck's elegant 1931 map, although initially turned down by the railway's publicity department, solved many of its problems at

one go. Unlike any previous transport map, it was reminiscent of an electronic circuit board; it used only vertical, horizontal, and 45-degree lines; eventually had a symbolic River Thames drawn in; introduced a neat way of representing the exchange stations; and distorted the geography of outer London to make remote places like Rickmansworth, Morden, Uxbridge, or Cockfosters seem close to the heart of the city while enlarging the crowded inner region. Beck continued to refine and extend this map over the next forty years, accommodating new lines and extensions of old ones, always striving for simplicity and clarity. He succeeded brilliantly.

Beck's classic piece of design was the first topological map. This means that it can be changed by stretching it and distorting it in any way that doesn't break connections between stations. Imagine it drawn on a rubber sheet which you could stretch and twist however you liked without cutting or tearing it. You could make space in the central area where there were lots of lines and stations, and bring distant stations closer to the center so that the map didn't contain lots of empty space near its boundaries. Beck was able to manipulate the spacing between stations and the positions of the lines so as to give an aesthetically pleasing balance and uniformity to the spread of information on the map. It displayed a feeling of unhurried order and simplicity. Pulling far-away places in toward the center not only helps Londoners feel more connected; it also helps create a beautifully proportioned diagram that fits on a small fold-out sheet which can be popped in your pocket.

Its impact was sociological as well as cartographical, by redefining how people saw London. It drew in the outlying places on the map and made their residents feel close to central London. It defined the house-price contours. For most people who lived in the city this soon became their mental map of London. Not that Beck's map would help you much if you were aboveground – as the tourists mentioned at the start presumably discovered – but

its topological approach makes good sense. When you are on the Underground you don't need to know where you are in the way that you do when on foot or traveling by bus. All that matters is the next station, where you get on and off, and how you can link to other lines.

# 81

# Möbius and His Band

Take a long rectangular strip of paper and stick the two ends together to make a cylinder. At primary school we did it dozens of times. The cylinder that results has an inside and an outside. But if you repeat the experiment giving the strip a twist before sticking the ends together you will have created something that is strangely different. The resulting band, resembling a cross between a figure-of-eight and an infinity sign, has a surprising property: it doesn't have an inside *and* an outside; it has only one surface. (This also happens if you give it any odd number of twists but not if you give an even number.) If you begin coloring one side with a crayon and keep going, never lifting the crayon from the surface, you will eventually color the whole of it. Install a conveyor belt to move goods in a factory with a twist in the belt to convert it into this one-sided surface and it will last twice as long before wearing out.

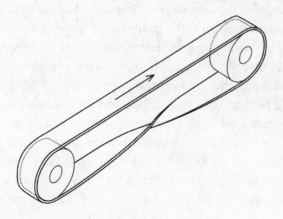

The first person to notice this curious state of superficial affairs – what mathematicians now call a "non-orientable" surface – was the German mathematician and astronomer August Möbius. His description of his discovery of the "Möbius band" in 1858 was only found among his papers after his death in September of that year. It subsequently came to light that the Möbius band was discovered independently in July of the same year by another German mathematician, Johann Listing,[1] but it is by Möbius's name that it has always been known.

Often, the appearance of the Möbius band alongside Maurits Escher's gallery of impossible triangles and waterfalls[2] has led viewers to think that it is also just an imaginary object. But there is nothing impossible about Möbius's band. It is simply unexpected.

Escher was not the only prominent artist to exploit the properties of the Möbius band. In the 1930s, the Swiss sculptor Max Bill became convinced that new mathematical developments in topology could open up an unexplored world for artists, and he started to create a series of endless ribbon sculptures, in metal and granite, using the Möbius band as a paradigm. Whereas Escher used it on paper, Bill developed solid, three-dimensional versions. Other sculpted manifestations, in stainless steel and in bronze, were made in the 1970s by the American high-energy physicist and sculptor Robert Wilson, and by the English sculptor John Robinson, whose work *Immortality* used the Möbius band to make a gleaming trefoil knot (the geometry of which we discussed in Chapter 51) in highly polished bronze. Many other artists and designers have used it in architecture to create exciting buildings and stimulating children's play areas.[3] The Möbius band retains a powerful hold on our imaginations. It is a never-failing source of fascination to anyone encountering it for the first time.

One use of the Möbius band from the world of design is so familiar that we no longer notice it. In 1970, Gary Anderson, a student at the University of Southern California, won a student design competition advertised by the Container Corporation of

America, a leading player in industrial and corporate graphic design. It wanted a logo to symbolize recycling so as to encourage environmental responsibility among its customers and those of other companies seeking to promote the recycling of their packaging. Anderson won the $2,500 prize with his now famous recycling symbol that uses a flattened Möbius band. The symbol was not trademarked and remains freely usable in the public domain, just as the Container Corporation intended. Anderson went on to a very distinguished career in graphic design, architecture, and urban planning. His representation of the Möbius band can be seen almost everywhere.

# 82

# The Bells, the Bells

Bell ringing has been practiced in English village churches since the twelfth century; but in about 1600 a new style of ordered sequences, or ringing "changes," started to sound throughout East Anglia, home to many small churches with high bell towers. This was motivated by a desire to create a more controlled sequence of sounds that could be heard at greater distances from each bell tower, but by the nineteenth century it had evolved into a challenging art form in its own right. Bells served the community by telling the time, announcing great social or ecclesiastical events, and signaling warnings. The huge mass and inertia of church bells, and their uncontrollability once they are spinning, means that they are not for creating complex melodies. As a result they were rung in complex sequences to create a pleasing sequence of rising and falling tones.

Bell ringing, or "campanology," was traditionally described as an "exercise" to reflect the special combination of physical and mental fitness required for its execution. Bells are rung in sequence by a band of ringers who must operate a long sequence of changes without any written instructions: everything must be committed to memory. If there are, say, four bells then they will be rung in a row, with the number 1 for the smallest bell with the highest note (the "treble"), down to the largest bell, which rings the lowest note (the "tenor"). Initially, they are rung in the sequence 1234 of descending notes. This simple sequence is called a "round." The rules governing each subsequent playing of the original row are that each bell is rung once and only once in the row; each bell can

move only one place in position when the row is next played (so that we can have the sequence 1234→2134 but not 1234→2143), and no row can be repeated (except for the first and the last sequence 1234). The ringing finishes when the sequence returns to the original 1234 round. There are therefore $4 \times 3 \times 2 \times 1 = 24$ different sequences of four bells to play, and if there are N bells there will be N! possibilities.[1] This set of possibilities is called an "extent" of a given number of bells, and its size grows quickly with N: for eight bells we are faced with 40,320 changes to ring. Remember that the ringers have to remember these sequences. No notes or sheets of "music" are allowed, although the ringers will be led by a conductor, who is one of them. Typically, each bell takes about two seconds to ring and so the twenty-four extent takes about forty-eight seconds to complete, but the 720 extent on six bells takes twenty-four minutes. The longest extent that is practically possible with one ringer pulling each bell is with eight bells. It might take over twenty-two hours but has been done in under eighteen hours! Longer extents would need substitutes to take over each bell after a certain period. In the figure below we show the sequence known as "Plain Bob," which runs through all the twenty-four permutations of four bells. All the sequences have equally quaint old English names, like "Reverse Canterbury Pleasure Place Doubles," "Grandsire Triples," and "Cambridge Surprise Major."

| 4 bells | | |
|---|---|---|
| 1234 | 2314 | 3124 |
| 1243 | 2341 | 3142 |
| 1423 | 2431 | 3412 |
| 4123 | 4231 | 4312 |
| 4213 | 4321 | 4132 |
| 2413 | 3421 | 1432 |
| 2143 | 3241 | 1342 |
| 2134 | 3214 | 3124 |
| | | (1234) |

This sounds mathematical – and it is. The study of the permutations of bells that were possible subject to the rules we have mentioned was really the first systematic study of groups of permutations, made in the 1600s by Fabian Stedman[2] long before they became a formal part of mathematics in the 1770s.[3] The permutations of four bells can be visualized nicely by rotating the numbered corners of a square (the letter "R" is used here simply to show the different orientations more clearly):

For larger numbers of bells we replace the square with a polygon with the same number of sides as the number of bells and carry out all possible operations on its orientation.

# 83

# Following the Herd

Birds, fish, and many mammals, like antelope and buffalo, group together into "swarms" that we call flocks, shoals, or herds. Their self-organizing behavior is often uncannily precise. When huge flocks of starlings fly through the air at the end of the day we might ask how they organize themselves to create a group that seems to move as one great coordinated body. Sometimes the movement follows simple defensive rules. If you are in a shoal of fish that might be under attack from predatory sharks then it is a good idea to keep away from the periphery. This produces a continuous churning of the shoal as members try to avoid being on the vulnerable edge. Conversely, some flying insects want to be on the outside of the swarm in order to be the first to attract the attention of potential mates. Some birds and fish stay near their immediate neighbors; they move away from those who get too close, but are attracted back to the group if they stray too far from it. Others only pay attention to their seven or eight nearest neighbors and align themselves with their speed and direction of movement.

All these strategies can lead to large-scale orderly swarms and the impressive patterns of birds and fish that we see in Nature. Other more complicated strategies can be imagined for human interactions. For example, someone might move around at a large cocktail party aiming to get as close to one person as they can while getting as far away as possible from someone else. If lots of people are doing that at the same party then the result is not easy to predict!

Another, mathematically interesting strategy is that adopted by a herd of vulnerable wildebeest or antelope when a single predator, like a lion, appears on their horizon. Each animal will move so as to ensure that there is at least one other animal along the line of sight between itself and the predator. When the predator is stationary this will result in the herd adopting a particular pattern that mathematicians call a "Voronoi tessellation." To construct it for a collection of points just draw straight lines between all the pairs of points and then construct new straight lines at right angles to them passing through their midpoints. Continue each of these new bisecting lines until they encounter another one, and then stop them. The result is a network of Voronoi polygons.[1] Each has one point at its center and the polygon around it maps out the part of space that is closer to it than to any other point.

This polygon defines a region of danger for the animal at its central point. If this animal's region of danger is entered by a predator, it will find itself the nearest potential prey. Each animal wants to make its polygon of danger as small as possible and to be as far as possible from the predator. This type of collective behavior is called that of the "selfish herd" because each member acts in its own self-interest. Predators like lions move around quickly, making the changing Voronoi polygons difficult to determine in real

situations, even though a computer program can easily come up with predictions. You need a slow-moving predator–prey scenario.

Interesting studies have been done by filming the dynamics of large groups of fiddler crabs when they feel threatened.[2] Crabs are slow enough and small enough in number to enable careful studies of their movement before and after a predator threatens. They appear to follow the selfish-herd behavior very closely, forming a pattern with large Voronoi polygons around each of them when the threat first arises. Next, they enter a panic mode in which they become much closer to each other with a smaller Voronoi pattern, each trying to keep someone else between itself and the predator. The threatened crabs do not necessarily scuttle away from the predator. They tend to move toward the center of their group (or "cast") so as to put others between them and the predator:

(a) Before

(b) After

Sometimes this means actually running toward the predator. Remember, an individual's level of risk is proportional to the area of the Voronoi polygon defining its region of danger. These areas all become smaller when the crabs panic and get closer together and everyone feels safer. Evolutionary biologists teach us that those crabs that are less inclined to follow this behavior will be more likely to get picked off by a predatory sea bird, while those that instinctively respond quickest will be most likely to survive to produce offspring that share that trait.

# 84

# Finger Counting

It is not hard to see the influence of human anatomy on our systems of counting. Our ten fingers and ten toes formed the basis for systems of counting in many ancient cultures – a so-called "decimal" system. Fingers provided the first digits for people to record quantities of things and group them into collections of five and ten and twenty (by adding toes). Occasionally, we see interesting variants. For example, there is one old Central American Indian culture that used a base of eight rather than ten. I have occasionally asked audiences why base eight might have been chosen. Only one person, an eight-year-old girl attending the Royal Society of Arts Christmas lecture, ever came up with the right answer: they counted the gaps between their fingers because that's where they held things. Perhaps she was used to playing children's playground games like cats cradle.

The ubiquity of finger counting made it the precursor for the decimal system, with a place-value notation bequeathed to us by early Indian culture which was then spread to Europe by medieval Arab trade in the tenth century. In that type of counting system, the relative positions of the numerals carry information, so that 111 means one hundred + ten + one and not 3 (one + one + one), as it would in Roman numerals or ancient Egyptian or Chinese notation. This place-value notation also requires the invention of a symbol for zero so as to register an empty slot and avoid confusing 1 1 with 11 by writing it clearly as 101. Today, this place-value decimal system of counting is completely universal,

transcending the common use of any single written language or alphabet.

Despite the ubiquity of finger counting the manual technique employed to perform it varies slightly between cultures even today. Here is a story of something that happened during the Second World War in India.[1] A young Indian girl found herself having to introduce one of her Asian friends to a British serviceman who arrived unexpectedly at her house. Her friend was Japanese and had that become known to the visitor then her friend would have been arrested by the British army. She decided to disguise the girl's nationality by introducing her as Chinese. The man was evidently suspicious because a little later he suddenly asked the Asian girl to count to five on her fingers. The Indian girl thought he was mad, but the Asian girl, although mystified, counted out one, two, three, four, five on her fingers. Aha! announced the man – I see you are Japanese. Didn't you see that she began counting with her palm open and then coiled her fingers in one after the other as she counted to five? No Chinese person would ever do that. They count like the English, starting with the fingers coiled up into a fist and then uncoiling them one by one, beginning with the thumb,[2] until the palm is open flat. He had put the finger on her Indian friend's attempt at deception.

# 85

# The Other Newton's Hymn to the Infinite

Infinity is a dangerous topic that mathematicians treated with extreme caution, or even disdain, until the late nineteenth century. Attempts to count infinite lists of numbers, like 1, 2, 3, 4 . . . led to immediate paradoxes, because if you then form another infinite list of all the even numbers, 2, 4, 6, 8 . . . you feel that surely there are only half as many numbers in the list of even numbers as there are in the list of all numbers. However, you can draw lines between each member of the first list and one (and only one) member of the second, joining 1 to 2, 2 to 4, 3 to 6, 4 to 8, and so on. Every number in each of the two lists is going to be uniquely matched up with a partner. Carrying on indefinitely in this way shows that there is exactly the same quantity of numbers in the first list as in the second! These two infinite collections are equal. You could treat all the odd numbers in the same way so the addition of two infinities (the odd numbers and the even numbers) equals a single infinity (all the numbers). Strange, is it not?

The German mathematician Georg Cantor was the first to clarify this situation. The infinite collections that can be put into one-to-one correspondence with the natural numbers 1, 2, 3, 4 . . . are called "countable" infinities because that correspondence means that we can count them systematically. In 1873 Cantor went on to show that there are bigger infinities than the countable ones for which it is impossible to create such a correspondence: they

cannot be systematically counted. One example of such an uncountable infinity is the collection of all never-ending decimals, or the irrational numbers. Cantor then showed that we can create a never-ending staircase of infinities, each infinitely larger than the one below it in the sense that its members can't be put into one-to-one correspondence with the next infinity down the staircase.

Great physicists like Galileo had identified the strange counting paradoxes of infinite collections and decided that they should avoid having anything to do with them. In January 1693 Isaac Newton tried to explain the problems of established equilibrium between opposing forces of gravity in an infinite space, in a letter to Richard Bentley, but went off the rails because he thought that two equal infinities would become unequal if a finite quantity was added to one of them.[1] As we have seen, if N is a countable infinity then it obeys rules of "transfinite" arithmetic that are quite different from ordinary arithmetic with finite quantities: $N + N = N$, $2N = N$, $N - N = N$, $N \times N = N$ and $N + f = N$ where f is a finite quantity.

I have always found it intriguing that while Isaac Newton lost his way when grappling with the infinite, his eighteenth-century hymn-writing namesake and convert from slave trading, John Newton, appeared at first to have got it dead right. This other Newton was the author of the famous hymn "Amazing Grace" that has had repeated commercial and religious impact during the twentieth century, thanks in part to its striking "New Britain" tune that first appeared, penned by an unknown composer, in 1835 and was joined with Newton's words for the first time in 1847.

Newton wrote the original words of "Amazing Grace" as a poem for his small town parish of Olney in Buckinghamshire.[2] They would have chanted the words in those days, not sung them. It first appeared in a collection of Olney Hymns by Newton and William Cowper[3] in February 1779, and Newton wrote six stanzas. The first begins "Amazing grace! how sweet the sound/ That sav'd a wretch like me!/ I once was lost, but now am found,/ Was blind

but now I see." But his original sixth stanza is never sung today.[4] Instead, it has been replaced by another: "When we've been there ten thousand years,/ Bright shining as the sun,/ We've no less days to sing God's praise,/ Than when we first begun."

What catches the mathematical eye in these words is a characterization of infinity, or eternity, which is exactly right. Take any finite quantity from it ("ten thousand years" in this case) and it is no smaller and still infinite.

Alas, John Newton did not write this stanza. You can tell it is imported because the others are all in the first person "me" but suddenly we have switched to "we" and a "there" appears that refers to nothing that went before. The moving of stanzas between hymns was not unusual. This particular "wandering stanza," whose author is unknown,[5] has been around since at least 1790 but made its first appearance in this hymn when sung by a despairing Tom in Harriet Beecher Stowe's great anti-slavery novel of 1852, *Uncle Tom's Cabin*.[6] Whoever its unknown author was, he (or she) captured a profound definitional feature of the infinite that the great eighteenth-century mathematicians had missed because they lacked the confidence to think about the properties of actual infinities.

Poor Cantor, who saw the right path so clearly, was virtually hounded out of mathematical research for long periods of his career because influential mathematicians thought his work on the infinite was actually subverting mathematics by letting in potential logical contradictions that could threaten its entire structure. Today, Cantor's insights are fully recognized and form part of the standard theory of sets and logic.[7]

# 86

# Charles Dickens Was No Average Man; Florence Nightingale No Average Woman

Few realize that the great novelist Charles Dickens had an uneasy relationship with mathematics. Indeed, he led a great propaganda crusade against a part of it. Dickens lived at a time when the subject of statistics was emerging as a significant influence in Victorian social and political life. Pioneers like Adolphe Quetelet, in Belgium, were creating the first quantitative social sciences of criminology and human behavior – "the social physics" as Quetelet called it – while his disciples like Florence Nightingale (who was elected a Fellow of the Royal Statistical Society in 1858) used statistics to improve sanitation and patient care in hospitals, and devise vivid new ways to present data. In Scotland, William Playfair revolutionized economics and politics by creating so many of the graphs and bar charts that are now standard devices for presenting information and searching for correlations between different social and economic trends.

Dickens, in company with many other important political reformers, treated the new subject of statistics with deep suspicion. Indeed, he regarded it as a great evil. This sounds strange to modern ears. Why did he think like that? Dickens objected to measures that decided the health of society on the basis of averages, or downgraded

the fate of unfortunate individuals because they were a tiny minority
in a society whose health was being diagnosed by the statistics of
large numbers. Quetelet's famous concept of "the average man"
was a favorite bête noire because governments were able to use it
to say that people were better off now ("on the average"), even
though the poor were poorer than ever and their workplaces increas-
ingly hazardous. Low-paid jobs could be cut on the grounds that
average productivity needed to be higher. Individuals were lost in
the tails of the statistical bell curve. Dickens thought that politicians
used statistics to block progressive social legislation: they regarded
individual misery and criminal behavior as statistically determined
and unavoidable.

Several of Dickens's great novels touch on his deep antagonism
for statistics, but one in particular, *Hard Times*, published in 1854,
is fashioned around it. It tells the story of Thomas Gradgrind, a
man who wanted only facts and figures, who stood ready "to
measure any parcel of human nature, and tell you exactly what it
comes to." Even the pupils in the school class he teaches are
reduced to numbers. In Chapter 9 his daughter's friend Sissy Jupe
despairs that in class she always answers Gradgrind's questions
wrongly. When asked about the proportion when twenty-five
members of a city population of a million starve to death on the
streets in a year, she answers that it would be just as hard on them
if the others were a million or a million million – "and that was
wrong too," Mr Gradgrind said. On the wall of his office hangs
a "deadly statistical clock." The story tells how this attitude leads
to despair in his own life and that of his daughter Louisa, who is
forced to marry not where her love inclines, but where her father
judges the "statistics of marriage" unambiguously points her. The
end result of his single-minded philosophy was misery for all.

Dickens is a remarkable example of a great novelist energized
by a new part of mathematics which he thought was misused. If
he were alive today, he might be much engaged with statistical
league tables and the like.

# 87

# Markov's Literary Chains

The study of probability begins with the simplest situations, like throwing a die where each of the outcomes is equally likely (probability ⅙) if the die is fair. If the die is thrown a second time then this is an independent event and the probability of throwing a six both times is the product of the probabilities of throwing it each time, that is ⅙ × ⅙ = ⅟₃₆. However, not all successive events that we encounter are independent in this way. The air temperature today is generally correlated with the temperature yesterday, and a particular share's stock-market price today will be linked to its price in the past. The link, though, will have a probabilistic element to it. Suppose that we simplify by giving the weather only three states: hot (H), medium (M), and cold (C), then the nine possible temperature states over two successive days are HH, HM, HC, MH, MM, MC, CH, CM, or CC. Each pair can be given a probability using past evidence, so for example the chance of HH, i.e. a hot day coming after a hot day in the past, might have probability 0.6. In this way a 3 × 3 matrix Q can be constructed with these nine probabilities:

$$HH \quad HM \quad HC$$

$$MH \quad MM \quad MC$$

$$CH \quad CM \quad CC$$

If we start by putting the numbers in for the nine different temperature transitions we can work out, say, the probability that

in two days' time it will be hot given that it is hot or cold today by multiplying the matrix Q by Q to get the matrix product $Q^2$. To predict the probabilities for the temperature over three days given what it is today, just multiply by Q again to obtain $Q^3$. Gradually, after multiplying by the matrix Q lots of times, memory of the initial state tends to be lost and the transition probabilities settle down to a steady state in which each of the rows of the matrix are equal.

This extension of traditional eighteenth-century probability theory for successive independent events, like tossing a coin or a die, to the much more interesting situation of dependent events was created by the St. Petersburg mathematician Andrei Markov between 1906 and 1913. Today, his basic theory of chains of connected random events is a central tool in science and plays a key role in Internet search engines like Google. Their matrices of states are the billions of website addresses and the transitions are the links between them. Markov's probability chains help determine the probabilities that any searching reader will arrive at a particular page and how long it will take them.

After first developing this general theory Markov applied it in an imaginative way to literature. He wanted to know whether he could characterize a writer's style by the statistical properties of the sequences of letters that he or she habitually used. Today, we are familiar with such methods of authenticating newly discovered manuscripts claiming to be by Shakespeare or other famous authors. But it was Markov who first pursued this idea as an application of his new mathematical method.

Markov looked at an extract from Pushkin of 20,000 (Russian) letters which contained the entire first chapter and part of the second chapter of a prose poem, with its characteristic rhyming patterns.[1] Just as we simplified the temperature to just three states in our example above, Markov simplified Pushkin's text by ignoring all punctuation marks and word breaks and looked at the correlations of successive letters according to whether they were vowels

(V) or consonants (C). He did this rather laboriously by hand (no computers then!) and totalled 8,638 vowels and 11,362 consonants. Next, he was interested in the transitions between successive letters: investigating the frequencies with which the vowels and consonants are adjacent in the patterns VV, VC, CV, or CC. He finds 1,104 examples of VV, 7,534 of VC and CV, and 3,827 of CC. These numbers are interesting because if consonants and vowels had appeared randomly according to their total numbers we ought to have found 3,033 of VV, 4,755 of VC and CV, and 7,457 of CC. Not surprisingly, Pushkin doesn't write at random. The probability VV or CC is very different from VC, and this reflects the fact that language is primarily spoken rather than written and adjacent vowels and consonants make for clear vocalization.[2] But Markov could quantify the degree to which Pushkin's writing is non-random and compare its use of vowels and consonants with that of other writers. If Pushkin's text were random then the probability that any letter is a vowel is $^{8,638}/_{20,000} = 0.43$ and that it is a consonant is $^{11,362}/_{20,000} = 0.57$. If successive letters are randomly placed then the probability of the sequence VV being found would be $0.43 \times 0.43 = 0.185$ and so 19,999 pairs of letters would contain $19,999 \times 0.185 = 3,720$ VV pairs. Pushkin's text contained only 1,104. The probability of CC is $0.57 \times 0.57 = 0.325$. And the probability of a sequence consisting of one vowel and one consonant, CV or VC, is $2(0.43 \times 0.57) = 0.490$.

Later, Markov analyzed other pieces of writing in the same way. Unfortunately, his work only seems to have been appreciated when interest in the statistics of language arose in the mid-1950s, but even then an English translation of his pioneering paper was only published in 2006.[3] You can try his methods for yourself on other pieces of writing. Of course, there are many other indicators that can be chosen apart from the pattern of vowels and consonants, like measures of sentence or word length, and computers make more sophisticated indicators simple to evaluate.

# From Free Will to the Russian Elections

We have already seen that Charles Dickens became engaged in a propaganda battle against mathematical statistics, which he believed had a negative influence on social reform. In Russia an analogous collision between statistics and the humanities occurred in the first decade of the twentieth century when some Russian mathematicians with strong links to the Russian Orthodox Church sought to show that statistics could be used to establish the existence of free will. The leader of this movement was Pavel Nekrasov, a member of the mathematics faculty at Moscow State University, which was at that time a bastion of Russian theological Orthodoxy.[1] Originally, he had trained for the priesthood but later switched very successfully to mathematics and went on to make some important discoveries.

Nekrasov believed that he could make an important contribution to the age-old debate about free will versus determinism by characterizing free human acts as statistically independent events which had not been determined by what had gone before. Mathematicians had proved the Central Limit theorem, or the so-called "law of large numbers," that demonstrated that if a large number of statistically independent events are added together then the resulting pattern of frequencies of the different possible outcomes will approach a particular bell-shaped curve, known as the normal or Gaussian distribution. As the number of events gets

larger, so the convergence to this type of curve gets closer and closer. Nekrasov claimed that social scientists had discovered that all sorts of statistics governing human behavior – crime, life expectancy, and ill health – followed the law of large numbers. Therefore, he concluded, they must have arisen from the sums of very many statistically independent acts. That meant that they were freely chosen independent acts and so people must have free will.

Andrei Markov was enraged by Nekrasov's claims and maintained that he was abusing mathematics and bringing it into disrepute. We have already seen in the last chapter that Markov invented the mathematics of time series of dependent probabilities. Based in St. Petersburg, and a notorious curmudgeon, he seemed to dislike the Moscow academic world, with its ecclesiastical and monarchist leanings, in general, and Nekrasov in particular. Markov responded to the "proof" of free will by drawing on his studies of chains of random processes to show that although statistical independence leads to the law of large numbers the opposite is not true. If a system can reside in any one of a finite number of states, its next state depending only on its present state, and with the probabilities for possible changes at the next time-step remaining constant, then the state will evolve more and more closely toward the definite distribution predicted by the law of large numbers as time increases.[2]

Thus Markov disproved Nekrasov's grand claim, although he had to develop new mathematics to do so. Nekrasov was merely using the current assumptions about the relationship between independence and the law of large numbers that were part of the inherited wisdom of probability theory. Markov was the first to study sequences of linked probabilities[3] so he could provide the counterexample needed to refute Nekrasov's false deduction. The fact that social behavior followed the equilibrium distributions found by social scientists did not mean that they had arisen from statistically independent events and so they had nothing to tell us about free will.

Remarkably, this same type of dispute reemerged very recently in Russia following the last elections to the Russian Duma in December 2011. There were widespread demonstrations claiming that there had been electoral fraud because the distribution of votes between different voting precincts (the percentage of the vote for different parties) did not follow the law of large numbers. Banners were pressed through the streets proclaiming (in Russian!) "We are for the Normal Distribution" and "Putin doesn't agree with Gauss."[4] Alas, people do not vote independently of their friends, neighbors, and family and so the law of large numbers does not apply to the voting patterns across the precincts. Instead, we have a situation like Markov's where each person's vote is influenced by those of others. The distribution of votes between different precincts can therefore easily look like the flat pattern advertised as fraudulent on the protest posters. We do not expect the distribution of outcomes to follow Gauss's law of large numbers unless people all vote by tossing a coin. However, just because the voting patterns are consistent with Markov's picture doesn't mean they might not be rigged and the argument on that score continued for some time, with claims of systematic irregularities being made based upon other more sophisticated statistical probes.[5]

# Playing with Supreme Beings

One of the most appealing things about mathematics is when you see it applied to a subject that you didn't think was mathematical. One of my favorite exponents of imaginative applications of mathematics is Steven Brams of New York University.[1] One of his interests has been applying the mathematical theory of games to problems of politics, philosophy, history, literature, and theology.[2] Here is one example of a problem in philosophical theology about whether God exists.

Brams considers the different strategies that might be adopted by a human being (H) and God (or "Supreme Being" SB) in this matter. Taking on board some of the imperatives of the Judeo-Christian tradition he creates a very simple revelation "game" in which H and SB both have two possible strategies: H can believe in the SB's existence or H can disbelieve in the SB's existence. SB can reveal or not reveal Himself.

For H, the principal goal is to have his belief or unbelief confirmed by the evidence available; a secondary goal is a preference to believe in SB's existence. But for SB the principal goal is to have H believe in His existence and His secondary goal is to avoid revealing himself.

We can now look at the four possible combinations for the two "players" in the revelation game, ranking the outcome for each player on a scale from 1 (for the worst outcome) up to 4 (for the best). The grid showing the possible combinations is shown here with each of the four possible outcomes labeled by a pair (A, B)

where the first entry (A) gives the SB's ranking of this strategy and the second (B) gives the human's.

|  | H believes SB exists | H disbelieves SB exists |
|---|---|---|
| SB reveals existence | (3, 4) H's faith is confirmed by evidence | (1, 1) H doesn't believe despite evidence |
| SB doesn't reveal existence | (4, 2) H believes despite no confirming evidence | (2, 3) H's unbelief confirmed by lack of evidence |

Now we ask if there are optimal strategies for the human being and the Supreme Being to adopt in this revelation game, in the sense that if either of them deviated from that optimal strategy they would be worse off. We see that when H believes that SB exists, SB is better off not revealing His existence (4 > 3 in the first entry in the brackets), and when H doesn't believe in SB the same is true (because 2 > 1). This means that SB will not reveal Himself. But H can also deduce this from the table of outcomes and has then to choose between believing in SB (ranked 2 for him) and not believing (ranked 3 for him). So, with these rankings, H should go for the more highly ranked option (3) of not believing in SB's existence. Therefore, if each player knows the other's preferences, the optimal strategy for both is for the SB not to reveal Himself and for humans to disbelieve in His existence. However, while this may sound problematic for a theist, there is a paradox: the outcome seems worse for both players than the one (3, 4) where SB reveals Himself and H has his belief confirmed. Unfortunately, the SB's failure to reveal Himself may occur either because He doesn't exist or because He chooses to be secretive. This is the major difficulty that H faces here because game theory cannot tell us the reason for SB's strategy of nonrevelation.

# 90

# The Drawbacks of Being a Know-all

Omniscience, knowing everything, sounds as though it could be a useful attribute even though it might give you a headache after a while. Yet, surprisingly, there are situations in which it would be a real liability and you would be better off without it. The simplest example is when two people are vying with each other in a confrontation that is a game of "chicken." Such encounters are characterized by a situation in which the loser is the first player to "blink." If neither blinks then there is mutually assured destruction. The clash of two nuclear superpowers is one example. Another would be two car drivers heading toward each other at top speed to see who will swerve out of the way first to avoid the crash. The loser is the first to pull out.

This game of chicken has an unexpected property: omniscience becomes a liability. If your opponents know that you have it then you will always lose. If you know that your opponent always knows what you will do in the future then this means that you should never pull out of the looming crash. Your omniscient opponent will know this is your strategy and will have to duck out to avoid being destroyed. If he had not been omniscient he could still have counted on you coming to your senses and chickening out before him. Omniscience is powerful if it is held in secret. Otherwise it shows us that although a little knowledge is said to be a bad thing, too much can be far worse!

# 91

# Watching Paint Crack

Craquelure is the fine cracking you will see on the surface of an old oil painting. It arises because of the responses of the paint pigments, the glue, and the canvas to changes in temperature and humidity over time. It is complicated because these responses are all different. Sometimes the resulting criss-cross pattern adds a distinguished antique character to the picture, so long as its effects are regular and discreet. It also helps guard against forgery because it is extremely difficult to fake a realistic development of craquelure on an old painting.

After a canvas is initially stretched and fixed to its wooden frame the stress force exerted on the canvas will diminish, quickly at first and then more slowly as it stretches and relaxes, typically halving from about 400 to 200 N/m over three months. If this relaxation didn't occur then oil paintings wouldn't survive: the strain on the paint surface would just be too great. However, if the canvas is subsequently allowed to become too slack the paint will cease to hold to the surface and flake away. The strain produced by a stress applied to oil paint produces a steady elongation with respect to the applied force until a breaking point is reached. Then the paint will crack. This could be caused by the shrinking of the canvas as it dries out, or by the drying out of the paint if the temperature rises or humidity falls. This is why galleries and sites which contain great works of art in situ, like Leonardo's *Last Supper* on a wall in the church of Santa Maria delle Grazie in Milan, now go to great lengths to control visitor numbers: visitors mean heat and

humidity. If the picture's environment cools off at the end of the day when visitors leave or heating is reduced then the paint will shrink. The older the paint the less flexible it will be when subjected to this stress. It appears that the effects of changing the temperature by 50 to 68°F are greater than an alteration in humidity between 15 and 55 percent.[1] This is counter to the view one often hears about the prime importance of controlling humidity. When the canvas alone is tested the relative importance of temperature and humidity is reversed.

When cracking occurs on the surface of an oil painting there is a simple logic to the patterns that result.[2]

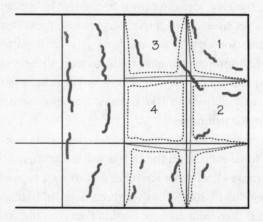

This figure shows the fate of a painting that has just undergone a temperature reduction of about 68°F. The right-hand end is held by a stiff frame along the top, bottom, and vertical side which restrains the tendency of the cooling paint layer to shrink. The thin solid grid lines show the original position of the paint. Each square will try to shrink by scaling down uniformly but cannot do so on the sides where it is held fixed to the frame. As a result the edge squares distort and follow the dotted lines. For example, square 1 (and its counterpart at the bottom corner) is held on two sides and suffers the greatest distortion; squares 2 and 3 are only fixed on one side and so suffer less; square 4 can

move in all directions and is tugged toward the two corners where the largest stresses are pointing. If we keep working toward the center of the painting the stresses and cracks will get less and less. Brittle paint will crack first along the directions that release most of the strain. This strain is at right angles to the applied stress and is shown by the short solid wiggly lines. In the middle of the picture, therefore, we see the cracks running parallel to the vertical sides. Gradually, as we approach the vertical side they bend around and flow horizontally into the sides. Conversely, cracks starting from the middle of the vertical side curve up and down toward the top or bottom horizontal edge of the frame according to which is closest. Right in the middle they just run horizontally. Simulations of this process confirm that we should expect cooling stresses to create cracking all over the picture with the corner stresses only about 5 percent greater than those at the center.[3] By contrast, when stresses in the paint layer arise because of drying paint the variations between the corners and the center are far greater – nearly twice as much – and the cracking will occur much more noticeably in the four corners.

# Pop Music's Magic Equation

Every so often there is a news story that an equation has been found to predict how to make the best chocolate cake, choose the best marriage partner, or create the most appealing artwork. This type of thing has a long history.

A more sophisticated example from this genre is an attempt to produce an equation that captures the essential ingredients of a "hit" pop record. In fact, to do this convincingly you should also be able to predict the characteristics of unsuccessful records ("misses") as well as many of the ones that end up somewhere in between. In 2012 a Bristol University research group in the Engineering Department's Intelligent Systems Group led by Tijl de Bie tried to do this by identifying a number of intrinsic qualities of pop music, weighting each one in some way and adding them all together.[1] This creates a formula for the "score" S of a pop song that in the case of twenty-three intrinsic qualities, $Q_1$ to $Q_{23}$, weighted by the numbers $w_1$ to $w_{20}$, looks like[2]:

$$S = w_1Q_1 + w_2Q_2 + w_3Q_3 + w_4Q_4 + \ldots + w_{23}Q_{23}.$$

The qualities chosen for the twenty-three Q's were individually simple to quantify and determine. While aspects of our brain structure no doubt play a part in determining what we like, these complicated neural and psychological factors can't so easily be discovered and measured. The investigators also excluded external influences like how big the publicity budget for a record was or

how often a pop group's members were arrested for outrageous behavior or whether they were married to well-known footballers. Instead, they picked twenty-three qualities like duration, loudness, tempo, complexity of time signature, beat variation, degree of harmonic simplicity, energy, or how noisily unharmonic the music was. This listing provides the Q's. What about the w's? Here, some computer analysis of huge numbers of pop records was needed to evaluate the past and present success of recordings that were found to possess particular suites of Q-rated qualities. Totaling up their hit-parade history against their qualities enabled the researchers to determine which qualities were shared by more successful hit records and which ones characterized misses.

Of course, this is a subtle analysis because musical tastes change steadily over time; one of the most interesting by-products of this research was to see how they did and which qualities came to the fore in different periods. This historical trend in pop-pickers' tastes was then used to reeducate the formula for S. The changing tastes mean that the weights need to change slowly in time, losing memory of their earlier values as trends and tastes evolve. Gradually, the formula forgets past trends and adapts to new ones. This is done by replacing each $Q_j$ by $Q_j \times m^{t-j}$ in the sum for S, where the number m is a memory factor which gauges how our liking for particular qualities changes over time. We may once have liked very loud music but later we may not. As j grows from 1 up to 23 in the sum of terms for S, the power t-j to which m is raised gets smaller and smaller and the effect of the memory is lost when j reaches its largest value[3] t = j, whereas when j = 1 the memory effect will be the largest. The new formula is now optimized[4] to find the set of weights that gives the highest score for the prespecified qualities. Given a new demonstration CD received through the mail from a prospective pop group, an agent can now evaluate its current hit potential by applying the magic formula.

The Bristol group retrospectively confirmed several big UK hits

from the past using their formula, like Elvis Presley's "Suspicious Minds" in the late 1960s, T. Rex's "Get It On" in the 1970s, and Simply Red's "If You Don't Know Me by Now" at the end of the 1980s. However, they found some unexpectedly successful hit records that scored low on the formula, like Pavarotti's "*Nessun Dorma*" after its massive audience during the football World Cup in 1990 and Fleetwood Mac's "Albatross" in 1968 – both somewhat atypical of their contemporary rock competitors but perhaps driven by other factors.

Needless to say, the university researchers devising this piece of computer intelligence do not dedicate their professional lives to studying the construction of pop music. The type of computer analysis and component analysis used to understand its most successful recordings are not confined to music. They are an important way of looking at many complex problems where the human mind just seems to make judgments intuitively but which, when evaluated in the right way, can be seen to follow a set of simple optimal choices.

# 93

# Random Art

Random art has many motivations. It may be a reaction to clas-
sical artistic style, the desire to explore pure color, an attempt at
seeing what can emerge from a composition in the minds of the
viewer, or simply an experiment with new forms of artistic expres-
sion. Despite the appealing absence of rules and constraints about
what (if anything) goes on the canvas and how, this form of art
has produced a number of surprisingly well-defined genres. The
most famous are those of Jackson Pollock and Piet Mondrian.
They both have particular mathematical features, with Pollock's
apparent use of scale-invariant fractal patterning (although this
has become increasingly controversial as we shall see in the next
chapter) and Mondrian's primary-colored rectangles described in
Chapter 36.

A third example, that is neither the abstract expressionism of
Pollock nor the cubist minimalism of Mondrian, is provided by
the formal constructivism of Ellsworth Kelly or Gerhard Richter.
Both use random color selection to attract the eye. The colors
are hard edged and arrayed in regular fashion, most notably in
grids of colored squares.[1] Richter puts together up to 196 different
$10 \times 10$ (or $5 \times 5$) panels with each grid square taking a color
from a palette of 25 possibilities. He can assemble them into a
single gigantic $1,960 \times 1,960$ (or $980 \times 980$) square or space them
out into isolated panels, or clustered groups, according to the
available gallery space. The color for each square is chosen
randomly (a 1 in 25 chance of any color) and has an interesting

psychological effect. Most people have a wrong view of what a random pattern looks like. Their intuition is that there must be no runs of the same outcome: they think it must be far more orderly, with fewer extremes, than is a true random sequence. If we toss a coin with outcomes heads (H) and tails (T) then here are two sequences of thirty-two tosses: one is randomly generated by the coin tossing and the other is not random – which is which?

THHTHTHTHTHTHTHTHTTTHTHTHTHTHTHH

THHHHTTTTHTTHHHHTTHTHHTTHTTHTHHH

Most people identify the top sequence as being random. It alternates a lot between H and T and has no long runs of H's or T's. The second looks intuitively non-random because there are several longs runs of H's and T's. In fact, the bottom sequence was randomly generated by real unbiased coin tosses and the top sequence is one I just wrote down to look "randomish" so it tends to avoid long runs of H's or T's.

Independent coin tossing has no memory. The chance of a head or a tail from a fair toss is ½ each time, regardless of the outcome of the last toss. They are each independent events. The chance of a run of r heads or r tails coming up in sequence is just given by the multiplication $½ \times ½ \times ½ \times ½ \times \ldots \times ½$, r times. This is $½^r$. But if we toss our coin very many times so that there are N different possible starts to the run of heads or tails, our chance of a run of length r is increased to $N \times ½^r$. A run of length r is going to become likely when $N \times ½^r$ is roughly equal to 1, that is when $N = 2^r$. This has a very simple meaning. If you look at a list of about N random coin tosses then you expect to find runs of length r where $N = 2^r$. All our sequences were of length $N = 32 = 2^5$, so we expect there is a better than even chance that they will contain a run of five heads or tails

and they will almost surely contain runs of length four. For instance, with thirty-two tosses there are twenty-eight starting points which allow for a run of five heads or tails and on average two runs of each is quite likely. When the number of tosses gets large we can forget about the difference between the number of tosses and the number of starting points and use $N = 2^r$ as the handy rule of thumb. The absence of these runs of heads or tails is what should make you suspicious about the first sequence and happy about the randomness of the second. The lesson learned is that our intuitions about randomness are biased toward thinking it a good deal more uniformly ordered than it really is.

It is this counterintuitive structuring in purely random sequences that artists like Kelly and Richter exploit in order to engage us when we look at their pictures. Each realization in Richter's panels is random in the sense that the color chosen for each square is selected at random independently of all the others. Runs of one color will arise. Take his giant grid of 196 colored $10 \times 10$ squares. If we cut up the rows and put them side by side to form a single strip then we have a line of $1,960 \times 1,960 = 3,841,600$ squares. There are twenty-five different colors to choose from, so if they were simply a one-dimensional line then a run of r squares of the same color would occur for $3,841,600 = 25^r$. Since $25^4 = 390,625$ and $25^5 = 9,765,625$ we see that it is very likely that we will find linear runs of four squares of the same color and we might occasionally see runs of five. However, when the lines of colors are made into a square the eye can seek out other lines along vertical columns or diagonals which occasionally form small blocks of the same color. The figure on the next page shows a $5 \times 5$ square that has been populated by taking the random sequence of H and T shown above across one row after another from the top down. The H squares have been colored black to highlight the color blocks.

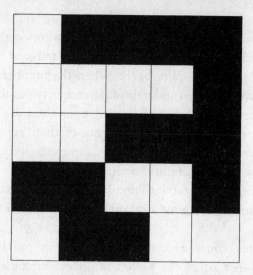

With only two colors the blocks of one color are rather large. As the palette increases in size more variation is possible. Horizontal and vertical runs of one color are proportional to log(n) in a random square n × n array of blocks of two colors. If we are interested in diagonal runs as well then an increased number of starting points doubles the probability. The diagonal runs are therefore twice as likely. Lines of one color are not the only distraction. When several are adjacent they produce blocks. The purely random population of squares can occasionally produce rather too many blocks of the same color so there seems to be some intervention by the artist to harmonize the appearance of the overall pattern by changing the colors of some of the random outcomes. The message is that creating aesthetically appealing random art is not so easy. Viewers always tend to think that truly random patterns have too much order in them.

# 94

# Jack the Dripper

There has been considerable controversy in recent years over one fascinating application of mathematics to art. Art historians, valuers, and auction houses would love to find a completely foolproof means of identifying a painter's work. Back in 2006, this Holy Grail appeared to have been found, at least for one famous artist, when Richard Taylor and colleagues at the University of Oregon in Eugene showed that it was possible to do a mathematical analysis of the complexity of the paint layers in the works of abstract expressionist Jackson Pollock and reveal a special complexity signature.[1] The signature was the "fractal dimension" of the brushwork. Roughly speaking, it measures the "busy-ness" of the brushwork and the extent to which this quality changes with the size of the regions surveyed on the picture.

Imagine that a square canvas is divided into a grid of smaller squares. If we draw a straight line across the canvas then the number of squares it intersects will vary according to the size of the grid squares we draw. The smaller the squares, the more intersections there are. For a straight line, the number of squares cut through is proportional to $1/L$ where $L$ is the edge length of the square.

If the line we draw is not straight but can wiggle around the canvas then it will intersect many more squares than a straight line. It would be possible for a sufficiently intricate line to visit every square, even when the grid is very fine. In these cases the wiggly line, although just a one-dimensional line from a geometrical point of view, is behaving increasingly like a two-dimensional area when it comes to its coverage of space. We say it is a "fractal" if the number of squares of side L that it intersects increases as $1/L^D$ as L gets smaller and smaller. The number D is a number called the fractal dimension and measures the complexity of the line pattern. It lies between 1, in the case of the straight line, and 2, the case where the entire area is colored in by a very complicated wiggly line. When D is in between 1 and 2 the line behaves as if it has a fractional dimension.

A pattern need not conform to this simple $1/L^D$ rule: not all patterns have a fractal form. Notice that if L doubled in a fractal, say, to 2L then the number of intersections is still proportional to $1/L^D$. This property of "self-similarity" is what characterizes a fractal. If you look at a fractal under a magnifying glass then it looks statistically the same at all magnifications. In itself, this is a very interesting property of an abstract artwork. Perhaps, as we suggested in Chapter 50, Pollock intuitively sensed this feature in his work?[2] It means that the viewer gets the same impression regardless of whether he or she sees the painting full size, or reduced in a book.

Taylor applied this method to the different paint layers in several of Jackson Pollock's drip paintings. There is film of Pollock at work and we can understand his technique in some detail. The paintings were made on a large canvas laid on his studio floor. The final work was cut out of its center so as to minimize edge effects. Different colors were applied layer by layer using two distinct techniques. Over short distances he dripped paint and over larger distances he threw it randomly. Taylor analyzed seventeen Pollock canvases using a square grid size that ran from L = 2.08

m (the whole canvas size) down to L = 0.8 mm (the smallest paint drip size). He found that they had a double fractal structure, with $D_{throw}$ close to 2 over 1 cm < L < 2.5 m and $D_{drip}$ close to 1.6–1.7 over 1 mm < L < 5 cm: $D_{drip}$ was always less than $D_{throw}$ so the large-scale complexity is greater than the small-scale complexity.

This can be done for each color layer. Taylor and his colleagues later argued that studies of other artworks and patterns indicated that fractal dimensions with D near 1.8 were found to be aesthetically more pleasing than others.[3] Other investigators looked at more detailed aspects of their approach and applied them to other abstract artworks.[4] They turned out to have analogous properties, so fractal methods did not look promising as a tool to distinguish the work of different artists – although that distinction is rarely needed except in the case where one of the "artists" is an unknown forger. In their Pollock studies, Taylor et al. argued that there was evidence for a gradual increase in the value of $D_{throw}$ from a value near 1 up to about 1.7 during Pollock's career from 1940 until 1952: his work was therefore becoming more elaborate with time.

These interesting studies led to a proposal that it should be possible to determine the authenticity of unsigned "Pollocks" – of which there are many – by subjecting them to a fractal analysis. The criteria put forward combined the identification of fractal variation over small and large scales for each color layer with the presence of a characteristic change in the value of D, at a scale of a few centimeters, and the requirement that $D_{drip} > D_{throw}$.

Taylor was able to disqualify at least one purported Pollock by this method and was then invited by the Pollock–Krasner Foundation to analyze six of the cache of thirty-two small unsigned Pollock-like canvases discovered by Alex Matter in May 2005 among his late parents' possessions. Herbert and Mercedes Matter had been close friends of Pollock and these canvases were found after their deaths with identifying labels written by Herbert, describing them as "experimental works" of "Pollock (1946–9)." Although they were authenticated by a leading Pollock scholar, Ellen Landau,

at Case Western Reserve University, none met Taylor's fractal criteria when he applied them[5] at the request of the Pollock–Krasner Foundation[6] in New York. So far, none of these works have sold. The question of authenticity is a very big one because Pollock's works are among the most expensive in the world – one entitled *No. 5, 1948* was sold by private sale at Sotheby's in 2006 for over $161 million. To add to the controversy, a forensic analysis in 2006 at Harvard University's art museums of the paint in some of the works claimed that they contained orange pigments that were not available until 1971, long after Pollock's death in 1956. This suggests the works in question may, at the very least, have been added to by hands other than Pollock's.

The publicity surrounding these developments led Kate Jones-Smith and Harsh Mathur, like Landau at Case Western Reserve University, to look again at the fractal signature of Pollock's paintings.[7] They ended up disagreeing with Taylor's claims. They found that there were several known Pollocks that clearly failed the fractal criteria and believed that too few Pollock works had been analyzed to arrive at a useful quantitative fractal test. Moreover, they were concerned that the range of box sizes used, from canvas dimension down to individual paint blob size, was too small to establish the fractal behavior and the reality of any change in the value of D. They also disagreed with the conclusion to fail one of the Matter group that they studied as a true Pollock and created a number of their own freehand wavy drawings and Photoshop works that passed Taylor's publicized Pollock-authentication tests. Overall they maintained that this type of simple fractal analysis could not be used to tell true Pollocks from fakes.

Taylor, now working with Adam Micolich and David Jonas, responded by arguing that the range of box sizes was entirely adequate and at least as wide as that used to identify many other fractals in *Nature*.[8] They also revealed that they had employed further criteria, in addition to those they made publicly available, when testing for true Pollocks. The counterexamples provided by

Jones-Smith and Mathur were said to fail this more stringent set of criteria and did not adequately mimic fractal behavior. Although some extra criteria have been revealed,[9] it is still claimed that all the extra validation criteria have not been made public by Taylor et al., together with the methods they use to separate colors. This is not surprising: forgers should not know what tests they have to pass in order to get their efforts authenticated! It is clear that the last drip of this type of mathematical analysis has not yet fallen.

# 95

# The Bridge of Strings

The Bridge of Strings, or the Jerusalem Chords Bridge as it is also known, is an aesthetically pleasing steel-cabled, 118-meter-high suspension bridge designed by the Spanish architect Santiago Calatrava which opened in 2008. It is at the entrance to the west side of Jerusalem and carries the light railway system. Calatrava had originally been challenged by the mayor of Jerusalem to create the most beautiful bridge possible. He responded by using an elegant mathematical construction in which the suspension cables of the bridge hang like the strings of a harp – King David's harp, perhaps – yet combine to create an elegant flowing curve.

The basic recipe for the construction is something you may recognize from small-scale string art. We use a collection of straight lines to generate a smooth curve, or "envelope," that is traced out

by their points of intersection. Label the x and y axes of a graph by 0, 0.1, 0.2, 0.3 . . . as in the figure below.

Now draw a straight line from the point $(x,y) = (0,1)$ down to cut the x axis at $(x,y) = (T,0)$. The equation of this straight line with intersection at $x = T$ is:

$$y_T = 1 - T - x(1 - T)/T \ (\star)$$

The figure shows lots of these lines with equally spaced starting points on the vertical axis and intersection points on the horizontal. You can see how they create a bounding curve, the "envelope," which will get smoother and smoother as the number of straight lines used increases and they start and end closer together.

What is the form of this enveloping curve? To generate its smooth form we just look at the whole family of straight lines that arises as we let T change from 0 to 1. Look first at two straight lines that are very close together, one cutting the x axis where $x = T$, and the other neighboring one that cuts it at

x = T + d, where d is very small. We get the equation of this neighboring line by replacing T with T + d in the equation on the previous page (*) to get:

$$y_{T+d} = 1 - (T + d) - x(1 - T - d)/(T + d)$$

To find the intersection point of this line with the one described by (*) just put $y_T = y_{T+d}$ and we find $x = T^2 + Td$. As we let the two lines get closer and closer together by allowing d to tend toward zero we see that we tend toward $x = T^2$. Then substituting from the first formula (*) gives us the corresponding answer for $y = 1 - T - T^2(1 - T)/T = (1 - T)^2$ after a little algebra. The curve of the envelope formed by all the straight lines as we change T from 0 to 1 is therefore $y = (1 - \sqrt{x})^2$. This curve is a parabola, inclined at 45 degrees relative to the vertical axis.[1]

The parabolic envelope that arises from the family of touching straight lines traces out a special smooth curve that makes the transition from the vertical y axis to the horizontal x axis as smoothly as possible. It creates the aesthetically pleasing curves of the Bridge of Strings without any actual curved cables being used: it is a visual effect. In fact, the Jerusalem Bridge incorporates more than one of these envelopes in different directions for added visual effect and structural stability. This envelope curve is the simplest example of an unlimited collection of smooth transition "Bézier" curves that can be created to handle transitions containing any number of changes of direction or wiggles.[2] They were first used to design the profiles of sports cars[3] and characterize the "stringed figure" sculptures of Henry Moore, who spanned small sculptures in wood and stone with families of lines to create parabolic envelope curves.

Smooth Bézier transition curves are how modern fonts like Postscript and True Type were created and how graphics programs like Adobe Illustrator and CorelDRAW work. You can see from

these enlargements of simple characters how smooth curves build up the symbols in a font:

$$£\ 6\ a\ g\ e\ 9\ ?$$

They are also used in computer animation for films, where they produce natural smooth motion of cartoon characters through space by controlling the speed at which a smooth transition occurs along their paths of movement.

# 96

# Lacing Problems

The transformation of canvas shoes into running shoes and then into "sneakers" has created a raft of unforeseen fashion challenges as well as an increase in price by a factor of ten at each step. The way these shoes are laced up (or aren't laced at all) becomes an important sartorial statement among young people. Looking farther afield, one can see that lacing patterns have played an important historical role in dresses and bodices of the past and present.

Let's look specifically at the shoelace problem in which there are an even number of eyelets perfectly aligned in two parallel columns for a lace to pass through. We assume the lace is completely flat. It can crisscross from one column of eyelets to the other, horizontally or diagonally, or it can link vertically with its nearest neighbor in the same column. In order for the lacing to be useful, at least one of the two links should not be entirely in the same column as the eyelet it ends up at. This ensures that when the laces are pulled taut every eyelet feels some tension and will help to draw the two sides of the shoe together.

There are many ways to lace the shoe. If there are twelve eyelets then theoretically you have twelve choices about where to start the lacing and then two more because you can lace up or down in the same column or crosswise to the other column – so there are twenty-four starting moves. Similarly, for the next step you have $2 \times 11 = 22$ possible moves, and so on, right down to the last eyelet, where you have only a choice of the two directions.

These are all independent choices and so there are 24 × 22 × 20 × 18 × . . . × 4 × 2 = 1,961,990,553,600 possible lacings! We can divide this astronomical number by 2 because half are simply mirror images of others and then divide by 2 again because following one lacing from start to finish is the same as tracing it in the opposite direction. This still leaves over 490 billion permutations.[1] However, if you really want more, then you could introduce different ways of crossing the laces between eyelets or allow multiple visits to the same eyelet.

If the purely vertical links are excluded so that all the lacing goes across between the two columns then the number of possibilities is just ½ n!(n − 1)!, which is 43,200 for n = 6 in each column.

Most of these lacing paths are not terribly interesting as practical ways to tie your shoes up. Shoelacing aficionado Ian Fieggen[2] selects just thirty-nine of them as practical ones. The simple feature one can calculate for each is the total length of lace required. The shortest length possible might be a useful thing to know.

bow tie   crisscross   zigzag   star   crazy

Five interesting styles are shown in the figure. The total length of each depends on the vertical distance between eyelets in the same column (h, say) and the distance between columns (1, say). The total length of any lacing is easily calculated by multiplying the number of vertical links by h and adding the number of

horizontal links times 1 and the number of diagonal links times their lengths (which can be obtained by using Pythagoras' theorem around the triangles whose perpendicular sides will be 1 and some multiple of h. For example, in the "crisscross" lacing, each diagonal length is just the square root of $1^2 + h^2$). The four possibilities shown in the figure use more lace as you go from left to right. Obviously, the diagonal is always longer than either the horizontal or vertical spacing. The most economical lacing is the "bow tie" configuration with a total length of $6h + 2 + 4\sqrt{(1 + h^2)}$. The crisscross has length $2 + 10\sqrt{(1 + h^2)}$, which is clearly longer because $\sqrt{(1 + h^2)}$ must be bigger than h.

Length is not the only factor in choosing a lacing pattern though. The bow tie may be economical on cord, and avoids putting too much pressure on sensitive bits of your instep, but by having some vertical links it doesn't bring the two sides of the shoe together as forcefully as it might when you pull on the two lace ends. The laces act like pulleys winding around the eyelets, and the force that tightens the lacing up is the sum of all the horizontally directed tensions in the laces. You can work this out by summing up all the horizontal links, ignoring the perpendicular vertical ones, and multiplying the diagonal ones by the cosine of the angle between their direction and the horizontal, which is $1/\sqrt{(1 + h^2)}$, if they join neighboring rows. Math and shoelacing aficionado Buckard Polster of Monash University in Melbourne did this accounting and found[3] that when there are more than two eyelets there is a particular spacing between rows of eyelets, h*, relative to the distance between columns (1, here) such that when h is less than h* the crisscross is the strongest lacing whereas when h exceeds h* the zigzag lacing is strongest. When h = h* the two are equally strong. Typical shoes seem to have an h value close to the special value h*, and so you can use either lacing with almost equal results. In those circumstances you might well go for the standard crisscross lacing because, unlike the zigzag, it is easy to see that you are going to end up with the same lengths of free lace with which to tie the knot.

# Where to Stand to Look at Statues

Many of the great cities of the world offer fine statues to be admired from a distance. Usually, they stand on pedestals or are affixed to facades far above our heads. Where should we stand to get the best possible view of them? If we stand very close we find ourselves looking almost vertically upward and capture only a small cross-section of the front. So we need to be farther away, but how much farther? As we go away from the statue on its pedestal it appears smaller and smaller; go closer and it looks steadily larger until we get too close and it starts to look smaller again. In between there must be an optimal viewing distance, in the sense that the statue appears at its biggest.

We can find this distance by setting up the viewing scenario as in the figure on the next page. You are located at Y; the height of the statue's pedestal is T above your eyes and the height of the statue on top of it is S. These distances are fixed but we can change x, the distance you stand from the pillar.

A little geometry helps. The tangents of the angles $b$ and $b + a$ between the ground and the top of the pillar and the ground and the top of the statue, respectively, are given by:

$$\tan(a+b) = (S+T)/x \text{ and } \tan(b) = T/x$$

If we use the formula for:

$$\tan(a+b) = [\tan(a) + \tan(b)]/[1 - \tan(a)\tan(b)]$$

then we find that:

$$\tan(a) = Sx/[x^2 + T(S+T)]$$

Now we want to find the value of x for which the angle $a$ subtending the statue is maximized. To do this we just work out the differential $da/dx$ and set it equal to zero. Differentiating, we have:

$$\sec^2(a)da/dx = -S[x^2 - T(S+T)]/[x^2 + T(S+T)]^2$$

Since $\sec^2(a)$ is a square it is positive for $a$ values in between 0 and 90 degrees; we see that $da/dx = 0$ and the statue looks biggest when the numerator on the right-hand side is zero – that is, when:

$$x^2 = T(S+T)$$

This is the answer to our question. The optimal viewing distance x that makes the facade of the statue look the largest is given by

the geometric mean of the altitude of the pedestal and the altitude of the top of the statue, or x = $\sqrt{T(S+T)}$.

We can try this formula out for some well-known monuments. Nelson's Column in Trafalgar Square in London has T = 50 m above eye level, roughly, with S = 5.5 m, so you should stand about x = $\sqrt{2775}$ = 52.7 m away to get the best view. The Sphinx, at Giza just south of the Pyramid of Khafre, has S = 20 m and T = 43.5 m, so the optimal viewing distance is at 52.6 m. Michelangelo's statue of David in Florence[1] has S = 5.17 m and S + T = 6.17 m, so we need step back only to x = 2.48 m for the best view.[2] If you want to prepare for your visit to view one of the world's great statues on a pedestal then you can find the dimensions you need for calculating the optimal viewing point on helpful websites.[3]

# The Hotel Infinity

In a conventional hotel there is a *finite* number of individual rooms. If they are all occupied then there is no way a new arrival can be given a room at the hotel without evicting one of the existing guests from another. The mathematician David Hilbert[1] once imagined some of the odd things that could happen at an infinite hotel. In my stage play *Infinities*, directed by Luca Ronconi, and performed in Milan in 2001 and 2002, the first scene is an elaboration of the simple paradoxes that Hilbert imagined the hotel could face, set in an extraordinary theatrical space.[2] Suppose a traveler arrives at the check-in counter of the Hotel Infinity where there is an *infinite* number of rooms (numbered 1, 2, 3, 4 . . . and so on, forever), all of which are occupied. The check-in clerk is perplexed – the hotel is full – but the manager is unperturbed. Just ask the guest in room 1 to move to room 2, the guest in room 2 to move to room 3, and so on, forever. This leaves room 1 vacant for our new guest and everyone else still has a room.

The traveler returns next week with an *infinite* number of friends – all wanting rooms. Again, this popular hotel is full, and again, the manager is unperturbed. Without a second glance at the register, he moves the guest in room 1 to room 2, the guest in room 2 to room 4, the guest in room 3 to room 6, and so on, forever. This leaves all the odd-numbered rooms empty. There are now an infinite number of them free to accommodate the new arrivals. Needless to say room service is a little slow at times.

The next day the manager is downcast. His hotel's chain has

decided to sack all the other managers and close every hotel in their infinite chain except his (cutting an infinite amount off their salary bill). The bad news is that all the infinite number of existing guests staying in each one of the infinite number of other hotels in the Hotel Infinity chain are to be moved to *his* hotel. He needs to find rooms for an influx of guests from infinitely many other hotels, each of which had infinitely many guests, when his own hotel is already full. The new guests will start arriving soon.

Someone suggests using prime numbers (2, 3, 5, 7, 11, 13, 17 . . .), of which there are an infinite number.[3] Any whole number can be expressed as a product of prime factors in only one way; for example $42 = 2 \times 3 \times 7$. So put the infinite number of guests from hotel 1 into rooms 2, 4, 8, 16, 32 . . . ; from hotel 2 into rooms 3, 9, 27, 81 . . . ; from hotel 3 into 5, 25, 125, 625 . . . ; from hotel 4 into 7, 49, 343 . . . and so on. No room can ever be assigned more than one guest because if p and q are different primes and m and n are whole numbers then $p^m$ can never be equal to $q^n$.

A slightly simpler system is soon suggested by the manager which the staff at the check-in desk can apply very easily with the aid of a calculator. Put the guest arriving from the $m^{th}$ room of the $n^{th}$ hotel into room number $2^m \times 3^n$. No room can have two occupants.

Still the manager is not happy. He realizes that if this plan is implemented there will be a huge number of unoccupied rooms. All the rooms with numbers like 6, 10, and 12, which cannot be written as $2^m \times 3^n$, will be left empty.

A new and much more efficient suggestion is quickly forthcoming. Draw up a table with rows denoting the old room number of the arriving guest and the column denoting the old hotel number. So, the entry on the $5^{th}$ column of the $4^{th}$ row labels the guest arriving from the $5^{th}$ room of the $4^{th}$ hotel. The pair (R,H) means the guest is arriving from room R in hotel number H. Now it is simple to deal with the new arrivals by working through the

top-left squares of the table.

When the guests arrive the check-in staff need to allocate room 1 to the guest from (1,1); in room 2 put (1,2); in room 3 put (2,2); in room 4 put (2,1). This deals with all the guests from the square of side 2 in the top left of the table. Now do the square of side 3. Put (1,3) in room 5, (2,3) in 6, (3,3) in 7, (3,2) in 8, (3,1) in 9. The square of side 3 is now done in the table. This shows how you reallocate the guest who was in room n at hotel number m, who is denoted by (R,H):

| (1,1) to room 1 | (1,2) to room 2 | (1,3) to room 5 | (1,4) . . . (1,n) |
|---|---|---|---|
| (2,1) to room 4 | (2,2) to room 3 | (2,3) to room 6 | (2,4) . . . |
| (3,1) to room 9 | (3,2) to room 8 | (3,3) to room 7 | (3,4) . . . |
| (4,1) | (4,2) | (4,3) | (4,4) . . . |
| (5,1) | . . . | . . . | . . . (5,n) |

Is there going to be enough room for everyone? Yes, because if a guest occupied room R in hotel H then if $R \geq H$ that guest will be put in room $(R-1)^2 + H$, and if $R \leq H$ they will be put in room $H^2 - R + 1$.

This solution is greeted with great enthusiasm by the manager. Every incoming guest will be accommodated in his or her own unique room and not a single room in his hotel will be left empty.

# 99

# The Color of Music

Music is the easiest artistic pattern to analyze because it is a one-dimensional sequence of notes with fairly precise frequencies and time intervals between them. Perhaps the forms of music that humans find appealing share some simple mathematical features that can be extracted from familiar examples?

Sound engineers call music "noise" and to record its character they make use of a quantity called the "power spectrum," which gives the power of the sound signal at each frequency that it contains. It gives a good measure of how the average behavior of a time-varying signal varies with frequency. A related quantity is the "correlation function" of the sound, which shows how the sounds made at two different times, T and t + T, say, are related.[1] Many natural sources of sound, or "noises," have the property that their power spectra are proportional to an inverse mathematical power, $f^a$, of the sound frequency f, where the constant $a$ is positive, over a very wide range of frequencies. Such signals are called "scale-free" or "fractal" (like the pictorial fractal forms we have met already in other chapters) because there isn't a particular preferred frequency (like repeatedly hitting the note middle C) that characterizes them. If all the frequencies are doubled or halved then the spectrum will keep the same $f^a$ shape but with a different sound level at each frequency.[2]

When noise is completely random then $a = 0$ and every sound is uncorrelated with its predecessors: all frequencies have the same power. This type of signal is called "white noise" by analogy with

the way that all colors combine to give white light. The lack of correlations make white-noise sound sequences continually surprising because of the lack of correlations. Eventually, the ear loses interest in seeking patterns in white noise, so at low intensities they are restful like the gentle breaking of sea waves; this is why recordings of white noise are sometimes used to treat insomnia. By contrast, if sound has an $a = 2$ spectrum then this "brown noise"[3] is heavily correlated and rather predictable ("black noise" with $a = 3$ is even more so) – if frequencies have been rising then they tend to keep on rising (doh-ray-me-fah-so . . .) and this is not so appealing to the human ear either: it is too predictable. In between, there might be an intermediate situation with a pleasing balance between unpredictability and predictability that the ear "likes" the most.

In 1975, two physicists, Richard Voss and John Clarke at UC Berkeley in California, carried out the first experimental studies of this question.[4] They determined the power spectrum of many styles of human music, from Bach to the Beatles, along with music and talk on local radio stations. Later, they extended their analyses to include long stretches of music from many non-Western musical traditions covering a range of styles. From their analysis of these recordings, they argued that there was a strong preference for humans to like music with $a = 1$; that is, the "$1/f$ spectrum" that is often called "pink noise."[5] This special spectrum has correlations on all time intervals. It optimizes surprise and unpredictability in a definite way.[6]

Voss and Clarke's work seemed to be an important step toward characterizing human music as an almost fractal process of intermediate complexity in the low-frequency range, below 10 Hz. Other physicists with interest in sound and complexity reexamined it in greater detail. Things then turned out to be not so clear-cut. The lengths of the snatches of music used to determine the spectrum of correlations are crucial, and an inappropriate choice can give a bias to the overall findings. The $1/f$ spectrum would arise

for *any* audio signal recorded over a long enough interval,[7] like that required to perform an entire symphony, or for the hours of radio-station music transmissions that Voss and Clarke recorded. So if you analyze the sound signal for long enough, all music should tend to have a $1/f$ spectrum. If we go to the other extreme, and consider musical sounds over very short intervals of time that encompass up to about a dozen notes, we find that there are strong correlations between successive notes, and the sounds are usually very predictable and far from random. This suggests that it is on the intermediate time intervals that the spectrum of music will be most interesting.

Jean-Pierre Boon and Oliver Decroly then carried out an investigation like that of Voss and Clarke, but confined to the "interesting" intermediate range of time intervals in the frequency range from 0.03 to 3 Hz.[8] They studied twenty-three different pieces by eighteen different composers from Bach to Elliott Carter, averaging only over a structural subpart of each piece. They found no evidence for a $1/f$ spectrum now, although the spectrum was still approximately scale free. It was generally found to fall as $1/f^a$, with $a$ lying between 1.79 and 1.97. Humanly appreciated music is much closer to the correlated "brown" ($a = 2$) noise spectrum than to the "pink" ($1/f$) noise when it is sampled in natural musical-time movements designed to be heard in one piece.

# 100

# Shakespeare's Monkeys: The New Generation

There is a famous image of an army of monkeys typing letters at random and eventually producing the works of Shakespeare. It seems to have gradually emerged as an outlandish example of unlikelihood since the idea of random composition was described by Aristotle, who gave the example of a book whose text was formed from letters thrown randomly on the ground.[1] In *Gulliver's Travels*, written in 1782, Jonathan Swift tells of a mythical Professor of the Grand Academy of Lagado who aims to generate a catalogue of all scientific knowledge by having his students continuously generate random strings of letters by means of a mechanical printing device.[2] Several eighteenth- and nineteenth-century French mathematicians then used the example of a great book being composed by a random deluge of letters from a printing works.

The monkeys first came on the scene in 1909, when the French mathematician Émile Borel suggested that monkey typists would eventually produce every book in France's Bibliothèque Nationale. Arthur Eddington took up the analogy in 1928 in his famous book *The Nature of the Physical World*, in which he anglicized the library: "If I let my fingers wander idly over the keys of a typewriter it *might* happen that my screed made an intelligible sentence. If an army of monkeys were strumming on typewriters they *might* write all the books in the British Museum."

It should be said that in 2003 the University of Plymouth Media Lab received an Arts Council grant to conduct an experiment at Plymouth Zoo with six Celebes crested macaques.[3] Alas, they seemed mainly to like the letter S, contributing five pages consisting almost entirely of S's, and they also urinated rather too much on the keyboards.

At about the same time as this artistic debacle, computer experiments were run with virtual monkeys striking keys at random, the output of which was then pattern matched against the *Complete Works of Shakespeare* to identify any matching character strings. This simulation began on July 1, 2003, with a hundred "monkeys"; their population effectively doubled every few days until 2007, when the project ended. In that time they produced more than $10^{35}$ pages, each requiring 2,000 keystrokes.

The daily records are fairly stable, around the eighteen- or nineteen-character-string range, and the all-time record inched steadily upward. For a while the record string was twenty-one characters long, with:

> . . . KING. Let fame, that [wtIA''yh!'VYONOvwsFOsbhzkLH
> . . .]

which matches the following twenty-one letters from *Love's Labour's Lost*:

> KING. Let fame, that [all hunt after in their lives,
> Live regist'red upon our brazen tombs,
> And then grace us in the disgrace of death;]

In December 2004, the record reached twenty-three characters with:

> . . . Poet. Good day Sir [FhlOiX5a]OM,MlGtUGSxX4IfeHQbktQ
> . . .]

which matched part of *Timon of Athens*:

> Poet. Good day Sir
> [Painter. I am glad y'are well.]

But in January 2005, after 2,737,850 million billion billion billion monkey years of random typing, the record stretched to twenty-four characters, with:

> . . . RUMOUR. Open your ears; [9r'5j5&?OWTY Z0d 'B-nEoF.
> vjSqj[ . . .]

which matches twenty-four letters from *Henry IV, Part 2*:

> RUMOUR. Open your ears; [for which of you will stop
> The vent of hearing when loud Rumour speaks?]

Although the output of this random experiment is rather paltry, it is striking in the sense that it shows it really is just a matter of time. Roughly one character was being added to the match with the real Shakespearean string every year. If a computer system was developed that was significantly faster than those used in this experiment we might see impressive gains. Also, of course, any program powerful enough to create a work of Shakespeare by random "typing" would also produce all shorter works of literature even sooner.

An American programmer named Jesse Anderson from Reno, Nevada, began a new project in 2011 which attracted a huge amount of media attention[4] after he claimed that he had rather quickly re-created 99.9 percent of Shakespeare's works by use of a random choice algorithm[5]:

> Today (2011-09-23) at 2:30 PST the monkeys successfully
> randomly re-created "A Lover's Complaint." This is the first time

a work of Shakespeare has actually been randomly reproduced. Furthermore, this is the largest work [13,940 characters in 2,587 words] ever randomly reproduced. It is one small step for a monkey, one giant leap for virtual primates everywhere.[6]

However, what Anderson had done was not as dramatic as he made it sound. He simply used the "cloud" of worldwide computer resources to generate nine-character strings of letters at random. If they matched a word, like "necessary," or a string of words, like "grace us in," that appeared anywhere in Shakespeare's *Complete Works* then those words were crossed off in his opus (punctuation and spaces were ignored). If the string didn't appear in Shakespeare's *Works*, then it was discarded. Once all the words in the text were crossed off in this way the text was said to have been generated by the random search.

This is not what most people understand by creating Shakespeare at random. For the poem "A Lover's Complaint" we would be looking for the random creation of a single 13,940-character string. With 26 letters to choose from there are $26^{13,940}$ possible strings of this length that could be randomly made. For comparison, there are only about $10^{80}$ atoms in the entire visible universe. Anderson made the task feasible by picking 9-character strings for random generation. You can see that generating 13,940-character strings and looking for the whole poem would have been hopeless. By contrast, single-character strings would be pretty unimpressive. You would very quickly generate all 26 different letters of the alphabet, enabling you to cross off every letter in every word in Shakespeare (and every other work in the English language as well). Might you then not claim that you had generated his *Complete Works* by random typing? Methinks not.

# Notes

Chapter 2. *How Many Guards Does an Art Gallery Need?*
1  If the polygon has S vertices there will be S-2 triangles.
2  We denote this number by [W/3]. This was first proved by Václav Chvátal, *Journal of Combinational Theory* Series B 18, 39 (1975). The problem was posed by Victor Klee in 1973.
3  This is an NP-complete problem; see J. O'Rourke, *Art Gallery Theorem and Algorithms*, Oxford University Press, Oxford (1987).
4  J. Kahn, M. Klawe, and D. Kleitman, *SIAM Journal on Algebraic and Discrete Methods* 4, 194 (1983).

Chapter 3. *Aspects of Aspect Ratios*
1  http:www.screenmath.com.

Chapter 4. *Vickrey Auctions*
1  W. Vickrey, *J. of Finance* 16, 8 (1961).

Chapter 6. *The* Grand Jeté
1  Your center of mass lies close to your navel at about 0.55 of your height above the ground when you stand upright.
2  This can also be seen in the floor exercises in women's gymnastics.

Chapter 7. *Impossible Beliefs*
1  Assume the barber is neither bearded nor female!
2  A. Brandenburger and H. J. Keisler, "An Impossibility Theorem on Beliefs" in *Games, Ways of Worlds II: On Possible Worlds and Related Notions*, eds V. F. Hendricks and S. A. Pedersen, special issue of *Studia Logica* 84, 211 (2006).

*Chapter 8. Xerography – Déjà Vu All Over Again*

1  There was a long history of mechanical document copying before Carlson's innovation, from hand-cranked machines to carbon paper. For an illustrated history, see the article "Antique Copying Machines" at http://www.officemuseum.com/copy_machines.htm.

2  He applied for his first patent in October 1937.

3  Carlson's materials were improved. Sulphur was replaced by selenium, a much better photoconductor; and lycopodium by an iron powder and ammonium salt mixture for a much clearer final print.

*Chapter 9. Making Pages Look Nice*

1  J. Tschichold, *The Form of the Book*, Hartley & Marks, Vancouver (1991).

2  Illustration devised by J. A. Van de Graaf, *Nieuwe berekening voor de vormgeving* in *Tété*, pp. 95–100, Amsterdam (1946), and discussed by Tschichold.

3  W. Egger, *Help! The Typesetting Area*, http://www.ntg.nl/maps/30/13.pdf (2004). It has also been argued that these page design ratios have links to those used in music and architecture which can be traced to religious veneration of Solomon's Temple. See C. Wright, *J. Amer. Musicol. Soc.* 47, 395 (1994). I am grateful to Ross Duffin for this information.

4  S. M. Max, *Journal of Mathematics and the Arts* 4, 137 (2010).

5  R. Hendel, *On Book Design*, Yale University Press, New Haven, CT (1998).

*Chapter 11. A Most Unusual Cake Recipe*

1  Our cake design would also allow us to build an infinitely high building without its weight (proportional to its volume) becoming arbitrarily large, which would cause it to break the molecular bonds in its base and collapse or sink.

2  This proof was first found by Nicole Oresme in the fourteenth century.

3  In practice we could not make a cake with an arbitrarily large number of tiers of diminishing size. If we allowed tiers to get as small as a single atom at $10^{-10}$ m and a bottom tier of 1-m radius then the 10 billionth tier would be the size of a single atom.

*Chapter 13. The Beginning of the Universe Live on TV*

1  Roughly 3° Kelvin divided by the antenna temperature of about 290° Kelvin, which is roughly 1.03 percent.

*Chapter 15. Art Is Critical*

1  E. O. Wilson, *Consilience*, Knopf, New York (1998).

*Chapter 16. Culinary Arts*

1  http://britishfood.about.com/od/christmasrecipes/a/roastguide.htm.

2  http://www.britishturkey.co.uk/cooking/times.shtml.

3  http://www.cooksleys.com/Turkey_Cooking_Times.htm.

*Chapter 17. Curved Triangles*

1  The width of a cover of any shape is defined to be the distance between two parallel lines that touch the edge of the cover on opposite sides.

2  A square, or other regular polygon, can be rolled smoothly along a road which is not flat. With a square wheel you get a smooth ride on a road that is an upside-down catenary curve. See J. D. Barrow, *100 Essential Things You Didn't Know You Didn't Know*, Bodley Head, London (2008), Chapter 64.

3  F. Reuleaux, *Kinematics of Machinery*, F. Vieweg und Sohn, Braunschweig (1875), Vols. 1 and 2, online at http://kmoddl.library.cornell.edu/bib.php?m=28.

4  This can't be done in three dimensions by drawing four spherical surfaces with centers at the corners of a regular tetrahedron. The resulting figure is not quite a surface of constant width: there is a 2 percent variation in widths across the surface. If you try moving a flat disk balanced on three spheres rolling on a table then there will be a very slight wobble.

5  There is an infinite number of possible curved shapes of constant width, some with sharp corners and others with rounded corners. The Reuleaux triangle is the one with the smallest area for its width.

6  It encloses an area $(4 - 8/\sqrt{3} + 2\pi/9)$ times the area of the unit bounding square; see S. Wagon, *Mathematica in Action*, W. H. Freeman, New York (1991), pp. 52–4 and 381–3.

*Chapter 18. The Days of the Week*

1  For a more extensive discussion see J. D. Barrow, *The Artful Universe Expanded*, Oxford University Press, Oxford (2005, 1st ed. 1995), pp. 177–90.

*Chapter 19. The Case for Procrastination*

1  C. Gottbrath, J. Bailin, C. Meakin, T. Thompson, and J. J. Charfman (1999), http://arxiv.org/pdf/astro-ph/9912202.pdf.

*Chapter 20. Diamonds Are Forever*

1 His doctoral thesis was on the grinding and polishing of diamonds rather than on their appearance.

2 Tolkowsky showed that for total internal reflection of incoming light to occur at the first face it strikes, the inclined facets must make an angle of more than 48° 52' with the horizontal. After the first internal reflection the light will strike the second inclined face and be completely reflected if the face makes an angle of less than 43° 43' with the horizontal. In order for the light to leave along a line that is close to vertical (rather than close to the horizontal plane of the diamond face) and for the best possible dispersion in the colors of the outgoing light, the best value was found to be 40° 45'. Modern cutting can deviate from these values by small amounts in order to match properties of individual stones and variations in style.

3 The small thickness at the girdle is to avoid a sharp edge.

*Chapter 21. How Do You Doodle?*

1 http://en.wikipedia.org/wiki/Doodle.

*Chapter 22. Why Are Eggs Egg-Shaped?*

1 I am most grateful to Yutaka Nishiyama for telling me about the mathematics of egg shapes during his visit to Cambridge from Osaka in 2005.

*Chapter 23. The El Greco Effect*

1 P. D. Trevor-Roper, *The World Through Blunted Sight*, Thames & Hudson, London (2nd ed. 1988).

2 S. M. Antis, *Leonardo* 35 (2), 208 (2002).

*Chapter 25. What the Eye Tells the Brain*

1 Take two circles of radii r and R > r and equally space N dots around each circle. The distances between dots around each of these two circles will be $2\pi r/N$ and $2\pi R/N$, respectively. You will tend to see circles when the inter-point spacing on the inner circle is smaller than the distance to a point on the outer circle, roughly when $2\pi r/N < R–r$. However, when $2\pi r/N > R–r$ you will see crescents.

2  J. D. Barrow and S. P. Bhavsar, *Quarterly Journal of the Royal Astronomical Society* 28, 109–28 (1987).

## Chapter 26. Why the Flag of Nepal Is Unique

1  http://www.supremecourt.gov.np/main.php?d=lawmaterial&f=constitution_schedule_i. See also T. Ellingson, *Himalayan Research Bulletin* 21, Nos. 1–3 (1991).

2  I make the bottom one 45 degrees exactly and the upper one 32 degrees to the nearest degree (its tangent equals $4/3 - 1/\sqrt{2}$).

## Chapter 27. The Indian Rope Trick

1  P. Lamont, *The Rise of the Indian Rope Trick: How a Spectacular Hoax Became a History*, Abacus, New York (2005).

2  R. Wiseman, R. and P. Lamont, *Nature*, 383, 212 (1996).

3  See P. L. Kapitsa, translated from Russian original in *Collected Papers by P. L. Kapitsa*, ed. D. ter Haar, Vol. 2, pp. 714–26, Pergamon Press, Oxford (1965); and A. B. Pippard, *European Journal of Physics* 8, 203–6 (1987). Interesting discussions can also be found in the book by D. Acheson, *1089 and All That*, Oxford University Press, Oxford (2010), from a mathematical perspective, and in M. Levi, *Why Cats Land on Their Feet*, Princeton University Press, Princeton, NJ (2012), from a physicist's perspective.

## Chapter 28. An Image That Defeats the Eye

1  This floral name, with its vital overtones, is modern. It was coined by the new-age author Drunvalo Melchizedek in *The Ancient Secret of the Flower of Life*, Vols. 1 and 2, Light Technology Publishing, Flagstaff, AZ (1999).

2  The earliest recorded example was in a thirteenth-century manuscript kept in the City Library at Chartres, but it was destroyed in 1944. See http://www.liv.ac.uk/~spmr02/rings/trinity.html for further history. Augustine's description doesn't draw the rings.

## Chapter 29. It's Friday the Thirteenth Again

1  From the Greek words for "three" (*tris*), "and" (*kai*), "ten" (*deka*), and "fear" (*phobia*), introduced in I. H. Coriat, *Abnormal Psychology*, 2, vi, 287, W. Rider & Son, London (1911).

2  In Greek, "*paraskevi*" is Friday.

3  Defined by Pope Gregory XIII in 1582 by his decree that the day

following October 4 would be October 15. This was adopted at once by Italy, Poland, Portugal, and Spain. Other countries responded later.

4 B. Schwerdtfeger, http://berndt-schwerdtfeger.de/articles.html.

5 The Gregorian leap year is only included when the year number is divisible by 100 and 400, so 2100 is not a leap year. The number of days in 400 Gregorian years is therefore $100(3 \times 365 + 366) - 3 = 146,097$, J. Havil, *Nonplussed*, Princeton University Press, Princeton, NJ (2010). Havil gives a fuller discussion of this problem.

## Chapter 31. The Gherkin

1 http://www.bbc.co.uk/news/uk-england-london-23930675.

## Chapter 32. Hedging Your Bets

1 The origin of the terminology "hedging your bets" is nearly 400 years old. It seems to follow from the idea of putting one type of financial risk or debt completely inside an advantageous one, so planting a hedge around it for security, just as you would around your land.

## Chapter 34. Shedding Light on (and with) the Golden Ratio

1 The nominal power printed on a light bulb in watts is what it would use when connected to the standard voltage (usually printed on the bulb as well), which would be 230 volts in the UK. This has nothing to do with the electric circuit in which the bulb is connected, and if you have two bulbs made for the same nominal voltage then the one with the lower resistance will draw on the higher power.

2 The power output is not the same as the brightness, which is what we perceive. The brightness varies as a power of the wattage, so optimal power ratios are the same as optimal brightness ratios.

3 It is a never-ending decimal, equal to 0.61803398875 . . . It is given here rounded to only two decimal places and equals $1/g$.

## Chapter 35. Magic Squares

1 This is because the sum of the first k numbers is $\frac{1}{2} k(k + 1)$ and so the sum of any row, column, or diagonal in an n $\times$ n magic square will be given by this formula with $k = n^2$ and then divided by n.

2 This can also be extended into a third dimension to create a magic cube.

3  This can't be done for $4 \times 4$ or $5 \times 5$ squares because then there isn't a whole number Q that solves $33 = \frac{1}{2} n(n^2 + 1) + nQ$. The choice $Q = 6$ is a solution for the $n = 3$ square.

## Chapter 36. Mondrian's Golden Rectangles

1  During his early period of growing international recognition Mondrian changed his surname from its Dutch-sounding original spelling, Mondriaan, to the Mondrian that we know today.

2  The limit of the ratio $F_{n+D} / F_n$ approaches $G^D$ as n grows large, where $F_n$ is the $n^{th}$ Fibonacci number, G is the golden ratio, and D is any whole number.

## Chapter 37. Monkey Business with Tiles

1  If there were N small squares, each allowing four orientations, the total number of possible puzzle configurations would be $N! \times 4^N$. I have calculated the case with $N = 9$. Note that the four final solutions are really the same because they correspond to rotating the entire puzzle through 90, 180, 270, or 360 degrees, which is the same as looking at it from different directions.

## Chapter 38. Pleasing Sounds

1  The approximation of $^{22}/_7$ for $\pi$ will be a familiar example from school: an even better one is $^{355}/_{113}$.

2  The successive rational approximations, by keeping one, two . . . terms in the continued fraction expansion, are $1, 2, 3/2, 8/5, 19/12, 65/41, 84/53$ . . . etc.

## Chapter 41. Paper Sizes and a Book in the Hand

1  If you wanted to trisect pages rather than bisect them, then after cutting in three $R = 3/h$, and this would only equal the initial R value of h if $R = \sqrt{3}$.

2  This ensures that photocopier reduction of an A4 document doesn't require a change of paper tray. The reduction factor that is offered on the copier usually says 70 percent, which is approximately the factor $0.71 = 1/\sqrt{2}$. If you want to enlarge, it shows 140 percent, which is approximately the factor $1.41 = \sqrt{2}$. Reducing two A4 pages by the $\sqrt{2}$ factor to A5 means they print out side by side on a sheet of A4. The US letter paper sizes do not have this rational property.

3  The exact value of the golden ratio is $g = \frac{1}{2} (1+\sqrt{5}) = 1.618$ . . .

The fraction $^{34}/_{21}$ is a very good rational approximation to an irrational number. Two quantities A and B are in the golden ratio if G $= A/B = (A+B)/A$. Then $G^2 - G - 1 = 0$, hence the solution for G.

4 When books get very small then $R = \sqrt{3} = 1.73$ or $5/3 = 1.67$ are the commonest aspect ratios.

## Chapter 42. Penny Blacks and Penny Reds

1 There were twelve old pennies (d) in one shilling (s), and four farthings (¼ d) in a penny.

2 Two examples of use dated May 2 and 5 exist and are very valuable. The May 5 envelope is in the Royal Philatelic Collection.

3 The original printings were withdrawn because of problems with the perforating, but a handful seem to have found their way into the public domain. The offending plate was decommissioned soon afterward by being defaced. One of the four known unused copies is in the Royal Collection, and a second is in the Tapling Collection in the British Library; the third was stolen from the Raphael collection in 1965 and the fourth (of questionable authenticity) was sold in the 1920s with the Ferrary collection. Neither of the latter two has been heard of since.

## Chapter 43. Prime Time Cycles

1 Female rabbits in a single warren tend to become synchronized in their pregnancies, again so that large numbers of baby rabbits appear at about the same time and predators, like foxes, encounter a glut.

## Chapter 44. If You Can't Measure It, Why Not?

1 J. Myhill, *Review of Metaphysics* 6, 165 (1952).

2 In a world with no Gödel's Incompleteness theorem every arithmetical statement would be listable.

## Chapter 45. The Art of Nebulae

1 See http://hubblesite.org/gallery/showcase/nebulae/n6.shtml.

2 E. Kessler in R. W. Smith and D. H. De Vorkin, "The Hubble Space Telescope: Imaging the Universe," *National Geographic* (2004), and E. Kessler, *Picturing the Cosmos: Hubble Space Telescope Images and the Astronomical Sublime*, University of Minnesota Press, Minneapolis, MN (2012).

3 J. D. Barrow, *The Artful Universe Expanded*, Oxford University Press, Oxford (2005).

*Chapter 48. Prize Rosettes*

1 For photographs of natural and human symmetries, including rosette symmetries, see I. and M. Hargittai, *Symmetry: A Unifying Concept*, Shelter Publications, Bolinas, CA (1994).

*Chapter 49. Getting a Handle on Water Music: Singing in the Shower*

1 If we approximate the shower as an upright pipe H = 2.45 m tall then the frequencies of the vertical standing waves are multiples of f = V/2H = 343/4.9 = 70 Hz, where V = 343 m/s is the sound speed at shower temperature. Hence, the frequencies created are given by f, 2f, 3f, 4f, etc. and, specifically, the ones less than 500 Hz are at 70, 140, 210, 280, 350, 420, and 490 Hz.

*Chapter 50. Sizing Up Pictures*

1 R. P. Taylor, A. P. Micolich, and D. Jonas, *Nature* 399, 422 (1999); & *Journal of Consciousness Studies* 7, 137 (2000); J. D. Barrow, *The Artful Universe Expanded*, Oxford University Press, Oxford (2005); and subsequent discussion by J. R. Mureika, C. C. Dyer, and G. C. Cupchik, *Physical Review* E 72, 046101 (2005).

2 The word "fractal" was only invented by Benoit Mandelbrot in 1972 and the mathematical concept would have been unknown to Pollock.

3 H. Koch, *Arkiv f. Matematik*, 1 (1904).

*Chapter 51. Triquetra*

1 The way in which this was deduced by Bradley Schaefer is explained in J. D. Barrow, *Cosmic Imagery*, Bodley Head, London (2008), pp. 11–19.

2 Creating a trefoil knot in 3-D space with coordinates (x, y, z) will be achieved by allowing the parameter u to vary in the three parametric equations for the trefoil: $x = \sin(u) + 2\sin(2u)$, $y = \cos(u) - 2\cos(2u)$ and $z = -3\sin(u)$.

*Chapter 52. Let It Snow, Let It Snow, Let It Snow*

1 H. D. Thoreau, *The Journal of Henry David Thoreau*, eds. B. Torrey and F. Allen, Houghton Mifflin, Boston (1906), and Peregrine Smith Books, Salt Lake City (1984), Vol. 8, 87–8.

2 Kepler conjectured what the best arrangement would be but it was not until 1998 that this was proved to be correct by Thomas Hales

of the University of Pittsburgh. The proof ran to 250 pages of text and a large amount of computer programming to check particular cases that might be counterexamples. The answer is the pyramid stack that greengrocers commonly use to pile up oranges (it would probably have been cannonballs in Kepler's day) on their market stalls. Each orange rests on the niche created by the three below it. The oranges fill 74.048 percent of the space: the rest is empty. Any other arrangement leaves more empty space.

3  J. Kepler, *On the Six-Cornered Snowflake*, Prague (1611), ed. and trans. C. Hardie, p. 33, Oxford University Press, Oxford (1966).

4  For the most beautiful collection of color images and research into the structure of snowflakes, see the work of Kenneth Libbrecht at http://www.its.caltech.edu/~atomic/snowcrystals/ and his many books of snowflake images.

## Chapter 53. Some Perils of Pictures

1  Helly's theorem says that if there are N convex regions in an n-dimensional space, where $N \geqslant n+1$, and any choice of $n+1$ of the collection of convex regions has a nonempty intersection, then the collection of N convex regions has a nonempty intersection. We are considering the case $n = 2$ and $N = 4$.

2  The result applies to regions which are convex. A convex region is one in which, if you draw a straight line between two points inside it, the line stays inside. This is clearly the case for a circle O but would not be the case for a region shaped like the letter S.

3  O. Lemon and I. Pratt, *Notre Dame Journal of Logic* 39, 573 (1998). For a philosopher's approach to the problem of depicting information see C. Peacocke, *Philosophical Review* 96, 383 (1987).

## Chapter 54. Drinking with Socrates

1  A water molecule is composed of two hydrogen atoms with one proton in each nucleus, and one oxygen atom with eight protons and eight neutrons of roughly equal masses in its nucleus. The mass of an electron ($9.1 \times 10^{-28}$ gm) orbiting the nucleus is negligible (1,836 times smaller) compared to the mass of the protons ($1.67 \times 10^{-24}$ gm) and neutrons in the nucleus.

2  Slightly different numbers will hold for different estimates of the total water mass (or volume) according to whether you include fresh water and frozen water. The reader might like to check that these make

small differences to the final numbers and don't change the main thrust of the argument.

*Chapter 56. Stylometry: Mathematics Rules the Waves*
1 http://www.charlottecaspers.nl/experience/reconstruction.

*Chapter 57. Getting It Together*
1 This beautifully simple explanation for many types of synchronized behavior seen in the natural world was introduced by the Japanese mathematician Yoshiki Kuramoto in 1975.
2 Z. Néda, E. Ravasz, T. Vicsek, Y. Brechet, and A. L. Barabási, *Physical Review* E 61, 6,987 (2000), and *Nature* 403, 849 (2000).

*Chapter 61. All the Wallpapers in the Universe*
1 For pictures of each see my book *The Artful Universe Expanded*, Oxford University Press, Oxford (2005), pp. 131–3. For an insightful and beautifully illustrated book about these patterns, see J. H. Conway, H. Burgiel, and C. Goodman-Strauss, *The Symmetries of Things*, A. K. Peters, Wellesley, MA (2008).

*Chapter 62. The Art of War*
1 *The Art of War by Sun Tzu – Special Edition*, translated and annotated by L. Giles, El Paso Norte Press, El Paso, TX (2005).
2 It is straightforward to solve them since $d^2B/dt^2 = -gdG/dt = gbB$, so $B(t) = Pexp(t\sqrt{bg}) + Qexp(-t\sqrt{bg})$, where P and Q are constants fixed by the initial number of the units at $t = 0$ given by $B(0) = P + Q$. Similar relations hold for $G(t)$.
3 F. W. Lanchester, "Mathematics in Warfare" in *The World of Mathematics*, ed. J. Newman, Vol. 4, pp. 2,138–57, Simon & Schuster, NY (1956); T. W. Lucas and T. Turkes, *Naval Research Logistics* 50, 197 (2003); N. MacKay, *Mathematics Today* 42, 170 (2006).
4 For example, we might use a more general interaction model for the G and the B units, with $dB/dt = -gG^pB^q$ and $dG/dt = -bB^pG^q$. This means that the constant quantity during the battle is $gG^w - bB^w$, where $w = 1+ p - q$. The simple model we discussed has $p = 1$ and $q = 0$. A model with completely random firing and distribution of units would have $p = q = 1$ and so $w = 0$. The outcome in the latter case would be determined by the difference in the effectivenesses, and the numbers of units would not be a factor. Researchers have studied

different battles to fit the best values of p and q to understand the outcome after the event.

### Chapter 63. *Shattering Wineglasses*
1  If you have ever had kidney stones treated in a hospital then you may have been zapped by sound waves which shatter them into smaller pieces.
2  W. Rueckner, D. Goodale, D. Rosenberg, S. Steel, and D. Tavilla, *American Journal of Physics* 61, 184 (1993).

### Chapter 65. *Special Triangles*
1  The angle at the apex of the triangle is 36 degrees $= \pi/5$ radians and its cosine is therefore equal to one half of the golden ratio.

### Chapter 66. *Gnomons Are Golden*
1  If all these lengths were multiplied by the same number then another example would be created.
2  R. Penrose, *Bulletin of the Institute for Mathematics and Its Applications* 10, 266 ff. (1974), and *Eureka* 39, 16 (1978).
3  P. Lu and P. Steinhardt, *Science* 315, 1,106 (2007).

### Chapter 67. *The Upside-down World of Scott Kim*
1  S. Kim, *Inversions*, W. H. Freeman, San Francisco (1989).

### Chapter 68. *How Many Words Did Shakespeare Know?*
1  B. Efron and R. Thisted, *Biometrical* 63, 435 (1976). They treated each different form of a word, e.g. singular and plural, as a different word.
2  J. O. Bennett, W. L. Briggs, and M. F. Triola, *Statistical Reasoning for Everyday Life*, Addison Wesley Longman, New York (2002).

### Chapter 69. *The Strange and Wonderful Law of First Digits*
1  F. Benford, *Proceedings of the American Philosophical Society* 78, 551 (1938).
2  S. Newcomb, *American Journal of Mathematics* 4, 39 (1881).
3  This applies to quantities like areas with dimensions. Newcomb and Benford's distribution is left unchanged by scaling quantities to have new units. This invariance condition, that the first digit distribution satisfies $P(kx) = f(k)P(x)$, with k constant, means $P(x) = 1/x$ and

$f(k) = 1/k$. It uniquely selects the Newcomb–Benford distribution since $P(d) = [\int_d^{d+1} dx/x] / [\int_1^{10} dx/x] = \log_{10}[1 + 1/d]$.

4  If we wrote our numbers in an arithmetic with base b, then the same distribution arises but with the logarithm to the base b rather than 10.

5  M. Nigrini, *The detection of income evasion through an analysis of digital distributions*, University of Cincinnati PhD thesis (1992).

6  Their law arises exactly for any process with a probability distribution $P(x) = 1/x$ for outcome x in the interval from 0 to 1. If $P(x) = 1/x^a$ with $a \neq 1$ then the probability distribution of first digits, d, is $P(d) = (10^{1-a} - 1)^{-1}[(d+1)^{1-a} - d^{1-a}]$. For $a = 2$, $P(1)$ is now 0.56.

## Chapter 70. Organ Donor Preferences

1  It has been suggested by Marvin Minsky, in his book *The Society of Mind*, Simon & Schuster (1987), that the human mind works like this too.

2  P. Young, *Equity in Theory and Practice*, p. 461, Princeton University Press, Princeton, NJ (1994). This is also discussed in *For All Practical Purposes*, ed. S. Garfunkel, 9th ed., W. H. Freeman, New York (1995).

3  This was proved for voting systems under very general conditions by the Nobel Prize–winning economist Ken Arrow.

## Chapter 71. Elliptical Whispering Galleries

1  If you tether a goat with ropes attached to two different fixed points, the border of the region of grass that it eats will be elliptical in shape.

2  We draw a tangent to the ellipse at the point of reflection. The angles that the incident and reflected lines make with this tangent are equal. This ensures that the reflected path goes through the other focus. Reversing the argument shows that a line from the other focus will pass through the first one after reflection.

## Chapter 72. The Tunnel of Eupalinos

1  Hero of Alexandria wrote a treatise nearly 500 years later that explained the geometrical theory of how to carry out the tunnelling process described here; see T. Heath, *A History of Greek Mathematics* Vol. 2, p. 345, Dover, New York (1981), first published 1921.

2  A. Burns, *Isis* 62, 172 (1971); T. M. Apostol, *Engineering and Science* 1, 30 (2004).

3  Å. Olson, *Anatolia Antiqua* 20, 25, Institut Français d'Études Anatoliennes (2012).

4   In Herodotus III.60 we read: ". . . about the Samians I have spoken at greater length, because they have three works which are greater than any others that have been made by Hellenes: first a passage beginning from below and open at both ends, dug through a mountain not less than a hundred and fifty fathoms [200 m] in height; the length of the passage is seven furlongs [1.4 km] and the height and breadth each eight feet, and throughout the whole of it another passage has been dug twenty cubits [9.26 m] in depth and three feet in breadth, through which the water is conducted and comes by the pipes to the city, brought from an abundant spring: and the designer of this work was a Megarian, Eupalinos the son of Naustrophos."

5   Photographs of the tunnel and its entrances can be found at http://www.samostour.dk/index.php/tourist-info/eupalinos.

*Chapter 73. A Time-and-Motion Study of the Great Pyramid*

1   The largest pyramid by volume is the Great Pyramid of Cholula in the Mexican state of Puebla. It was constructed between 900 and 30 BC and is believed to be the largest human construction in the world. Pyramids were built in many ancient cultures because the basic geometry is advantageous: a large proportion of the structure is close to the ground and the weight-bearing requirements are less demanding than for a vertical tower.

2   S. K. Wier, *Cambridge Archaeological Journal* 6, 150 (1996).

3   If the pyramid is hollow then this changes to $h/3$.

4   A different type of critical path analysis of the building project by engineers estimates about twenty years, quite a good consensus given the choices one can make about the number of workers and hours of work. See the article by C. B. Smith, "Program Management B.C.," *Civil Engineering* magazine, June 1999 issue; online at http://web.archive.org/web/20070608101037/http://www.pubs.asce.org/ceonline/0699feat.html.

5   The best method would be to have a hoist attached to a cradle with a rock on one side of the pulley and a big basket for lots of men on the other. When the weight of men exceeded that of the rock it would ascend while the men descended to the ground. Very recently it has been shown that wetting a sandy surface makes sliding heavy stones much easier, see A. Fall et al., *Physical Review Letters* 112, 175502 (2014).

*Chapter 74: Picking Out Tigers in the Bushes*
1 You can take the original test for yourself online at http://www.ink
blottest.com/test/.
2 http://www.sciencemuseum.org.uk/about_us/smg/annual_review/
breaking_cultural_barriers/hockney_hawking.aspx.

*Chapter 76. On a Clear Day . . .*
1 http://www.stephenfriedman.com/artists/catherine-opie/news/cath
erine-opie-twelve-miles-to-the-horizon-at-the-long-beach-museum-of
-art/.
2 The Earth is not quite spherical. Its polar radius is b = 6356.7523 km
and its equatorial radius is a = 6378.1370 km. Treating it as a spheroid
this means that its average radius is (2a + b)/3 = 6,371.009 km, or
3,958.761 miles: H. Moritz, *Journal of Geodesy* 74, 128 (2000).

*Chapter 77. Salvador Dalí and the Fourth Dimension*
1 A copy is at http://upload.wikimedia.org/wikipedia/en/0/09/Dali_
Crucifixion_hypercube.jpg.
2 C. Hinton, *Speculations on the Fourth Dimension*, ed. R. Rucker, Dover,
New York (1980). Hinton had also written pamphlets on the subject
as early as 1880.

*Chapter 79. Chernoff's Faces*
1 H. Chernoff, *Journal of the American Statistical Association* 68, 361 (1973).

*Chapter 81. Möbius and His Band*
1 E. Breitenberger and Johann Benedict Listing, in I. M. James (ed.),
*History of Topology*, pp. 909–24, North Holland, Amsterdam (1999).
2 M. C. Escher, *The Graphic Work of M. C. Escher*, trans. J. Brigham, rev.
ed., Ballantine, London (1972).
3 J. Thulaseedas and R. J. Krawczyk, "Möbius Concepts in Architecture,"
http://www.iit.edu/~krawczyk/jtbrdg03.pdf.

*Chapter 82. The Bells, the Bells*
1 Factorial N, or N! equals N × (N – 1) × (N – 2) × . . . × 2 × 1, so
3! = 6 for example.
2 A. T. White, *American Mathematical Monthly*, 103, 771 (1996).
3 G. McGuire, http://arxiv.org/pdf/1203.1835.pdf.

*Chapter 83. Following the Herd*

1   W. D. Hamilton, *Journal of Theological Biology*, 31, 295 (1971).

2   S. V. Viscido and D. S. Wethey, *Animal Behavior* 63, 735 (2002).

*Chapter 84. Finger Counting*

1   The story is described in T. Dantzig, *Number, the Language of Science*, Macmillan, New York (1937), and on p. 26 of my book, J. D. Barrow, *Pi in the Sky*, Oxford University Press, Oxford (1992); this book contains an extensive discussion of the origins of counting in general and finger counting in particular. There is also commentary on pp. 221–2 of B. Butterworth, *The Mathematical Brain*, Macmillan, New York (1999).

2   In other parts of the world a different finger may be used to commence the finger count.

*Chapter 85. The Other Newton's Hymn to the Infinite*

1   Newton's second letter to Richard Bentley (1756) in I. B. Cohen, *Isaac Newton's Paper & Letters on Natural Philosophy*, p. 295, Harvard University Press, Cambridge, MA (1958).

2   Based on David's prayer in I Chronicles 17. The Olney hymnal has a hymn for each book of the Bible and "Amazing Grace" is for the Book of Chronicles. See http://www.mkheritage.co.uk/cnm/html/MUSEUM/works/amazinggrace.html.

3   *Olney Hymns of Newton and William Cowper* (1779). "Amazing Grace" is number 41.

4   The earth shall soon dissolve like snow/The sun forbear to shine;/ But God, who called me here below,/Will be forever mine.

5   It is the last stanza (of more than fifty) in the anonymous hymn "Jerusalem, My Happy Home," found in *A Collection of Sacred Ballads* compiled by Richard and Andrew Broaddus and published in 1790.

6   H. Beecher Stowe, *Uncle Tom's Cabin, or Life Among the Lowly*, p. 417, chapter 38, R. F. Fenno & Co., New York (1899).

7   J. D. Barrow, *Pi in the Sky*, Chapter 5, Oxford University Press, Oxford (1992).

*Chapter 87. Markov's Literary Chains*

1   A. A. Markov, "An example of statistical investigation of the text *Eugene Onegin* concerning the connection of samples in chains" (first published in Russian 1913), English translation A. Y. Nitussov,

L. Voropai, G. Custance and D. Link, *Science in Context* 1(4), 591 (2006).

2  D. Link, *History of Science* 44, 321 (2006).

3  A reanalysis of the English translation of the text of *Eugene Onegin* by Brian Hayes, reported in *American Scientist* 101, 92 (2013), shows the different balance between consonants and vowels in Russian and English. Hayes's statistics for the English translation are reported here.

*Chapter 88. From Free Will to the Russian Elections*

1  E. Seneta, *International Statistical Review* 64, 255 (1996) and 71, 319 (2003).

2  This is called an ergodic theorem. For the result to hold we must have only finite sets of possibilities at any time; the state reached at the next time step depends only on its present state (not on its previous history) and the chance of each possible change occurring at any step is prescribed by a set of fixed transition probabilities; you can pass between any two allowed states given enough time; and the system does not possess a periodic cycle in time. If these conditions hold then any Markov process converges to a unique statistical equilibrium regardless of its starting state or the pattern of time changes during its history.

3  O. B. Sheynin, *Archive for History of Exact Sciences* 39, 337 (1989).

4  See, for example, the sixteenth image down in http://nl.livejournal.com/1082778.html and the discussion of Russian elections in http://arxiv.org/pdf/1205.1461.pdf or http://darussophile.com/2011/12/26/measuring-churovs-beard.

5  P. Klimek, Y. Yegorov, R. Hanel, and S. Thurner, *Proceedings of the National Academy of Sciences* 109, 16469 (2012) at http://www.pnas.org/content/early/2012/09/20/1210722109.full.pdf. M. Simkin, http://www.significancemagazine.org/details/webexclusive/1435463/US-elections-are-as-non-normal-as-Russian-elections.html.

*Chapter 89. Playing with Supreme Beings*

1  S. J. Brams, *Superior Beings: If They Exist, How Would We Know?* Springer, New York (1983).

2  S. J. Brams, *Game Theory and the Humanities: Bridging the Two Worlds*, MIT Press, Cambridge, MA (2011).

## Chapter 91. Watching Paint Crack

1 A. G. Berger and W. H. Russell, *Studies in Conservation* 39, 73 (1994).

2 http://www.conservationphysics.org/strstr/stress4.php.

3 M. F. Mecklenburg, M. McCormick-Goodhart, and C. S. Tumosa, *Journal of the American Institute for Conservation* 33, 153 (1994).

## Chapter 92. Pop Music's Magic Equation

1 http://scoreahit.com/science.

2 Mathematicians recognize this as the scalar product $\mathbf{w} \cdot \mathbf{Q}$ of the vectors $\mathbf{w}$ and $\mathbf{Q}$.

3 You can think of this as the definition of t.

4 Technically, the method is "ridge regression," also known as Tikhonov regularization.

## Chapter 93. Random Art

1 A similar construction was used on the record sleeve for the Pet Shop Boys' album *Yes* in 2009.

## Chapter 94. Jack the Dripper

1 R. P. Taylor, A. P. Micolich, and D. Jonas, *Nature* 399, 422 (1999), *Physics World* 12, 15 (October 1999), and *Leonardo* 35, 203 (2002).

2 J. D. Barrow, *The Artful Universe Expanded*, pp. 75–80, Oxford University Press, Oxford (2005).

3 R. P. Taylor, A. P. Micolich, and D. Jonas, *Journal of Consciousness Studies* 7, 137 (2000).

4 J. R. Mureika, G. C. Cupchik, and C. C. Dyer, *Leonardo* 37 (1), 53 (2004); and *Physical Review* E 72, 046101 (2005).

5 See A. Abbott, *Nature* 439, 648 (2006).

6 Lee Krasner was Jackson Pollock's wife.

7 K. Jones-Smith and H. Mathur, *Nature* 444, E9–10 (2006); K. Jones-Smith, H. Mathur, and L. M. Krauss, *Physical Review* E 79, 046111 (2009).

8 R. P. Taylor, A. P. Micolich, and D. Jonas, *Nature* 444, E10–11 (2006).

9 R. P. Taylor et al., *Pattern Recognition Letters* 28, 695 (2007).

## Chapter 95. The Bridge of Strings

1 Change coordinates from x, y to X, Y where X = x–y and Y = x+y and $y = (1 - \sqrt{x})^2$ transforms to a familiar parabolic equation Y =

$(1+X^2)/2$ in the X, Y coordinates, whose axes are rotated by 45 degrees relative to the x, y coordinates.

2  See the article by Renan for some pictures in http://plus.maths.org/content/bridges-string-art-and-bezier-curves.

3  The mathematics behind these smooth interpolating curves was developed separately by the French engineers Pierre Bézier in 1962 and Paul de Casteljau in 1959. Both were involved in producing car body designs by these methods, Bézier for Renault and Mercedes, and de Casteljau for Citroën.

### Chapter 96. Lacing Problems

1  This was first studied by J. Halton in 1965. See http://www.cs.unc.edu/techreports/92-032.pdf. Counting carefully, Polster found the total number of possibilities for n = 2m. See B. Polster, *Nature* 420, 476 (2002), and B. Polster, *The Shoelace Book: A Mathematical Guide to the Best (and Worst) Ways to Lace Your Shoes*, American Mathematical Society, Providence, RI (2006).

2  http://www.fieggen.com/shoelace/2trillionmethods.htm.

3  Polster (as above) and http://www.qedcat.com/articles/lacing.pdf.

### Chapter 97. Where to Stand to Look at Statues

1  Remarkably, the height of this statue was recorded as being 4.34 m in art history books and guides before it was accurately surveyed from a gantry by a Stanford research group in 1999 and found to be 5.17 m high – a huge error. See http://graphics.stanford.edu/projects/mich/more-david/more-david.html.

2  I have assumed the eye line is 1.5 m above the base of the pedestal in these examples.

3  http://en.wikipedia.org/wiki/List_of_statues_by_height.

### Chapter 98. The Hotel Infinity

1  David Hilbert was one of the world's foremost mathematicians in the first part of the twentieth century. His imaginary hotel is described by George Gamow in his book *One, Two, Three . . . Infinity*, pp. 18–19, Viking, New York (1947 and 1961).

2  J. D. Barrow, *Infinities,* performed in Milan 2001 and 2002 in a special space by Teatro Piccolo, directed by Luca Ronconi (see http://archivio.piccoloteatro.org/eurolab/?IDtitolo=268), and in Valencia in 2002. It is discussed in K. Shepherd Barr, *Science on Stage*, Princeton

University Press, Princeton NJ (2006), and P. Donghi, *Gli infiniti di Ronconi*, Scienza Express, Trieste (2013).

3   N. Ya. Vilenkin, *In Search of Infinity*, Birkhäuser, Boston (1995).

*Chapter 99. The Color of Music*

1   If the signal is always the same on the average then the correlation function will only depend on the interval, T, between the notes.

2   Departures from exact scale-free behavior clearly do exist, otherwise a recording would sound the same played at any speed.

3   This colorful term is used because the statistics of this form of noise are those of a diffusion-like process, like the "Brownian" motion of tiny suspended particles on a liquid surface first recorded by the botanist Robert Brown in 1827 and explained by Albert Einstein in 1905.

4   R. Voss and J. Clarke, *Nature* 258, 317 (1975), and *Journal of the Acoustical Society of America* 63, 258 (1978).

5   Although the $1/f$ spectrum was quite well approximated over long time intervals there were notable exceptions, like the music of Scott Joplin, which had lots of high-frequency variation from a single power-law form around 1–10 Hz.

6   The power spectrum is only one feature of musical sound variations. If you turn the musical score upside down or play it backward the power spectrum will stay the same but the music won't "sound" the same.

7   Yu Klimontovich and J.-P. Boon, *Europhysics Letters* 21, 135 (1987); J.-P. Boon, A. Noullez, and C. Mommen, *Interface: Journal of New Music Research* 19, 3 (1990).

8   J.-P. Boon and O. Decroly, *Chaos* 5, 510 (1995). Nigel Nettheim found something very similar in a study of only five melodies in *Interface: Journal of New Music Research* 21, 135 (1992); see also J. D. Barrow, *The Artful Universe Expanded*, Chapter 5, Oxford University Press, Oxford, 2nd ed. (2005).

*Chapter 100. Shakespeare's Monkeys: The New Generation*

1   Aristotle, *Metaphysics: On Generation and Corruption*.

2   The first mechanical typewriter had been patented in 1714.

3   http://timeblimp.com/?page_id=1493.

4  For examples, see http://www.bbc.co.uk/news/technology-15060310
   and   http://newsfeed.time.com/2011/09/26/at-last-monkeys-are
   -recreating-shakespeare/#ixzz2g5lpjK6t.
5  http://www.telegraph.co.uk/technology/news/8789894/Monkeys-at-
   typewriters-close-to-reproducing-Shakespeare.html.
6  http://news.cnet.com/8301-30685_3-20111659-264/virtual-monkeys
   -recreate-shakespeare-methinks-not/.